Fig. 3

Fig. 18

Fig. 17

Fig. 16

Fig. 27

Fig. 20

Fig. 21

Fig. 31

Fig. 32

STEAMPUNK
GRAPHICS

THE ART OF VICTORIAN FUTURISM

Published in 2014 by Graffito Books Ltd.,
32 Great Sutton Street,
London EC1V 0NB
www.graffitobooks.com

© Graffito Books Ltd, 2014
ISBN 978-1909051089
Text © Antoni Cadafalch

Art Direction: Karen Wilks
Editor: Katriona Feinstein

British Library cataloguing-in-publication data:
A catalogue record of this book is available at The British Library.

Printed in China.

STEAMPUNK GRAPHICS

THE ART OF VICTORIAN FUTURISM

General Editor
MARTIN DE DIEGO

Text by
ANTONI CADAFALCH

GRAFFITO

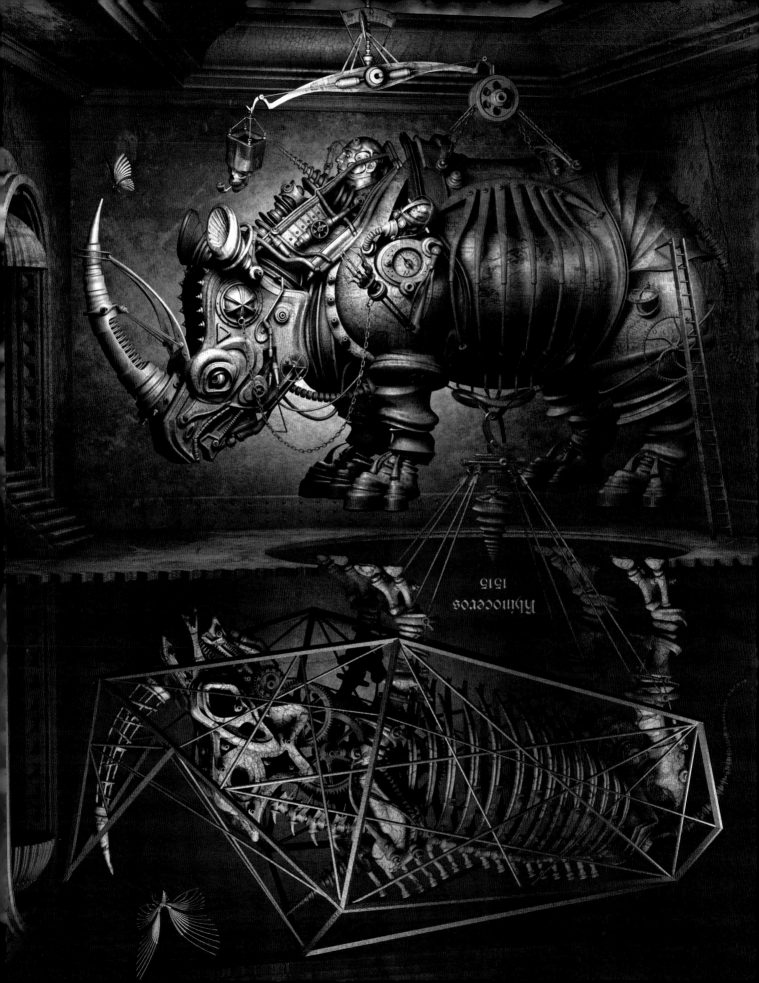

Rhinoceros
1515

Contents

LEFT: *Rhinocerus 1515* by Kazuhiko Nakamura

Introduction

"There is no past that lies beyond the reach of steampunk's capacity to create alternative histories that reveal tomorrow's possibilities, shaped by the rogue maker within us all."

Steampunk... the word conjures up fine gentlemen and cultured ladies, captains of the air, rascally rogues and streetwise waifs, adorned in Victorian or Western garb, outfitted with all manner of Jules Vernesque contraptions. Gears abound, steam hisses, technology that may be part paranormal, part science-fiction, lies embedded in brass and leather right alongside pistols, swords and walking sticks.

For the general public, discovering steampunk may feel like a fresh concept, but the truth of the matter is that steampunk has long since arrived. What began as a movement in speculative literary fiction has now established itself as a broad, persistent, artistic subculture, regularly feeding and inspiring worldwide creative participation. For decades now, its mechanical, neo-Victorian, sometimes post-apocalyptic aesthetic has heavily influenced major motion pictures such as *Sherlock Holmes*, *The League of Extraordinary Gentlemen* and *Hellboy*, and has seen a generation of gamers grow up on retro-futuristic classics like the *Final Fantasy* and *Bioshock* series.

Steampunk has its own legions of followers and participants ranging from the curious to the joyously committed makers and movers of the movement for whom grand adventure and artistic freedom is to be found in reimagining things that others have discarded — gadgets, technologies, ideas. If you've ever attended a steampunk event you'll have found individuals of every type and from every walk of life you might imagine — all greeting each other in crinolines and goggles of their own design, toting their own hand-crafted ray guns and clockwork contraptions. These steampunks are deeply engaged in their own personal expression of a living narrative and delighted by the pure inventiveness swirling around them. It's Cosplay meets Maker Faire, yet so much more.

Perhaps it's this flurry of creativity and imagination that has caused designers like Prada to jump on the steampunk bandwagon, and catapult its aesthetic into the stratosphere of high fashion, and, by extension, the global mass market. For some, there is concern that IBM's 2014 announcement that steampunk would be the world's Next Big Trend may have sounded the brassy death knell for a beloved subculture, taking its ticking heart and cheapening it through mass market usage with little meaning or commitment to its underlying ethos.

As with any artistic movement born on the fringes, authenticity is critical. However, steampunk's strength and armour lies in the siren song it sings to the maker within us all.

That call is the promise of the power of continually shifting artistic remix and, by definition, its soul belongs to each individual artist, not to a school or organization. It borders on being an ideology, not a format or defined rule-set. Steampunk is far more resilient and indestructible as a result. For those of us who have found that promise to be true, steampunk is not about an aesthetic subculture that needs protecting from posers, hipsters, bad movies and memes. It's about the next possibility: ideas and outcomes that our creativity brings to life, often leap-frogging on the shoulders of work others are contributing to the movement, as well as up-cycling what mass culture contributes, rather than being diluted by its participation.

Steampunk's graphic art is an excellent example of this constant evolution that is baked into the DNA of the movement, demonstrating the genre's expanding scope through innumerable, newly imagined worlds. This is graphic art which more often than not has a visual and conceptual mechanicity. Infused into steampunk's nature is an industrial quality brought to life by industrious minds. Its affinity for the Victorian era is not accidental. The late 1800s was a time when men's minds thrilled with the notion that the unknown was knowable, and theories modelled on emerging industrial knowledge imagined the universe, large and small, to have a clockwork nature. Today, we have smooth boxes that don't reveal their workings and in a sense, steampunk contains a rebellion against hidden function and agendas. In a digital age, it delights in exposing the mechanisms that run our world, or the world that may have been, based on our imaginings of a different future for our past.

With so many living edges to the art and ideas that are called 'steampunk', there's often robust and passionate debate within the community over what is steampunk and what isn't. Is 'real' steampunk strictly neo-Victorian, and all other notions of alternate histories faded copies? Or is steampunk an artistic recombinant superpower, free to be evolved and redefined on an individual basis? Across all the various formats, and categories of expression, it is within the world of fantasy art that steampunk's expansion is perhaps the most nuanced and self-aware. Originally, the 'punk' in steampunk was meant to identify a group of writers or 'punks' who were generally creating the steam-era speculative fiction that became the energy and ideas that drove the movement. Now, the term 'punk' has evolved to become an alternative technology modifier, applied to ages or genres of art and fiction, limited only by the imagination of the artist. Dieselpunk, saddlepunk, vampunk, cinopunk – on and on. Some of these explorations have brief moments of interest and then fade into the background of the bubbling explorations of the broader steampunk movement. Others, dieselpunk for example, stabilize and come to represent a growing and distinct variation on the original movement's core.

It is steampunk, though, that continues to undergo constant expansion and metamorphosis, like a visual meme being altered and co-opted over and over through the connected sociosphere. What began as a movement in speculative fiction has enthusiastically grown and expanded into virtually every major form of creative expression, with constantly changing sub-genres appearing almost monthly. The artists in *Steampunk Graphics* reveal the sheer wealth of aesthetics that the visual arts aspects of the movement today encompass, yet all, somehow, remain viscerally connected to steampunk's core.

Kevin Mowrer, Providence, Rhode Island.

Vladimir Bondar

V ladimir was born, and is still based, in Kharkiv, in Ukraine, a major industrial centre famed for its culture and arms industry (the legendary T-34 tank was designed and built there). He attended art school and then began drawing covers for publishers of science fiction books. It was whilst doing that that he came across steampunk as a distinct genre. "I began to develop a good base of source material and knowledge about the Victorian era, about machinery, objects and fashions. This would form a good basis for my later work." Bondar then switched to working in the gaming industry, where today he creates concept art for video games. He creates entirely in a digital environment. "I start with a good idea of what I want to achieve and then lay it down as a digital sketch. At that point I try and strike the right chord. It is important that thereafter there is no deviation from the scheme; it's a case of making the detail fit the main thrust and composition of the whole." Bondar loves his work – "I'm lucky that what I do for a living is fun"– and says his clients see that too: "It results in higher quality and that's what they come back for." Inspiration comes from too many artists to mention, but the work he finds most interesting is that of Craig Mullins: "the composition and dynamism of his paintings are fantastic." Vladimir used to show at conventions, "but it is no longer interesting, I prefer that people just come and view my work on my site. The only problem is that I'm too busy with commissions to keep it fully up-to-date!"

RIGHT: *Old Alyumen.*

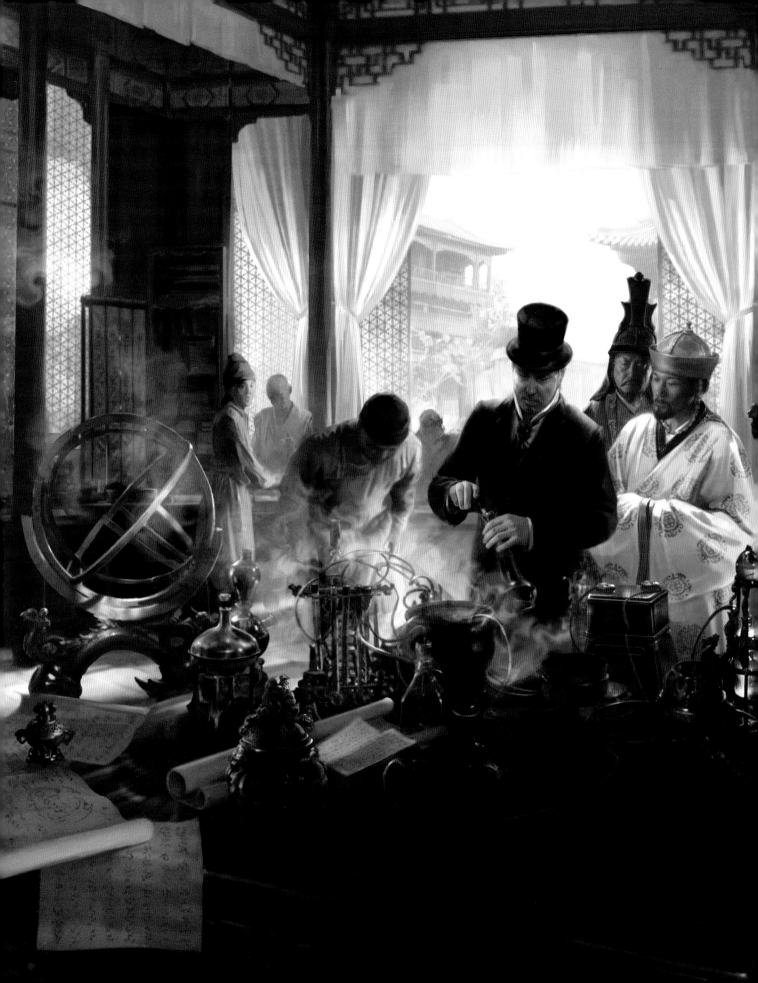

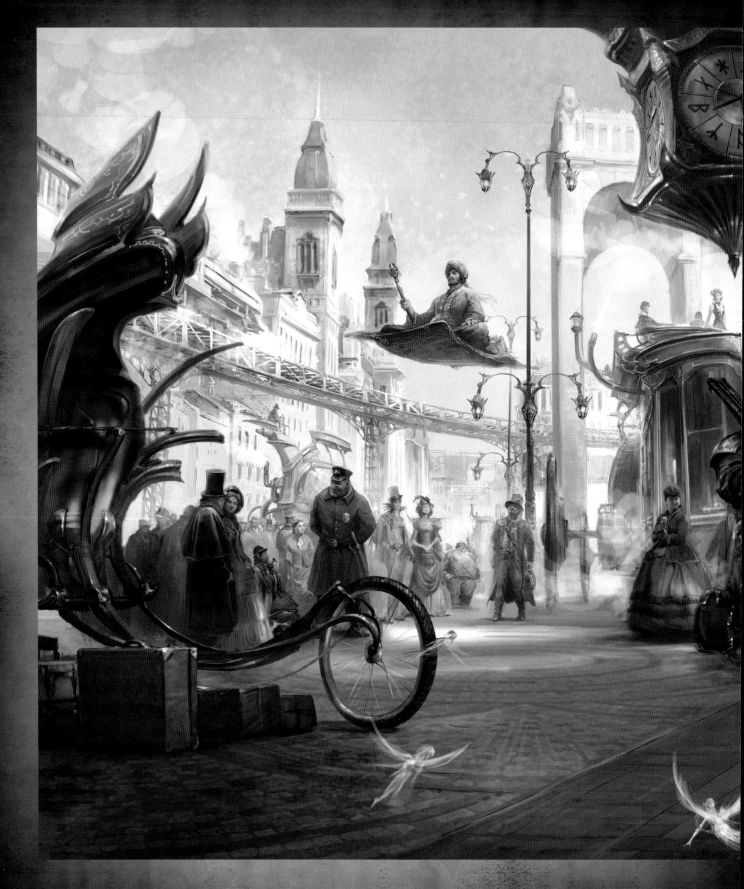

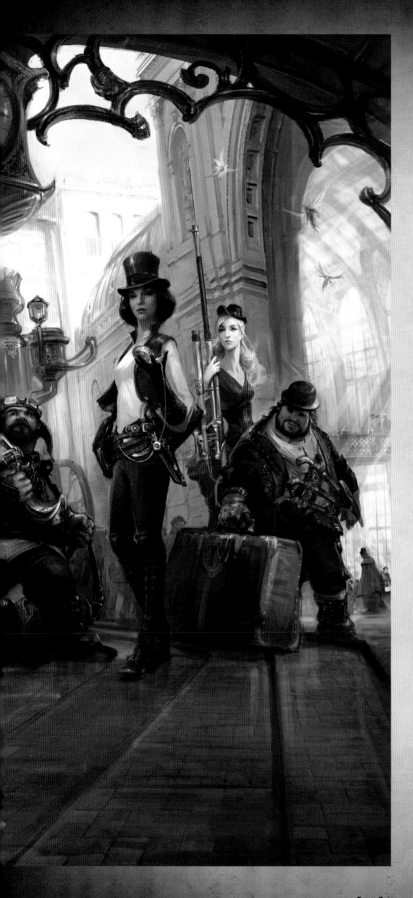

LEFT: Lady Canine.

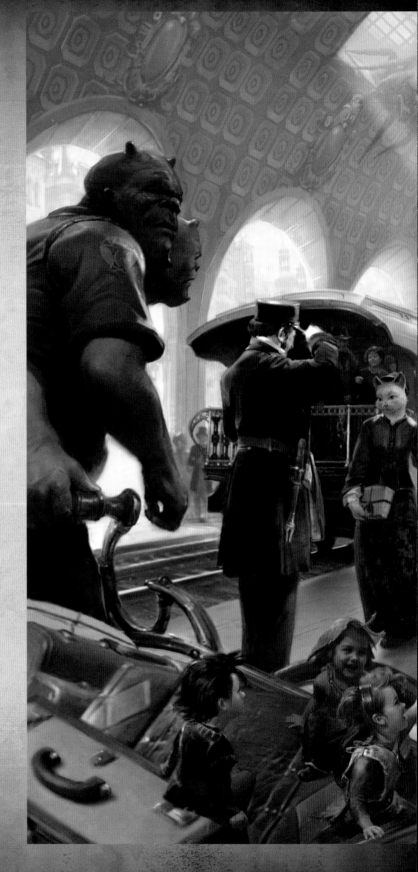

RIGHT: Mockingbird.
OVERLEAF: Luckcatchers.

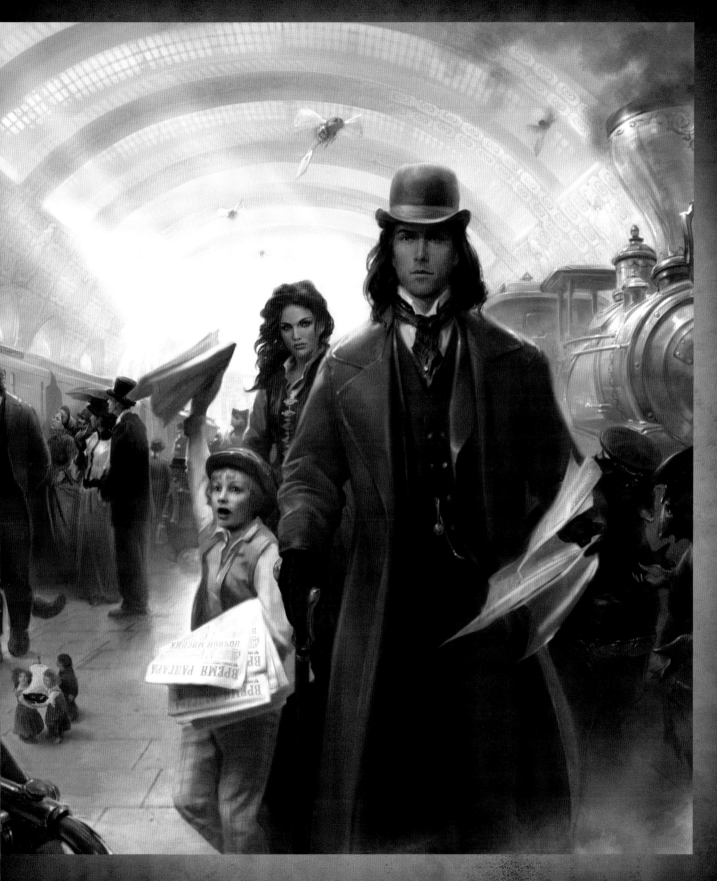

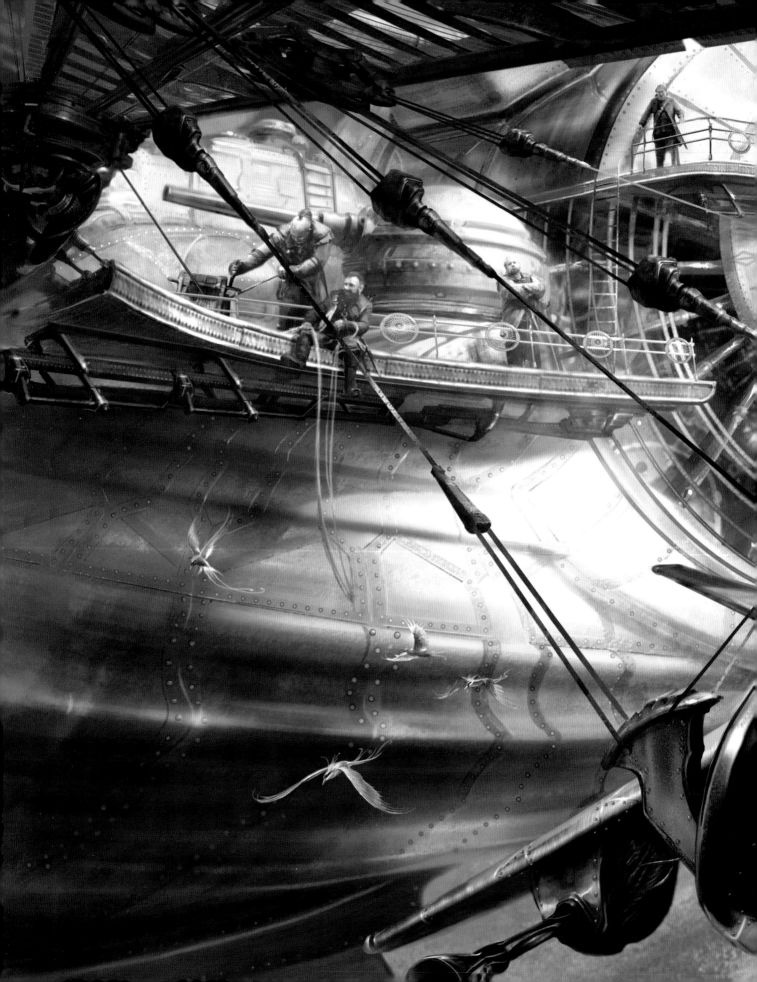

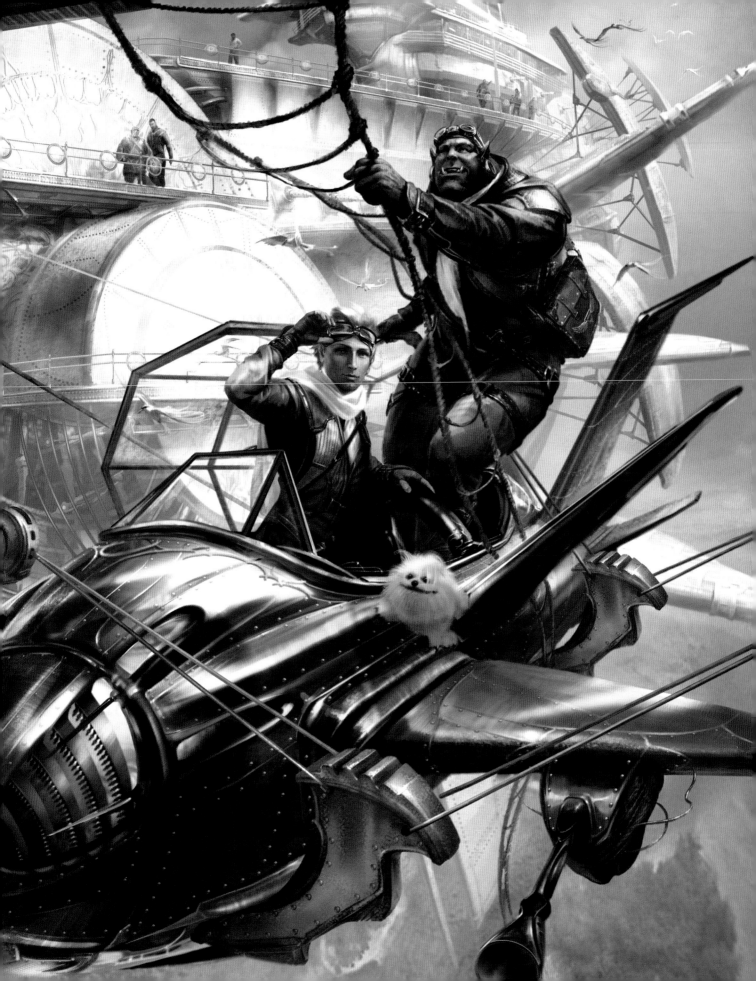

Luiz Eduardo Borges

Luiz, a.k.a. Ark4n, hails from Brazil. His early interest in becoming an artist was triggered by a fascination with the work of H.R. Giger, Moebius and Syd Meyer. He is entirely self-taught. "The difficult thing in art is not the techniques, it's finding one's direction. There are so many possibilities out there, it took me a while to find my groove." He keeps up his artistic investigations, currently doing some in-depth studies of 18th and 19th century masters. Luiz currently works in software design and development, but wants to spend more time with his art. "I've even written a book about software design — it's unlikely I know." His art pieces are constructed entirely in a digital environment. "I use programs like Blender 3D and GIMP. What I really want, however, is to return to a traditional approach — pen and paper." His steampunk pieces are linked by a theme — an alternative world called Uchronia. In Uchronia there are no more living beings and it's left to machines to try and keep remaining aspects of civilization going. The look of Uchronia is both 18th and 19th century. Of steampunk, Luis sees a clear evolution. "It started as old-fashioned science fiction associated with steam power. For me it has developed as an imaginary complex with clear philosophies, such as the enhancement and mastery of technology, or an expression of opposition to the way technology and industry dominate the world today, where individuals are just numbers and human knowledge and creativity is devalued."

RIGHT: *Watchbot.*

LEFT: *The Approach.*
ABOVE: r4k3r prototype.

ABOVE: Mechanical Core Returns.
RIGHT: The Lost Watcher.

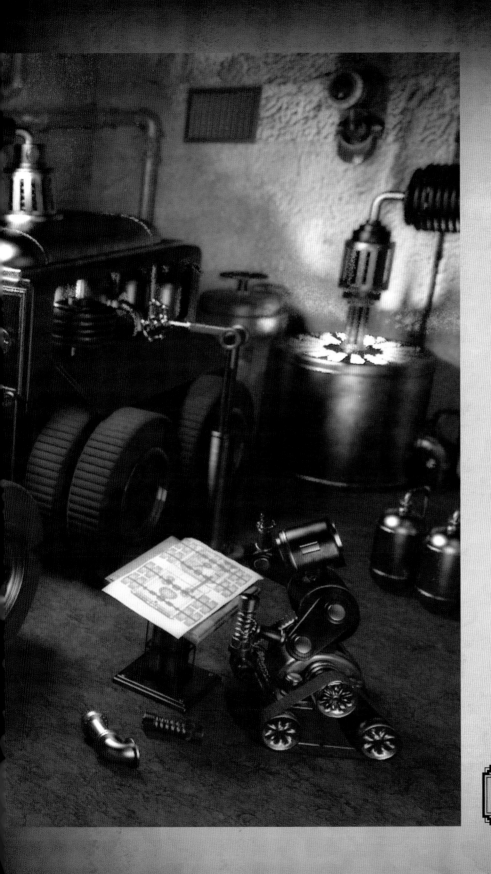

Jan Boruta

❦

Hailing from Tarnów, Poland, where he is still based, working as a freelance illustrator, Jan (a.k.a. Tomasz Bełzowski) became fascinated by steampunk aged 16, as something that grew out of his interest in 19th century naval history. His steampunk works are still grounded in a fantasy version of the 19th and early 20th centuries, in particular the Franco-Prussian War and then the Great War. "The whole steampunk thing for me represents a certain nostalgia for rapid technological advance, for art nouveau art and architecture, for a certain kind of warfare and weaponry and for that human drive to explore new worlds. I also see the movement as being in part descended from cyberpunk, but one which swapped the idea of a dystopian future for a utopian past." Artistic inspiration comes from the anime *Steamboy*, "which convinced me that I should keep my designs within the realm of probability," and artists such as Ilya Repin, Alphonse Mucha, Ivan Aivazovsky and the van de Veldes (father and son – both marine artists). Amongst Polish painters, Jan cites Jan Matejko, Jacek Malczewski and Stanisław Wyspiański. For his professional work, which includes game-related art, Jan works entirely in a digital environment. For his personal stuff, or for marine art commissions, he reverts to "traditional tools and methods: pencil, ink and acrylic."

RIGHT: Eidolon Palladium.

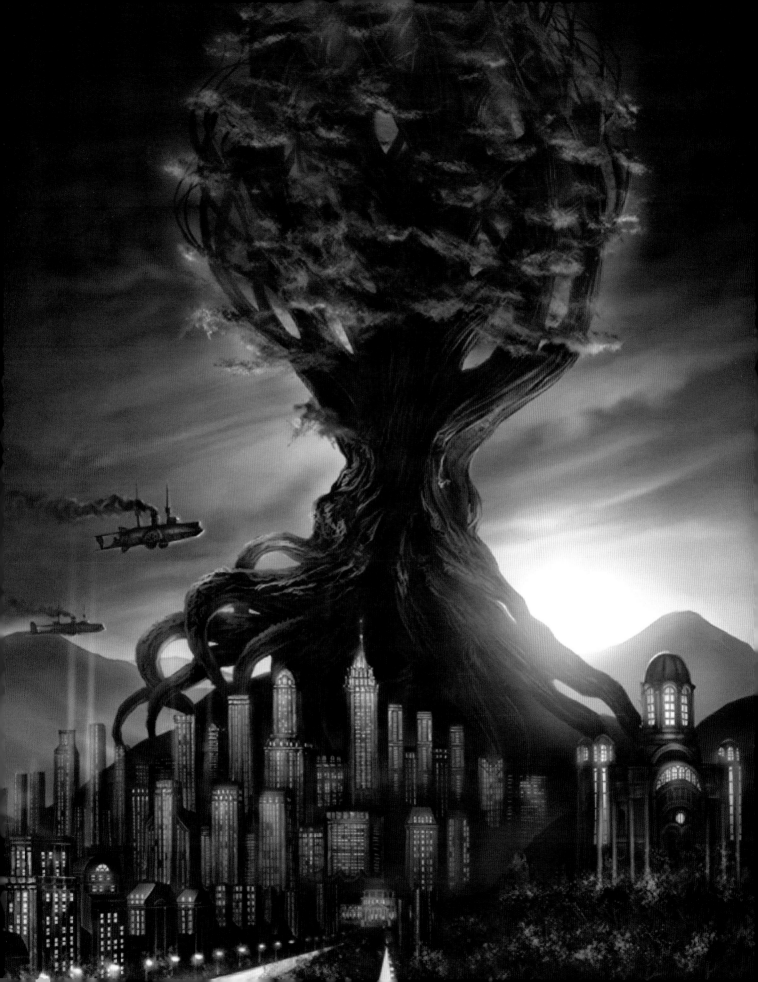

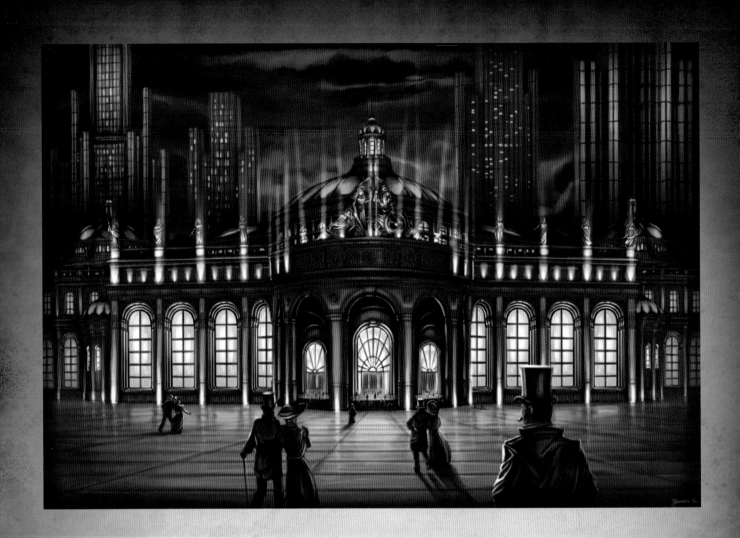

ABOVE: *Eidolon Night at the Opera.*

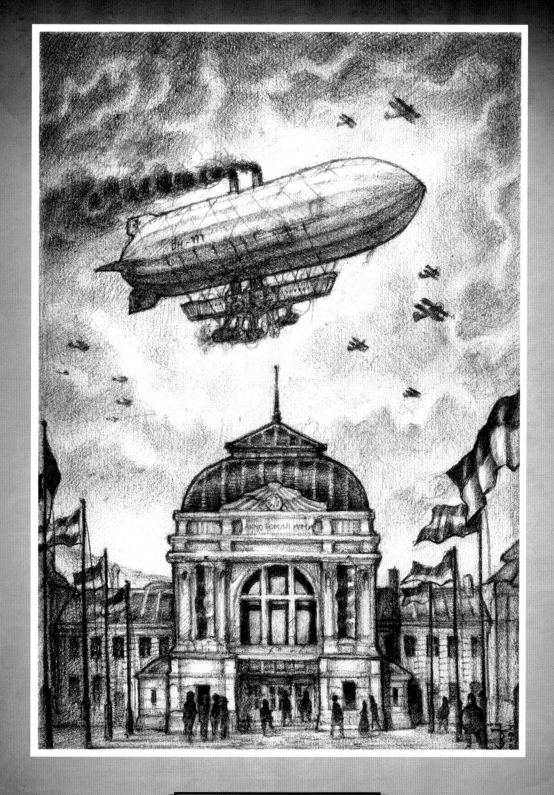

ABOVE: The Emperor's Visit.

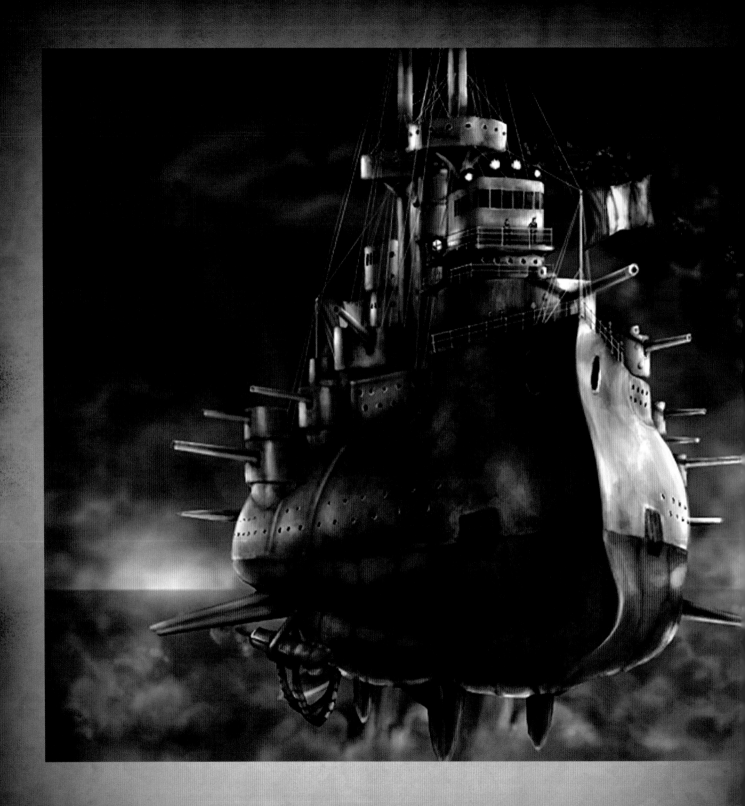

ABOVE: *Le Redoubtable.*

Cinvira

———◆◆◆———

I've always liked retro-futuristic culture," says Cinvira, a.k.a. Madrid-based Jésus Garcia. He discovered the steampunk aesthetic when he saw steampunked fairy tale movie *Howl's Moving Castle*, and was amazed at the way director Hayao Miyazaki applied the look and feel of a Jules Verne world to the (non-steampunk) novel by Diana Wynne Jones. "I had always loved Verne's novels and the science of that time. The movie showed how you can apply steampunk to almost anything." Cinvira, who studied Fine Arts at the Universidad Complutense de Madrid, always has a clear picture in mind before he begins an image, and always draws in graphite first whilst listening to music. He then modifies it on his tablet. Inspiration, in addition to Verne, comes from "Orson Welles, Mary Shelley, the films from Studio Ghibli, *Wild Wild West*, video games *Rise of Nations*, *Rise of Legend*, *Dishonored* and *Bioshock*; I could go on." Cinvira loves the way steampunk art is in a constant state of flux, where new, interesting ideas are always being produced. "It contains elements that contemporary society has forgotten, like the handmade, human imagination, dreams, the exotic and the true inventor's spirit and sense of adventure. I think it will continue to evolve. Imagine steam mixed with Tesla and electricty, or steampunk in space. Are steam spaceships possible? I don't know, but the idea is exciting!"

RIGHT: *Steam Tripod Arachno Globe.*
Pen and ink, digital colours.

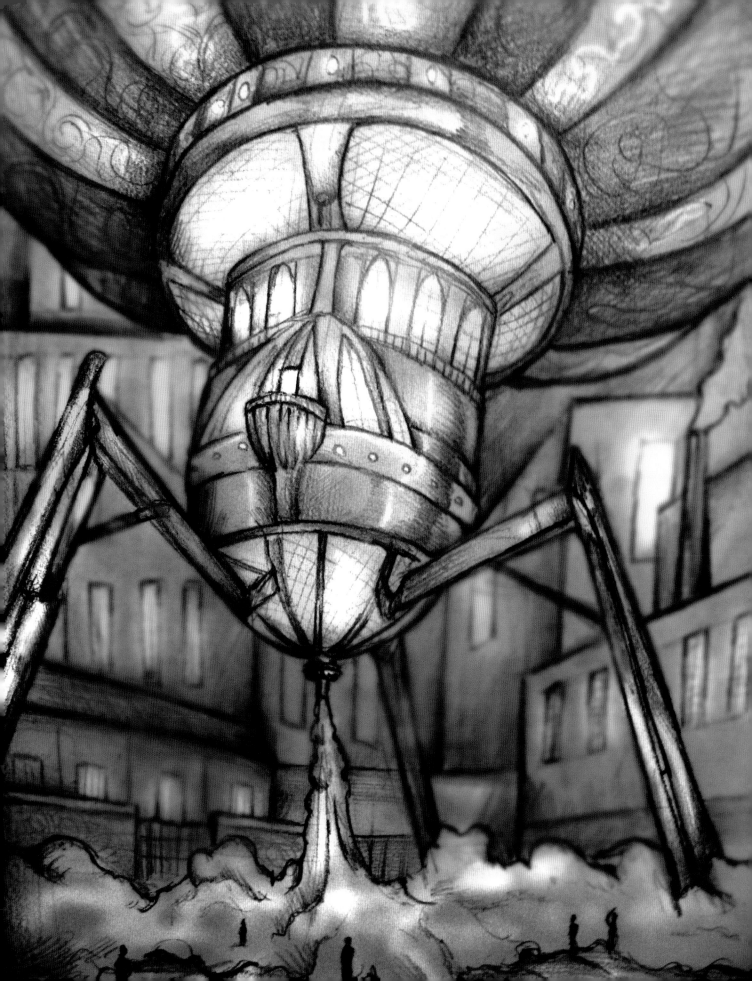

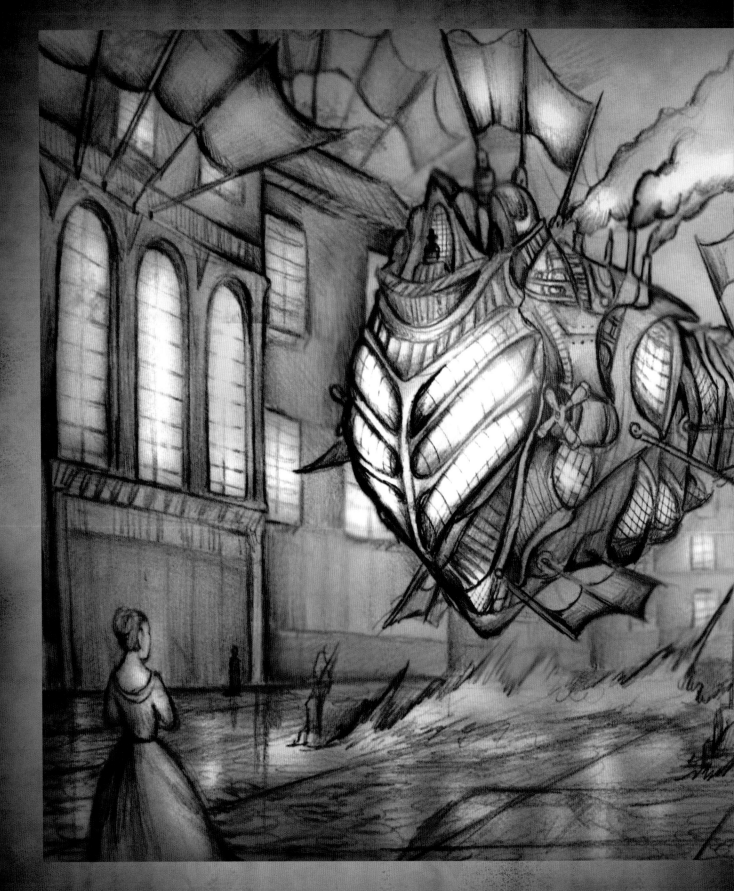

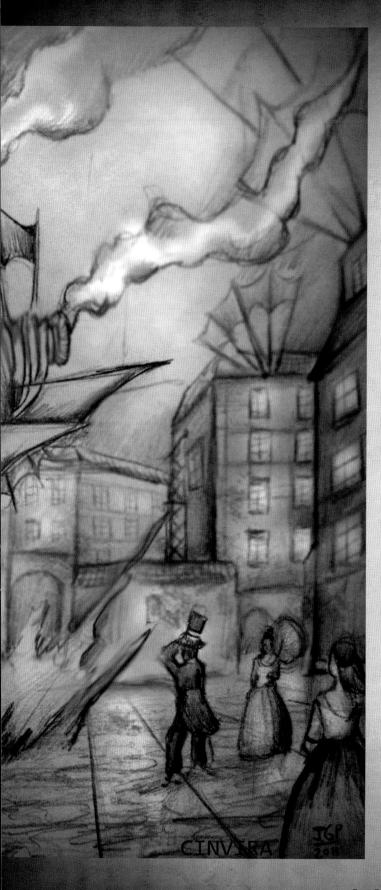

CINVRA

LEFT: *Steam Emolian Airship.*
Graphite on paper, digital colours.

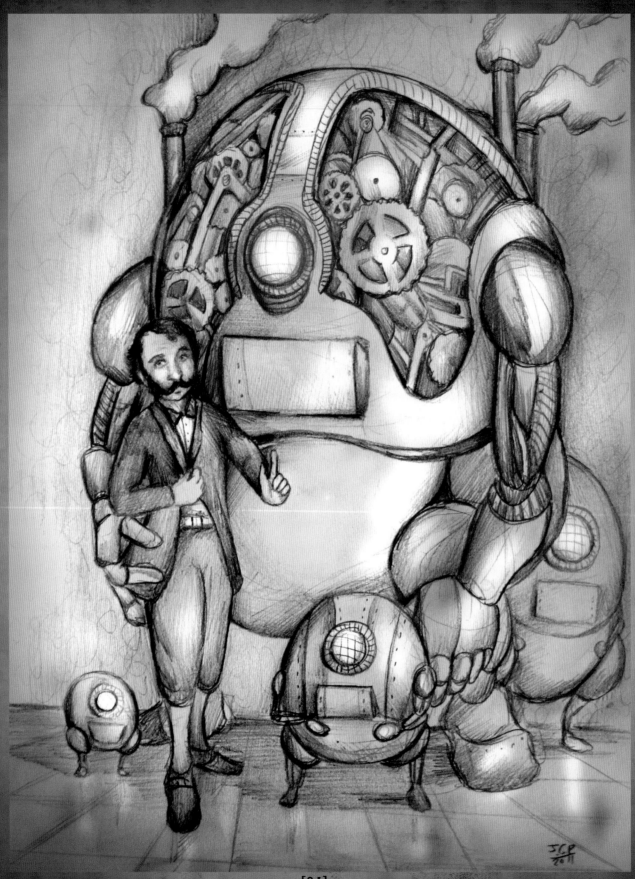

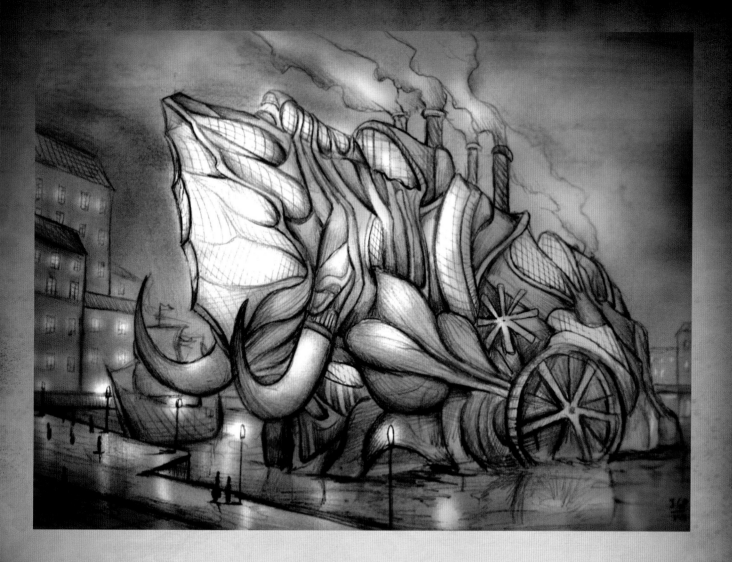

LEFT: *Family.*
Graphite on paper, digital colours.
ABOVE: *Water Mammoth.*
Graphite on paper, digital colours.

Michael Dashow

Michael, who also goes under the pseudonym 'Walrus' on occasion, remembers when steampunk first meaningfully crossed his path. "In 2009, CGSociety.com held one of their periodic art challenges with the theme of Steampunk Myths and Legends. They asked me to be a judge. As such, I was ineligible to enter a piece of my own. However, the steampunk theme was so exciting, I decided to create a work anyway. That was *Escape Plan B*, my first big steampunk illustration. After that, I was hooked." Originally from outside Boston, Mike moved to California to take a job at a comic book company. Today he is based in Oakland, near San Francisco, and works in the computer games industry (his career has included Broderbund, Blizzard Entertainment – where he worked on *Diablo* – and, latterly, as the Art Director at Kabam). "One of the hardest parts of creating any painting is deciding what to paint. I start on paper, developing sketches and thumbnails. Then it goes into the computer, where I refine and paint over. Then it's colouring, which can take 20 hours or 60 hours, depending on the piece. I have a certain rich palette which I use a lot for the steampunk works." His best pieces, he says, are those which have "a sense of humour and an unexpected juxtaposition of themes, genres and visuals." On his influences Mike says: "All artists are influenced by other artists! With me, the ones I've loved include Michael Whelan, Jim Burns, Masamune Shirow, Peter de Seve, Hyung-tae Kim, Dean Yeagle, Shane Glines, Bruce Timm and so many more!"

RIGHT: *Spyglass.*

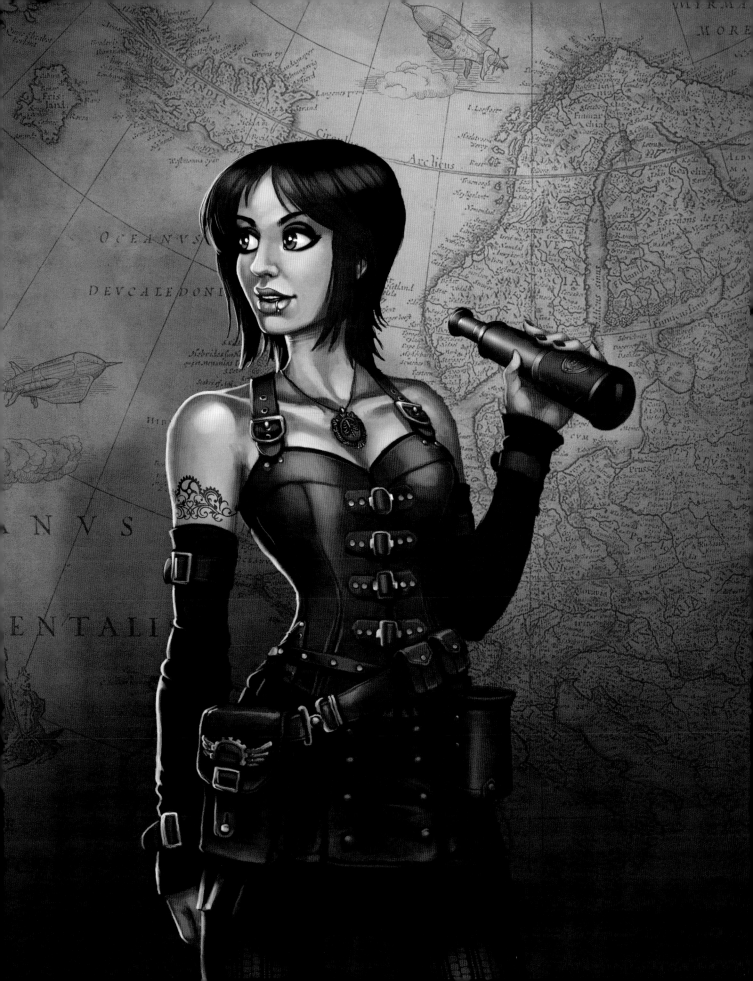

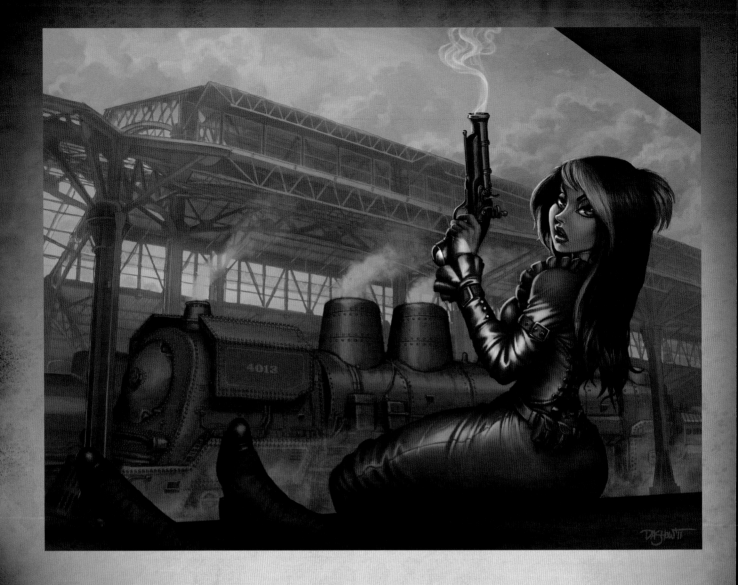

ABOVE: *Silver Streak.*
RIGHT: *Eliza.*

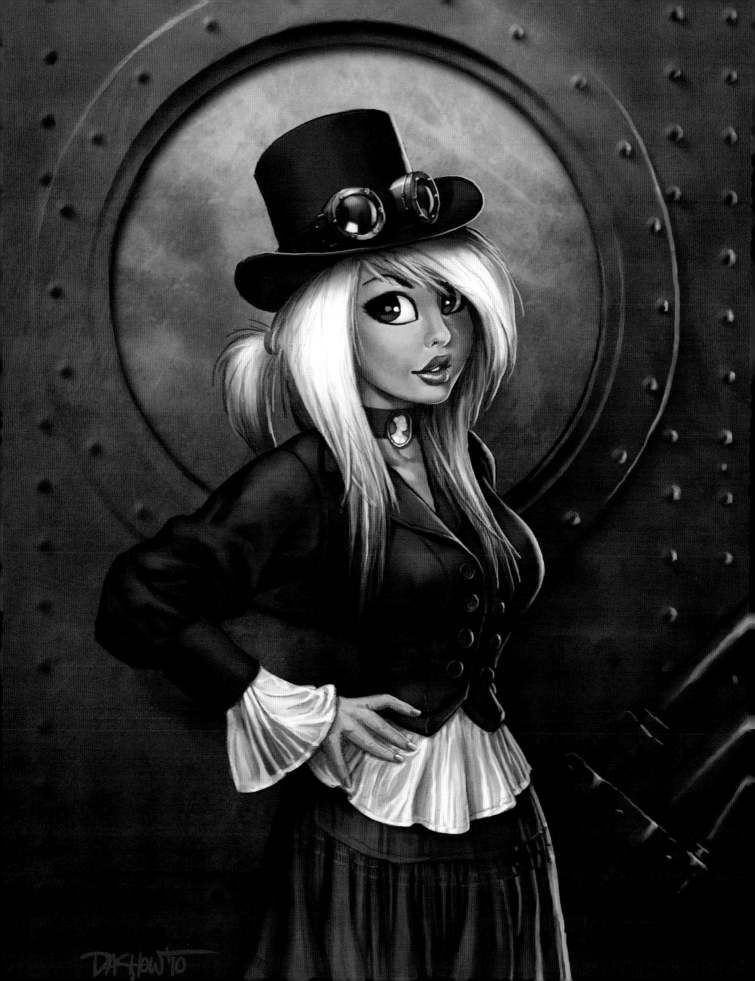

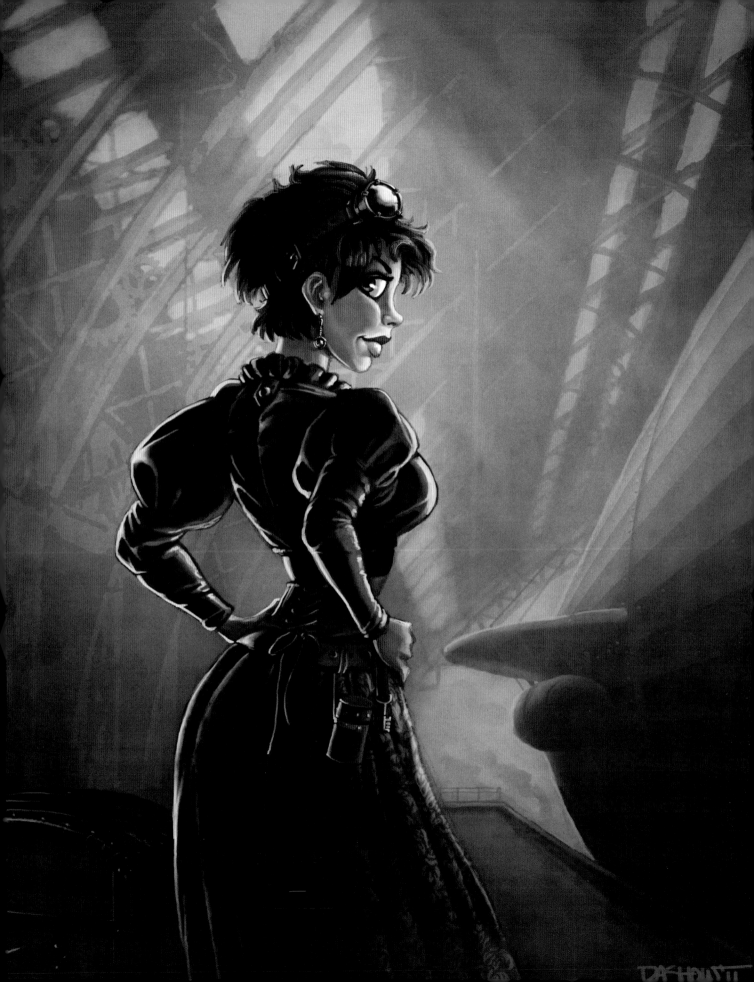

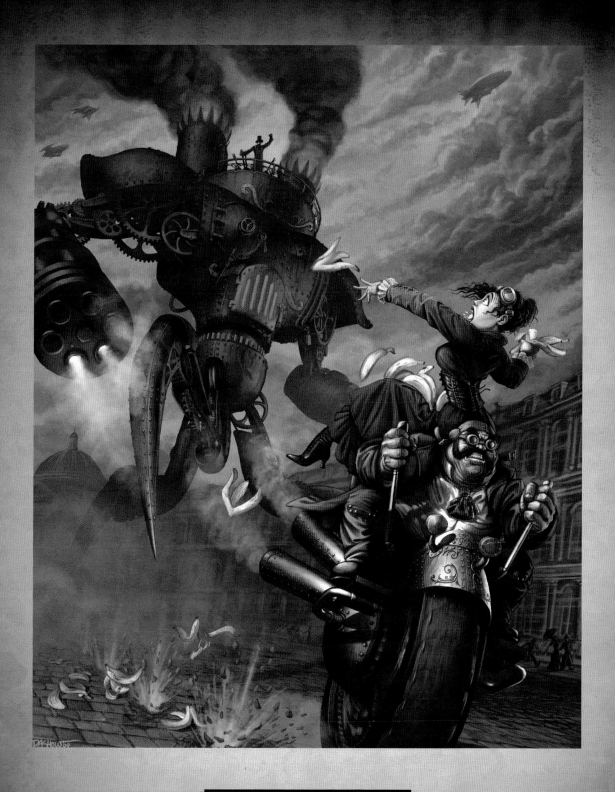

LEFT: Docking Bay.
ABOVE: Escape Plan B.

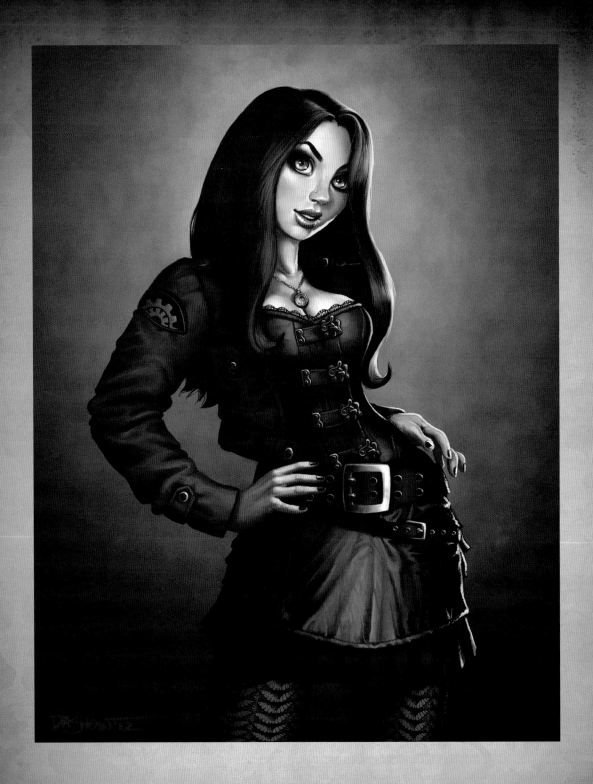

ABOVE: *Tessa.*
RIGHT: *Erin.*

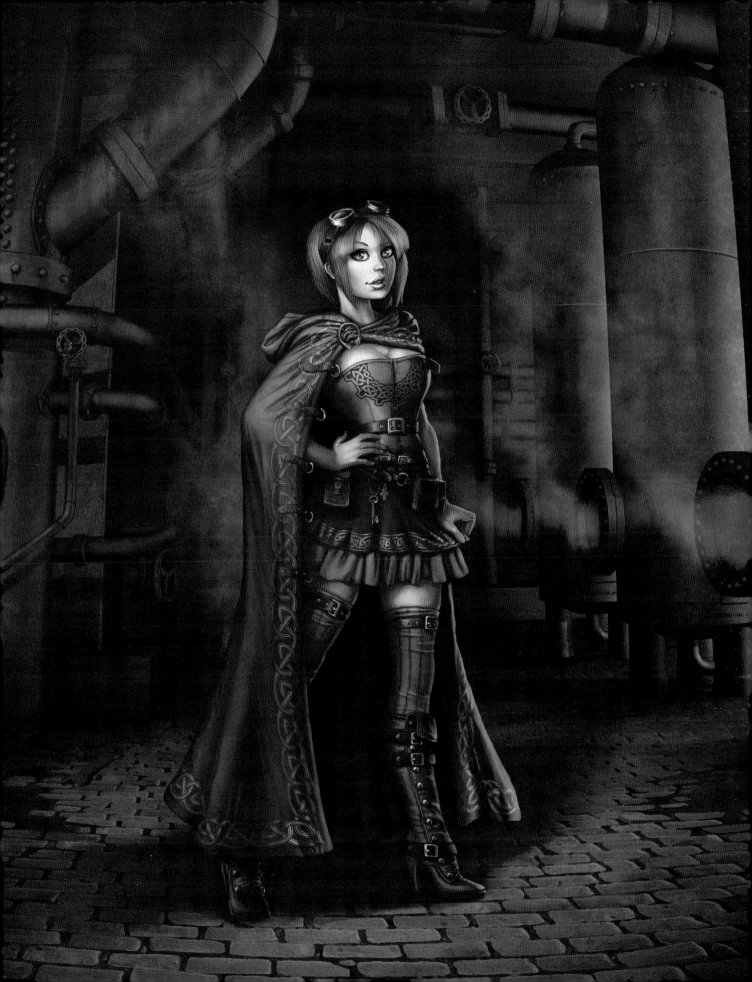

Cihan Oguz Demirci

It was watching *Steamboy* and *Last Exile* that got Cihan into trying to draw steampunk. "My imagination responded to the aesthetics. For some reason I am susceptible!" From Adana, Turkey, Cihan works full-time for a design agency. Amazingly he initially studied at an agricultural college, before deciding that art was his future (as a result he is self-taught). "Steampunk is my private passion, which I do in my spare time. Steampunk is not yet a trend in Turkey....I am still waiting." His works are initially created in traditional fashion: pencil, followed by inking with drawing pens or brush. "I love drawing on 100 gsm watercolour paper," he says. The hardest thing for Cihan is switching genres. "With sci-fi we're in the land of fibres, lazers and electrical circuits. I have to switch out of that to an imaginative structure involving gears, steam-powered mechanisms, Victorian guns and other ornaments." He likes his illustrations to have a theme and story; the ones shown here are based on Turkey's war of liberation between 1919 and 1922, fought against the Allies after the Ottoman Empire's defeat in World War I. Artists Cihan admires include Louis Royo, Boris Vallejo, Enki Bilal, Milo Manara, Mahmud Asrar and Hajime Sorayama. He loves the books of Jules Verne and *Metropolis* the movie, "of course!"

RIGHT: *Gölge.*
Pen and ink.

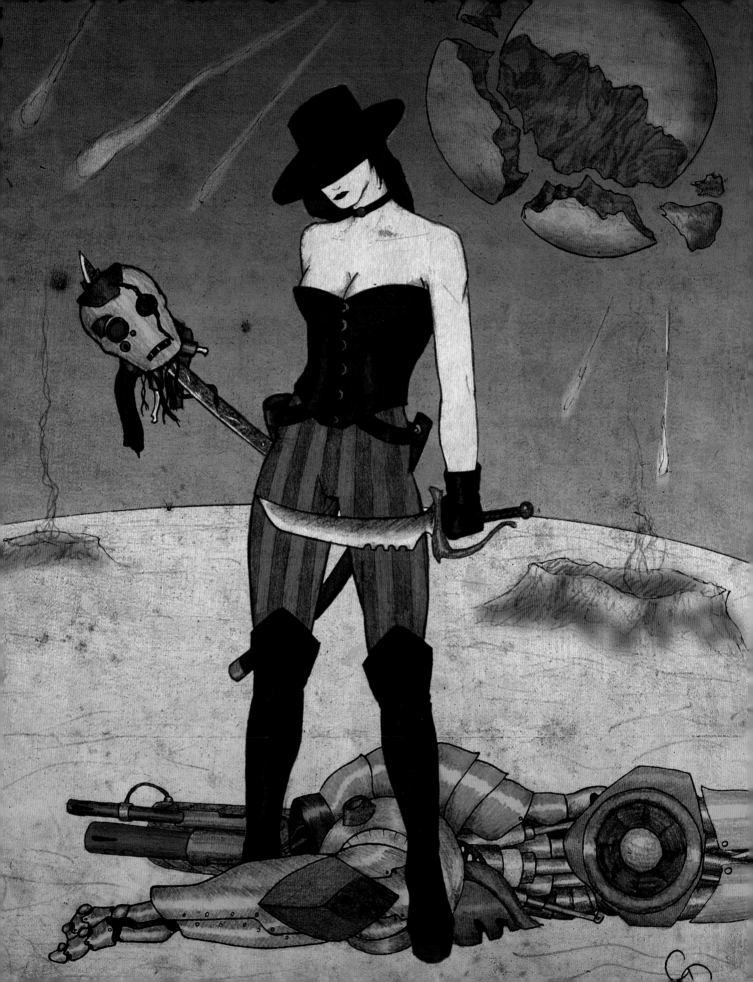

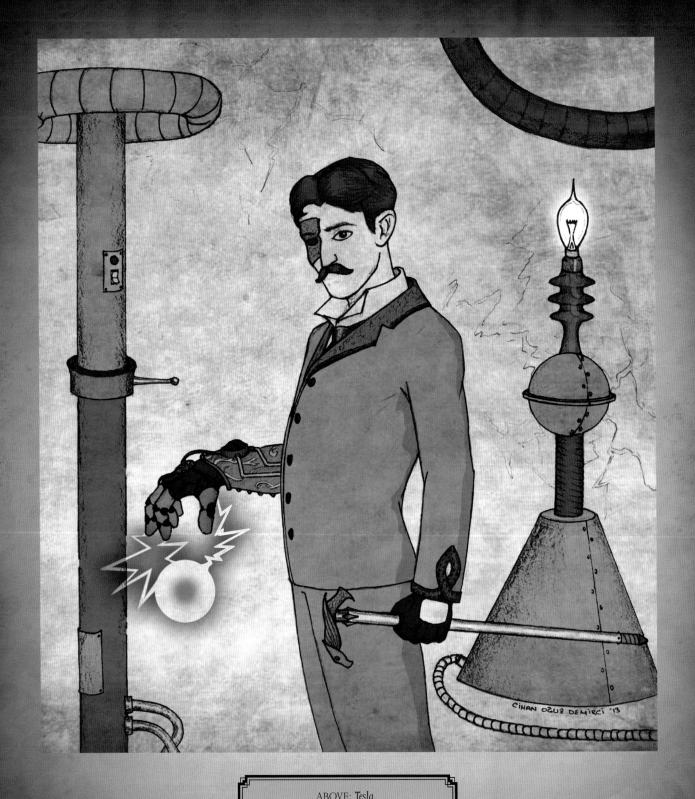

ABOVE: *Tesla.*
Pen and ink.
RIGHT: *Sabiha Gökçen.*
Pen and ink.

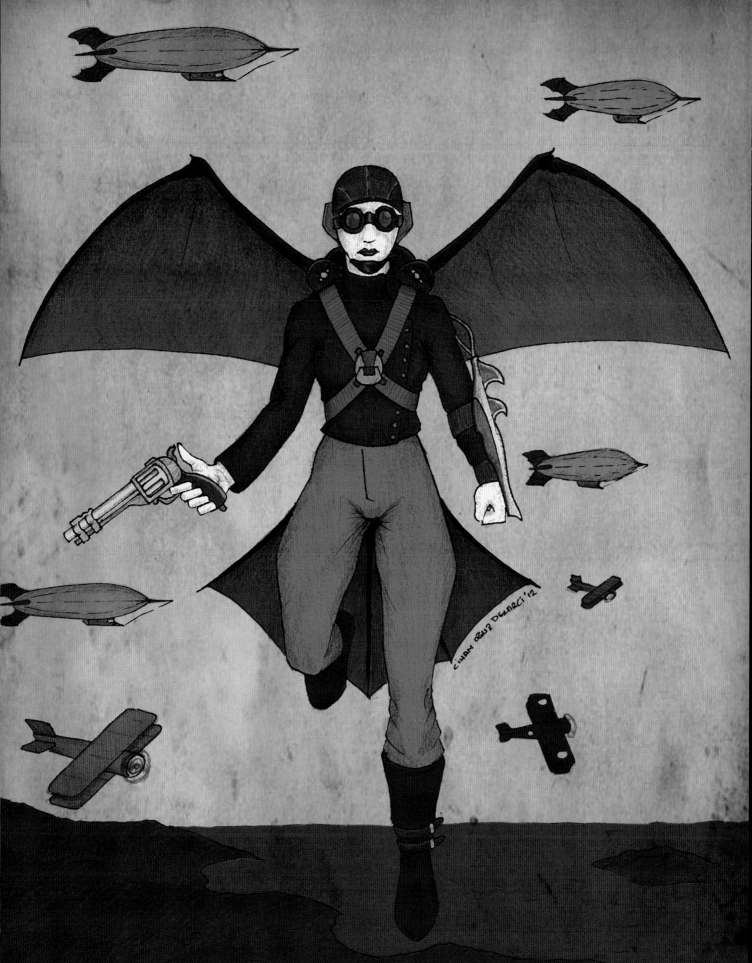

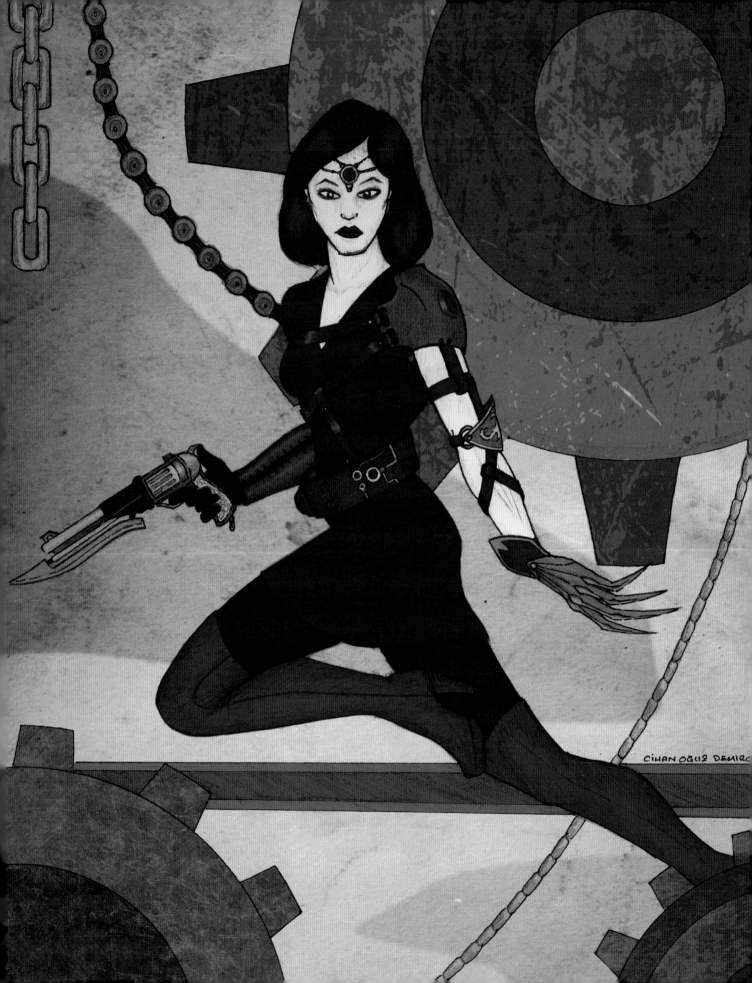

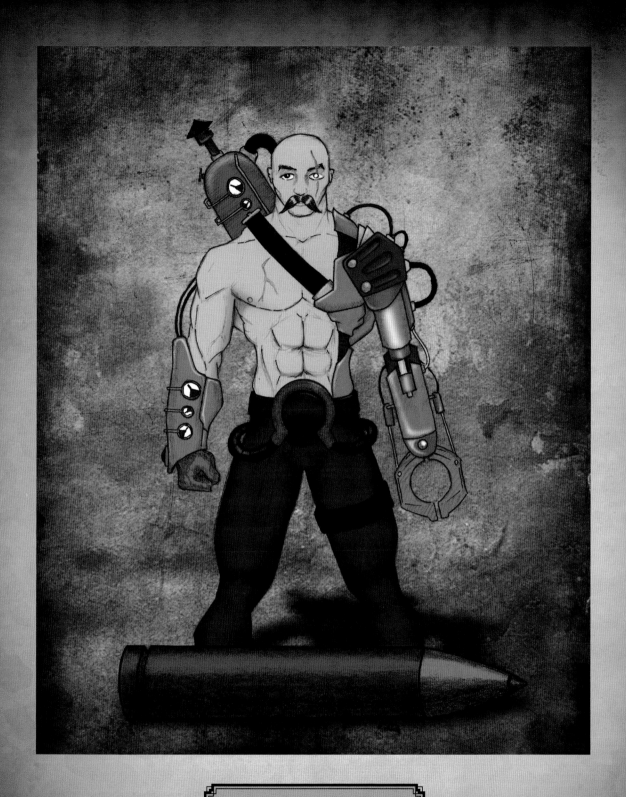

LEFT: *Steam 1.*
Pen and ink.
ABOVE: *Seyit Onbasi.*
Pen and ink.

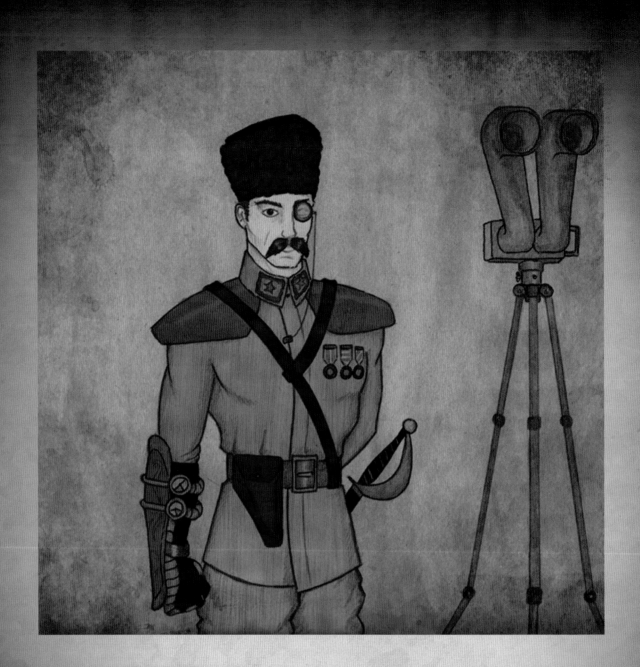

ABOVE: *Maresal.*
Pen and ink.
RIGHT: *Kara Fatma.*
Pen and ink.

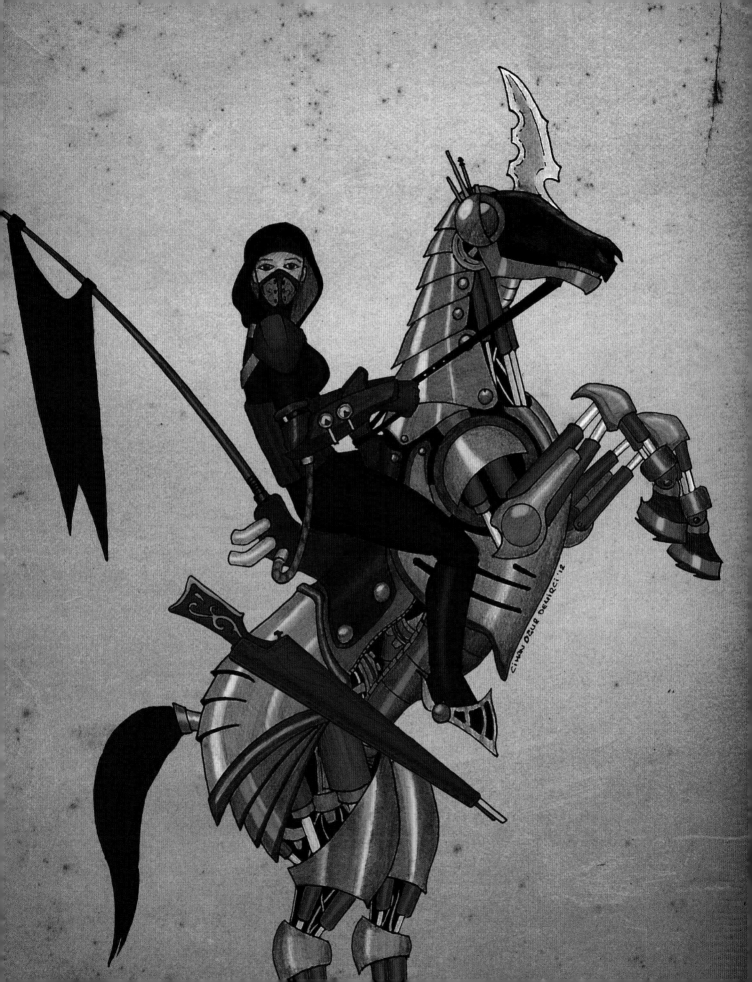

Ioan Dumitrescu

As an illustrator and concept artist, Ioan has worked in many fields: games, movies, book cover design, advertising and architectural design. Ioan is based in Bucharest, Romania, where he studied architecture. "It wasn't a great experience – an old-fashioned course and poor teachers. I found in the end that I was studying on my own, learning from books and the Internet. It's all about finding what resonates with you and staying true to that, whilst being open to fresh ideas." Ioan separates his client work – giving them what they want to see – and his personal projects. "For the latter I incline towards sci-fi, epic landscapes and extraordinary architecture and vehicles, creating worlds that incite curiosity." Inspiration comes from everything. "I do have a very long list of favourite artists; to pick just a few would do the others an injustice. I do tend to analyze the world as it is, but just take it that bit further, translating it with my own imagery." Steampunk for Ioan is "serious fun, a unique combination of elements that are at once outrageous and yet functional, using forgotten but extraordinary methods that define a seemingly abandoned future time."

RIGHT: *Flying Palace* (for Golem Studio).

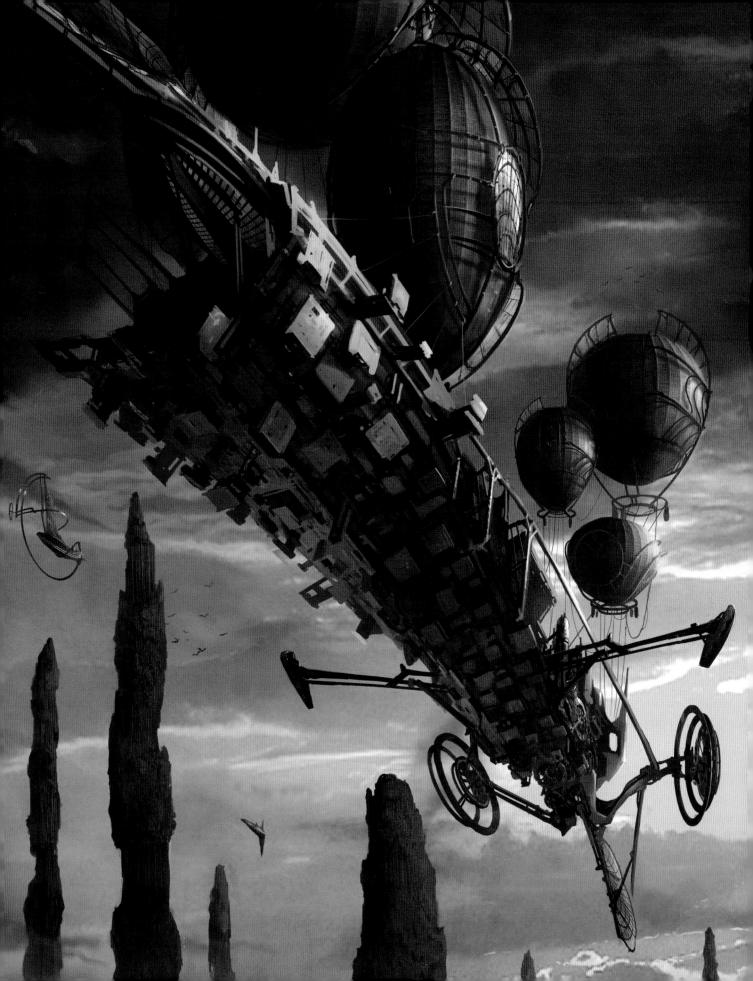

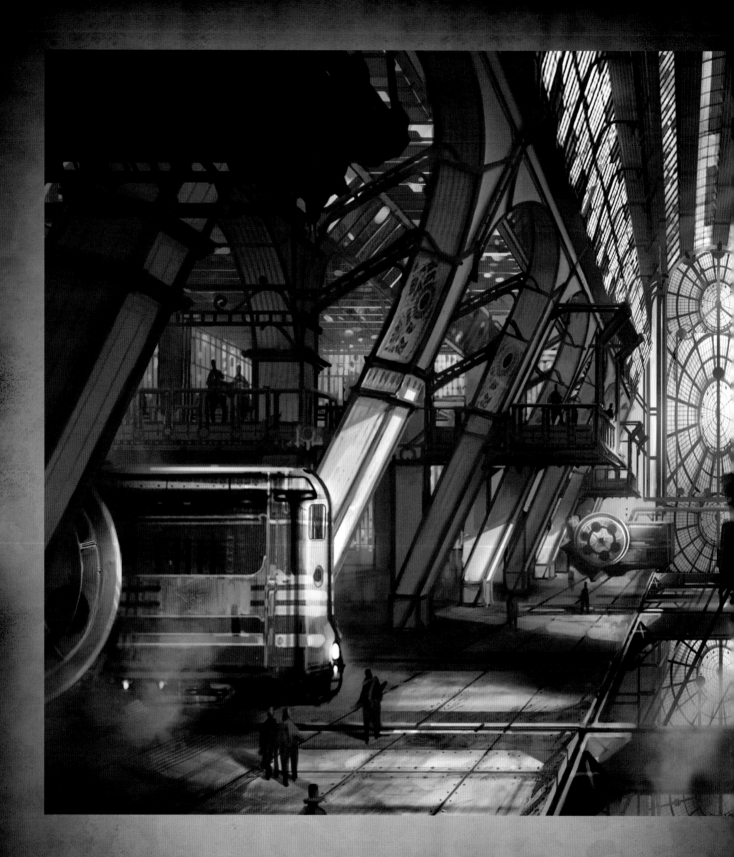

ABOVE: The Train Station (for 2D Artist Magazine).

Dysharmonnia

❖━◆━❖

Dysharmonnia, a.k.a. Sindija Mactama, grew up in a small village near the sea in Latvia. Today she is based in Riga, where she works as a designer for a fashion brand, whilst continuing part-time with her art studies at Latvia Academy of Art. Her formative years were inspired by a mix of animals – "especially cats and chickens" – and video games. "Fantasy games, in particular *Warcraft* really opened up my creative imagination and boosted my creativity." Her discovery of steampunk came via an interest in history and surrealism. "I love the genre, although drawing the mechanisms is still a challenge!" Sindija still starts any piece in traditional fashion, drawing the line art on paper before scanning and continuing in digital. "Many of my steampunk pieces revolve around a story I have been developing, based on my two cats. I have kept their appearance and personalities, but renamed them Captain Reech and the first mate Tom. It involves a trading and technological war between a monopoly called The Trading Company, with its superior flying ships, and Tom, the builder of The Dread Canary, the fastest and deadliest of airships." For Sindija, steampunk "is more than gears and goggles, it is a deconstructing and reconstructing way to look at things afresh. The style does tend to cut out the negatives of the 19th century, and presents a rather idyllic view of the era." She adds, ruefully, that the most significant thing about steampunk in Latvia is that "it has finally appeared here!"

RIGHT: *Dread Canary Pirates.*
Pen and ink, digital.

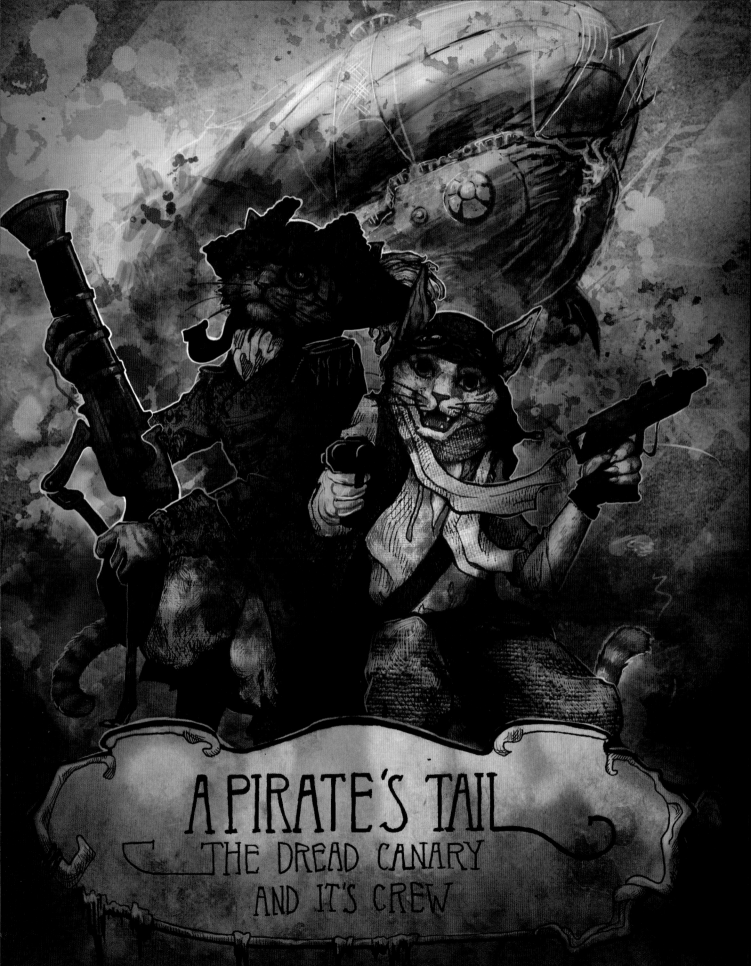

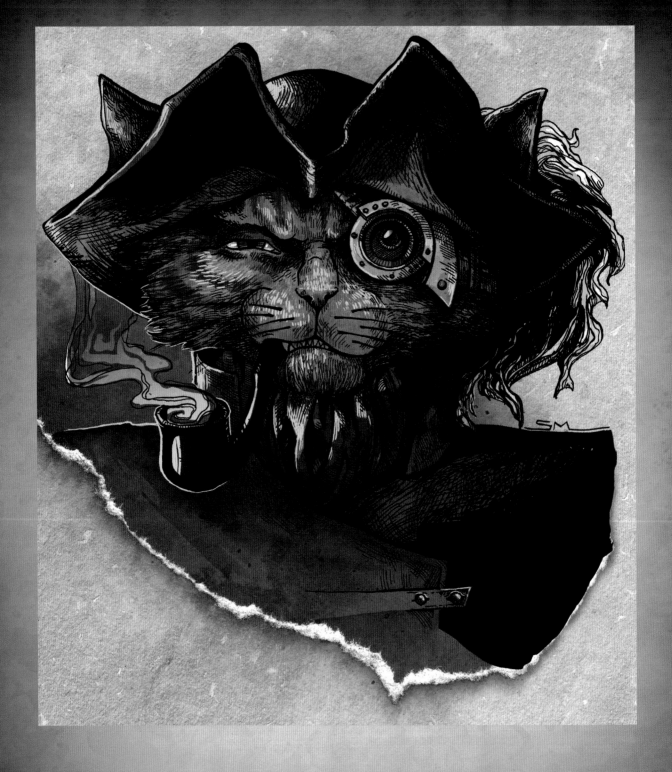

ABOVE: *Reech*.
Pen and ink, digital.

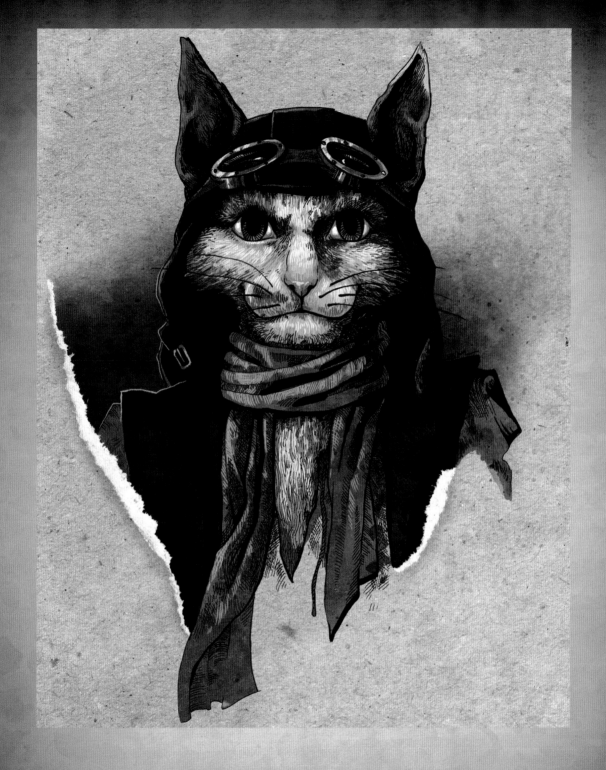

ABOVE: Tom.
Pen and ink, digital.

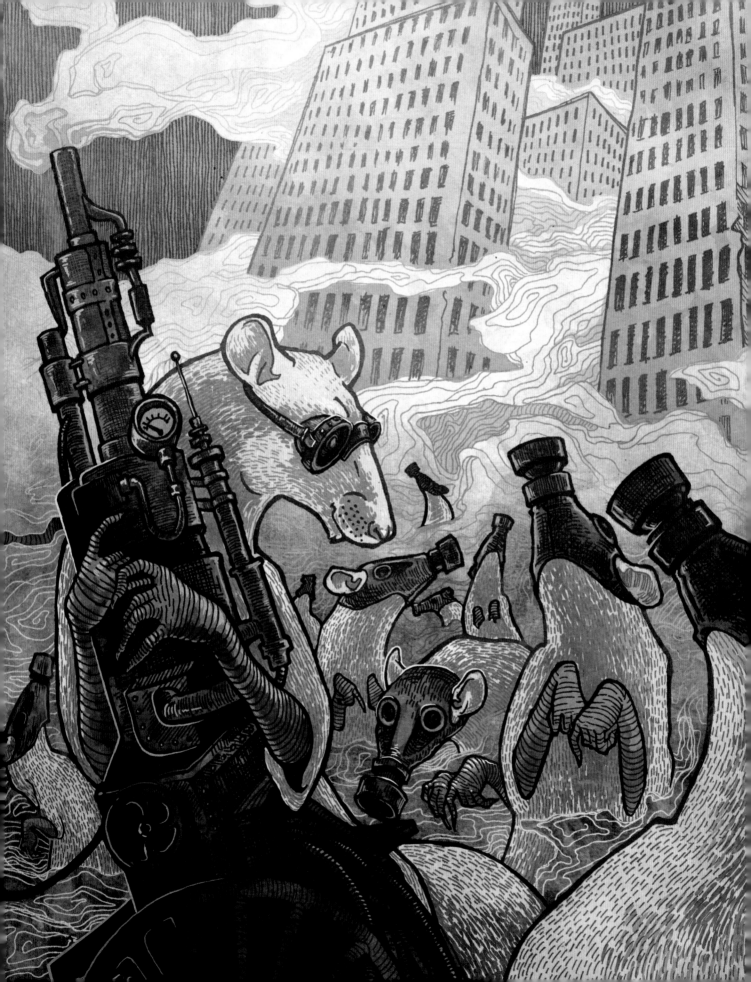

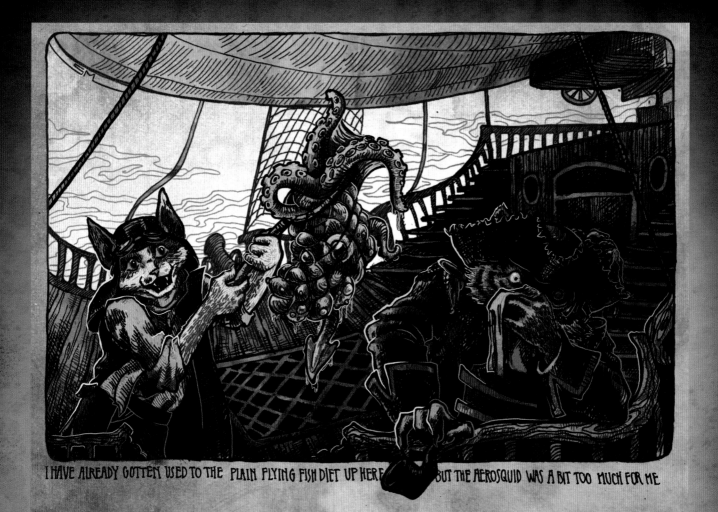

I HAVE ALREADY GOTTEN USED TO THE PLAIN FLYING FISH DIET UP HERE, BUT THE AEROSQUID WAS A BIT TOO MUCH FOR ME

LEFT: *White Plague.*
Pen and ink, digital.
ABOVE: *Aerosquid.*
Pen and ink, digital.

Tony Holmsten

Originally from Stockholm, Sweden, Tony is currently based in Seoul, South Korea, where he is a full-time freelance concept artist for computer games companies. His interest in steampunk started, he thinks, when he played *Metal Slug* for the first time. He started designing professionally, as a texture artist, for games companies aged just 18. "I remember being amazed at the sheer amount of work that goes into creating a game – I really had no idea what an intense process it is." It took him a few years to prove that he could be a concept artist, but that time was, he says, the best possible education. Tony then went on to Tokyo studio Grasshopper Manufacture, before setting up on his own. Inspiration for Tony comes from many sources. "At the moment I am really liking *Dice Tsunami* and the work of Robert Kondo at Pixar. Kazauo Oga, the old art director and illustrator at Studio Ghibli, has also been a big influence." Tony creates his images entirely in a digital environment. Some of the examples shown here were made for the the game *Sine Mora* and a comic book novel, *The Lost Kids*. Of steampunk he says "I don't exactly know why people like it so much, it's really the love for the old, industrialised Western period gone crazy. For me personally it's pure eye candy and really fun to think up and paint all the great period details."

RIGHT: *Sochen Falls' Lost Kids.*

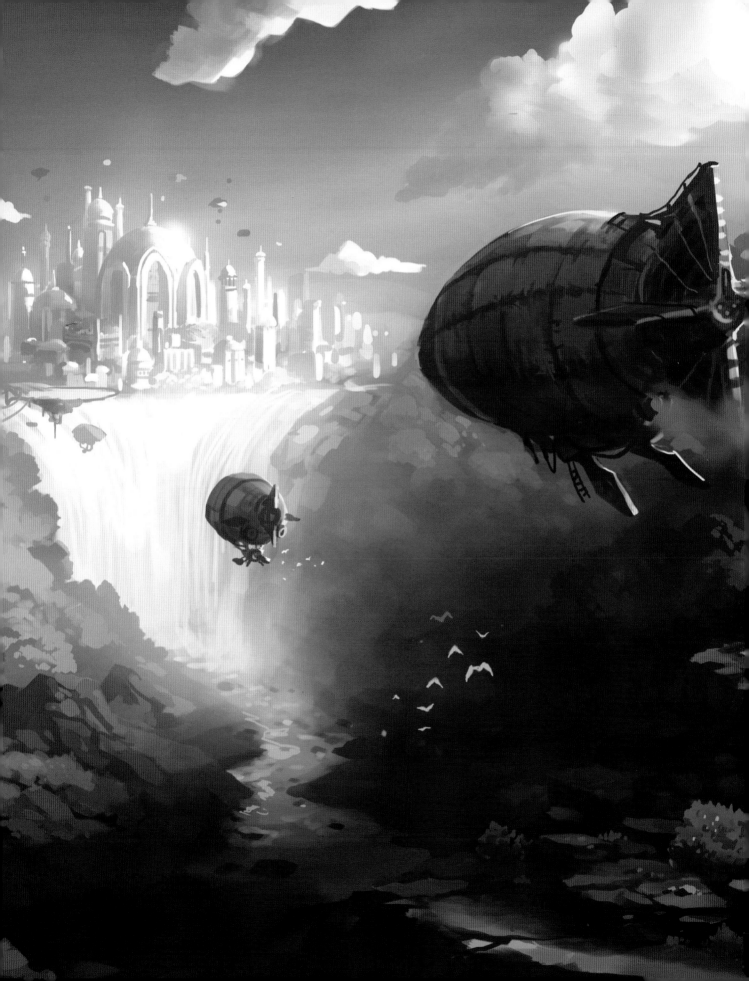

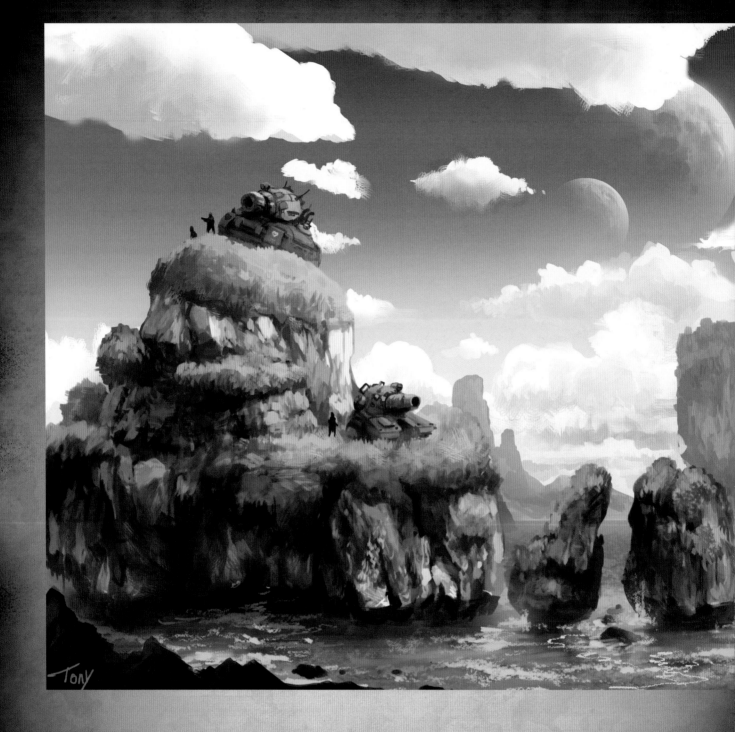

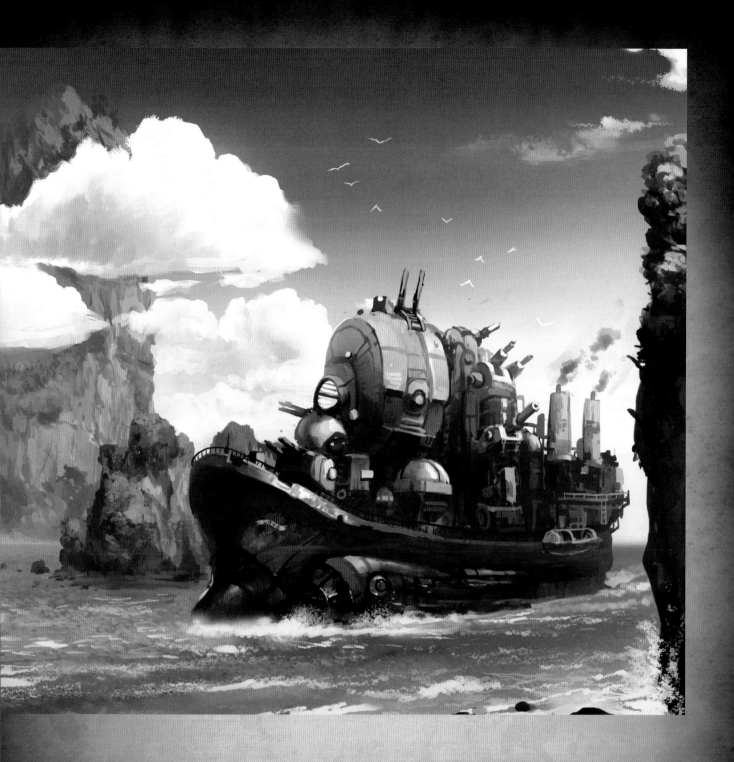

ABOVE: *Sin Mora Tropical.*
OVERLEAF: *Akkades.*

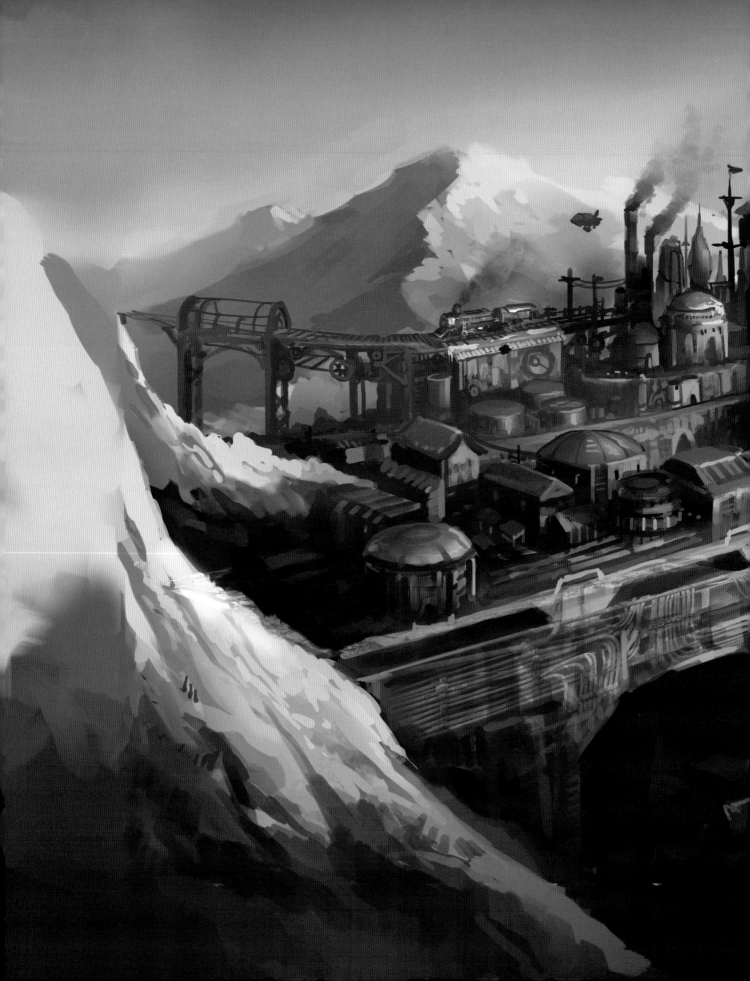

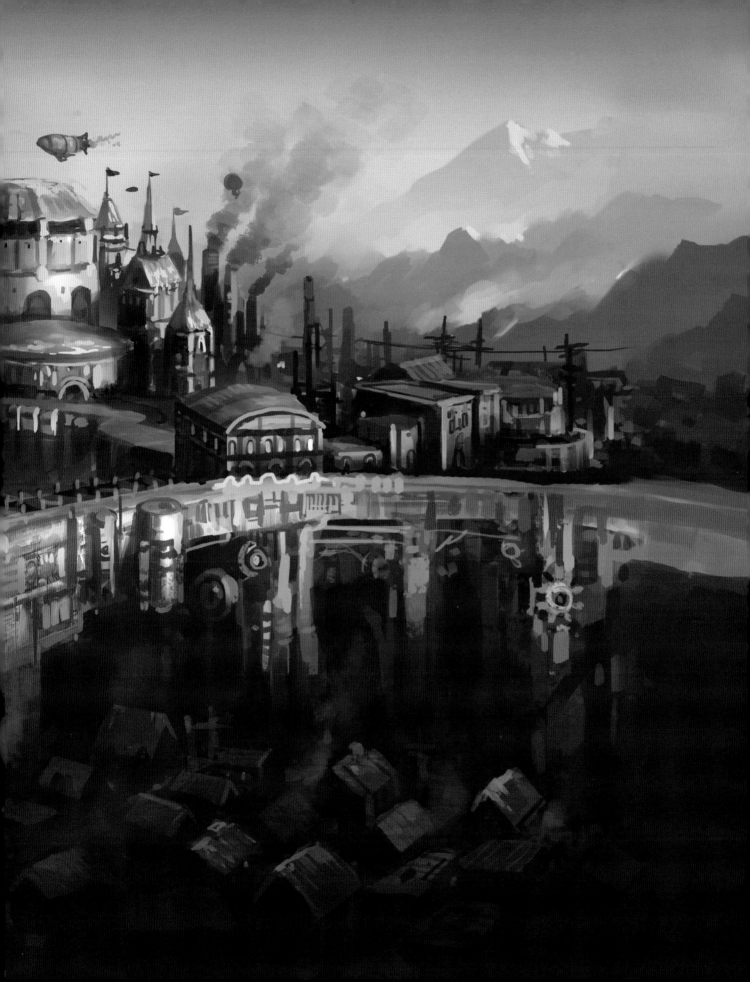

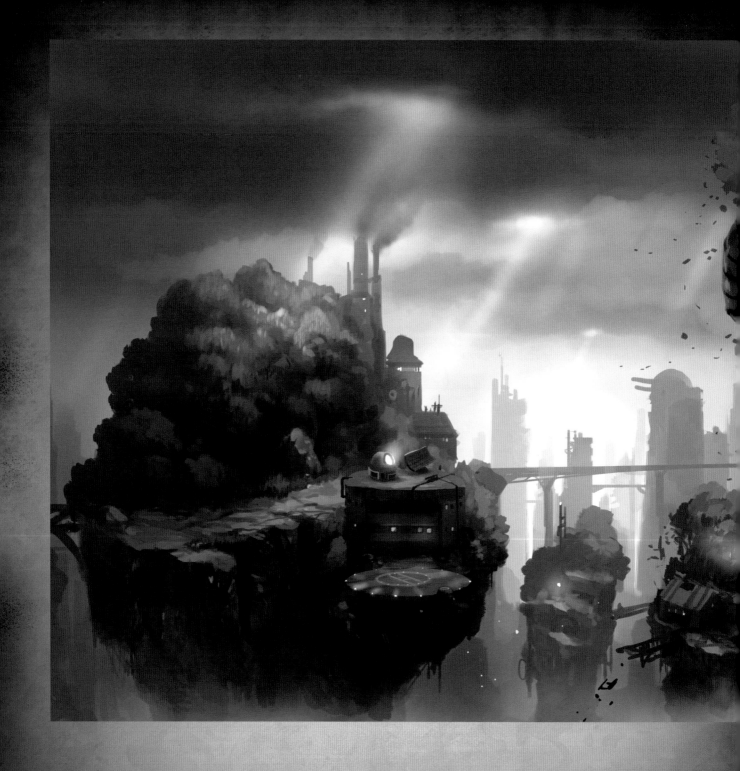

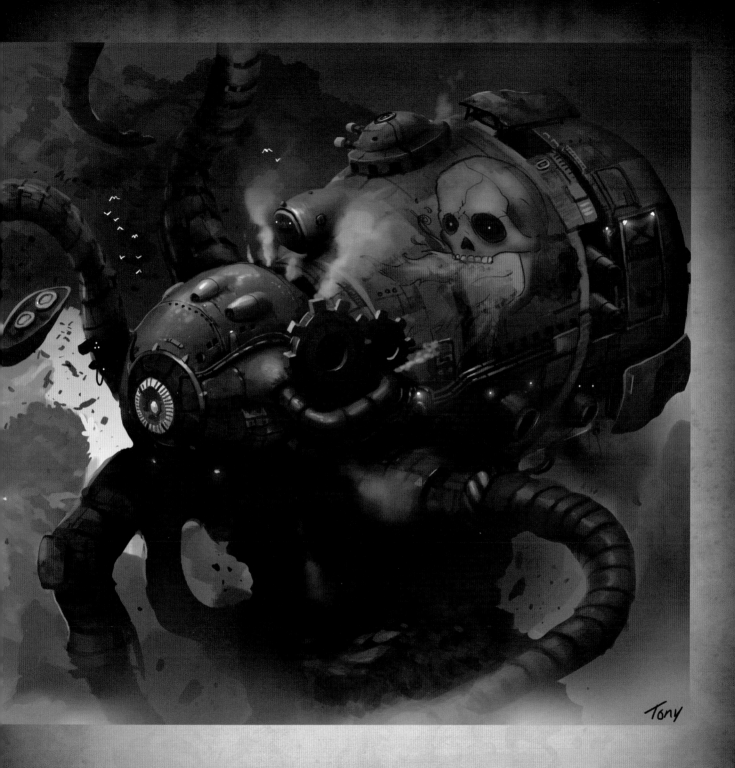

ABOVE: *Squidboss.*
OVERLEAF: *Trainboss.*

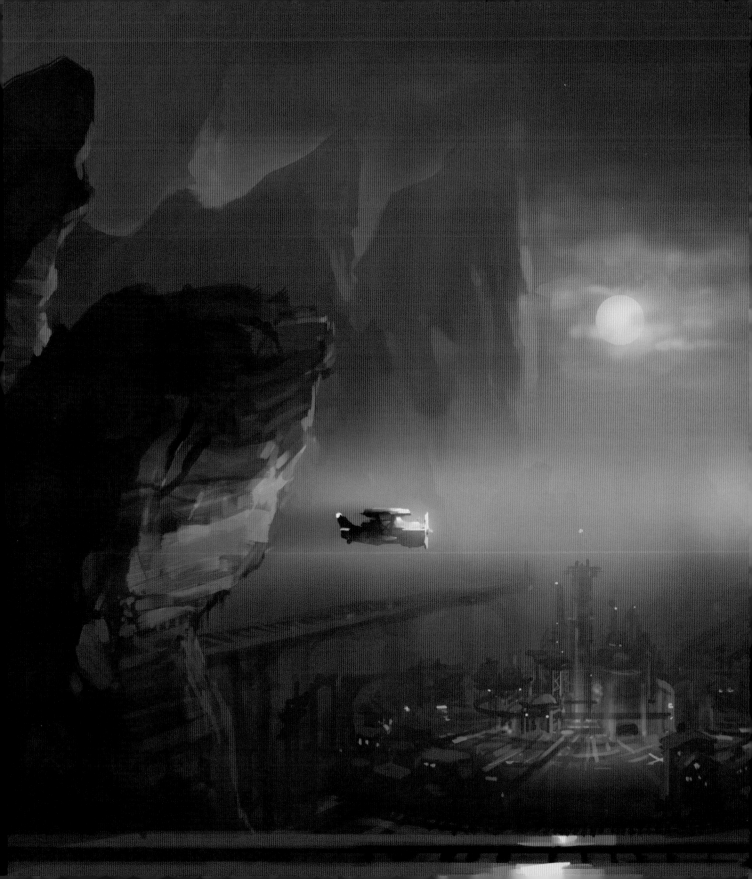

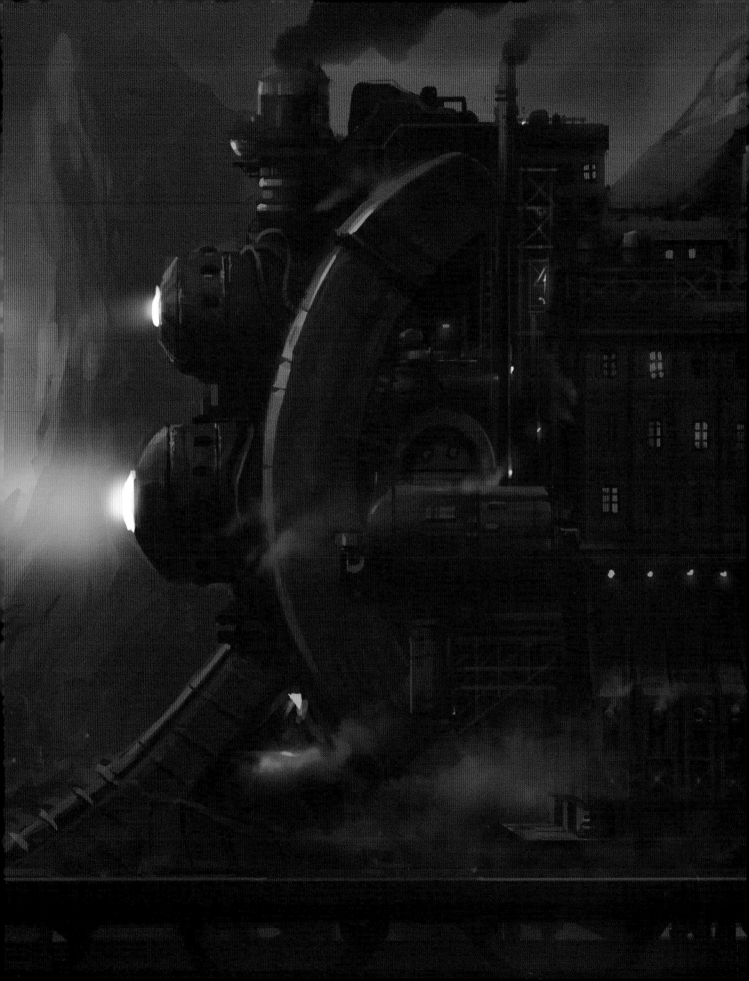

Industrial-Forest

"There are no stories to my pictures," says Remy Hoff, a.k.a. Industrial-Forest, "I paint and design stuff I like to look at." Based in Trondheim, Norway, where he also grew up, the name of his company does say something about his direction: "I am planning to make a story for my universe, where botany is very much present in the industrial world." If his pictures suggest a perfectionist, this is very much in his veins. "I used to be much worse – each of my pictures was so time-consuming. I am getting faster by loosening up a bit, being more sketchy, not focusing quite so much on the details in the distance that no one will ever see." The quality of the detail however remains outstanding and one of Remy's signatures, and it is therefore astonishing that far from being a full-time artist, all his works are personal projects, something he does as a hobby – "to use my creative energy" – although he hopes that one day he will be able to turn professional. Remy is inspired and influenced by Jugendstil (Art Nouveau as interpreted in Scandinavia), but, more than anything, by "the beauty of nature and architecture, other concept artists and science."
For Remy steampunk is a melding of many attributes and influences: "it's about curiosity, adventure, creativity, elegance and beauty."

RIGHT: Steampuke.

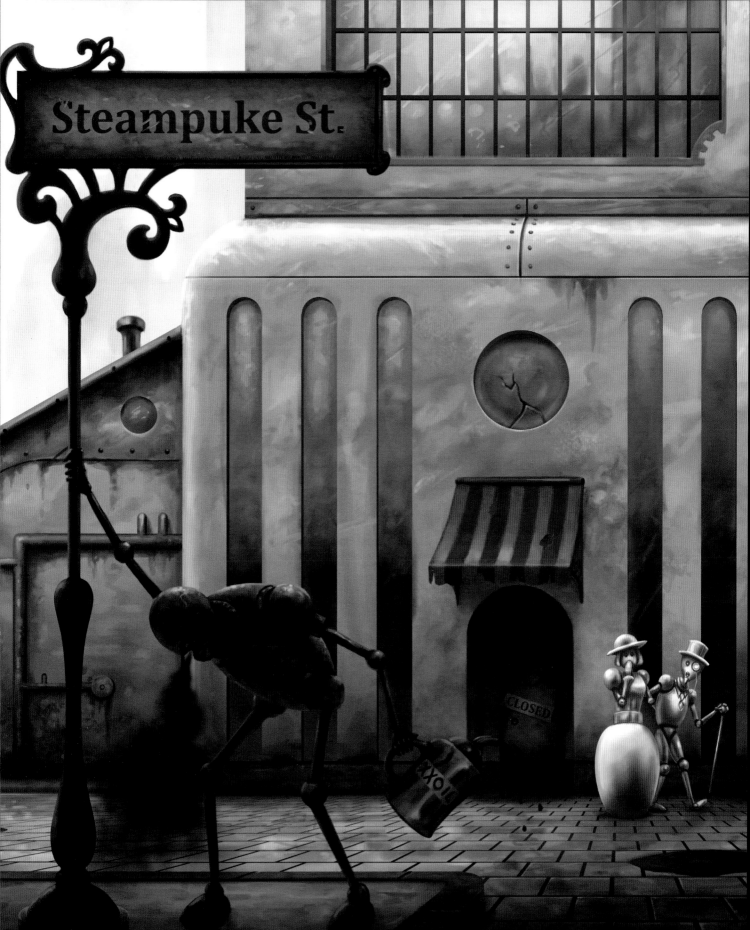

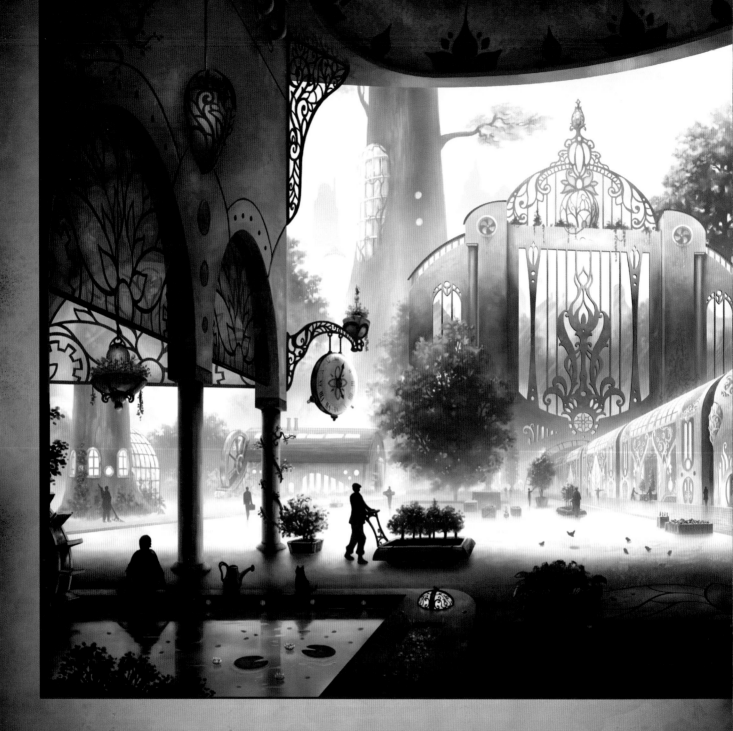

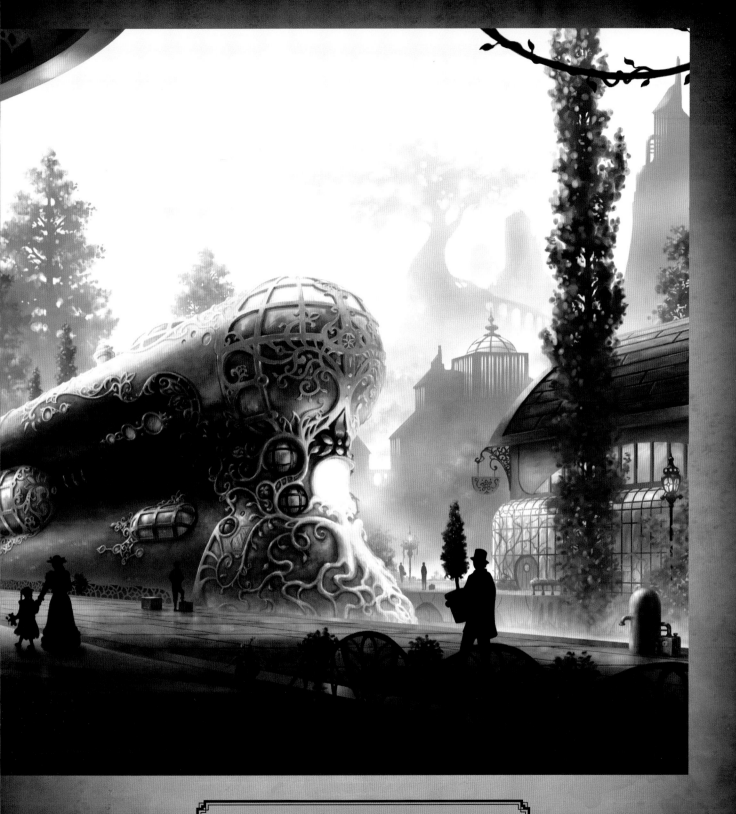

ABOVE: Train to Botanica.
OVERLEAF: Steampunk Ship Brassheart.

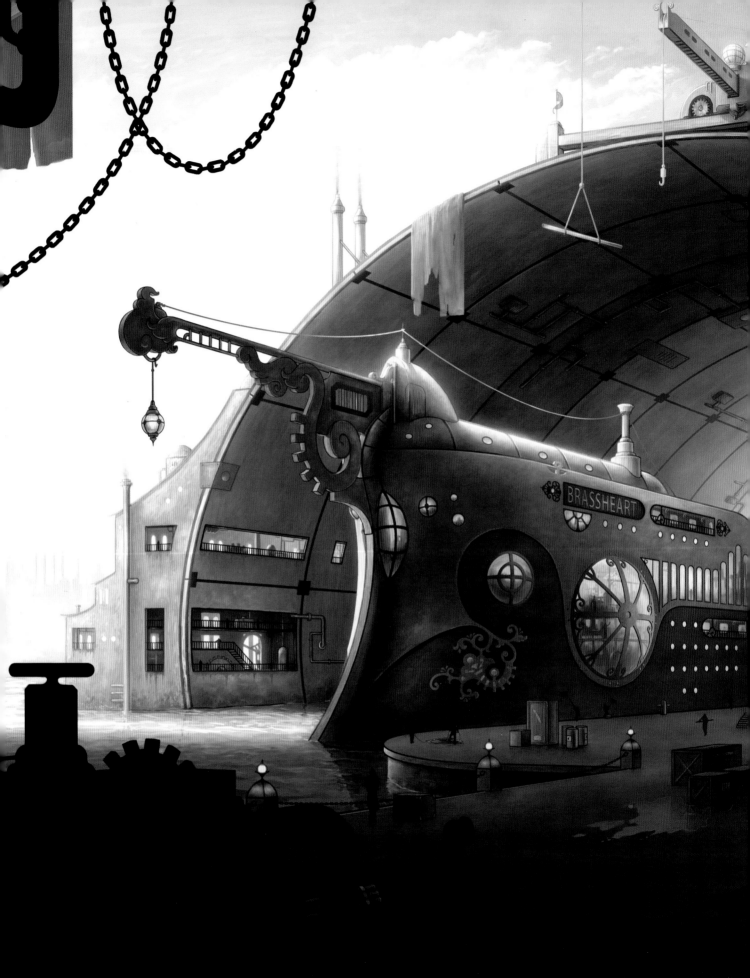

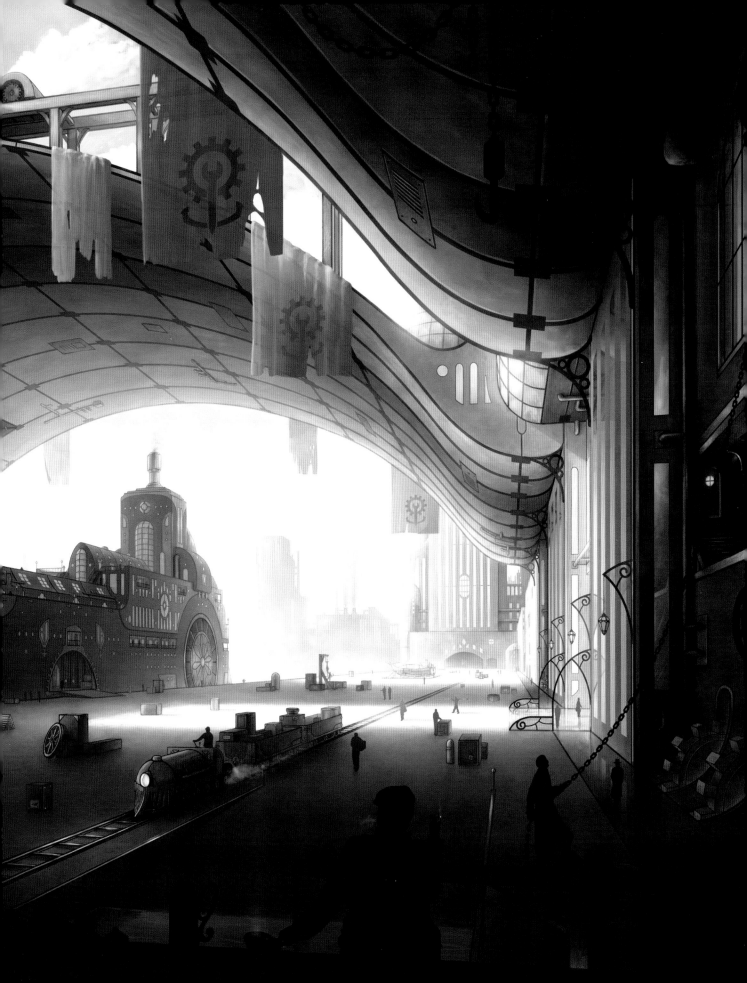

Arseniy Korablev

Born in Kineshma, a small town in Russia, but now based in Moscow, Arseniy was into *StarCraft*, *Heroes of Might and Magic*, *Neverhood*, "and many other atmospheric games" as a kid. He used to sketch everything – imaginary worlds, inventions and insects. "In the end, creativity and my technical mentality made me an artist who draws mechanical contraptions in interesting environments. That's how I became a steampunk and cyberpunk artist; it was a gradual, smooth process." Amazingly Arseniy is only twenty and still studying his art. Not so surprising when you realise he made his first attempt to try 3-D software aged eight. For him steampunk is "a world for inventors and researchers, like me. I also like the way it recalls a time when people paid more attention to detail, to achieving some kind of beauty. It's infinitely more interesting than the invisible world of electronics." Increasingly Arseniy likes to develop a story behind his works. "I begin with a simple idea and the immediate suggestion of an image. Then I start creating the story. So, with *Rusty Sky* the story was that of a drained mine on Mars, with *Habitable Zone*, mankind had left the Earth and the last colony existed in a Gliese 581 system. When I have a story, the rest of the design comes along more easily." He thinks steampunk will continue to develop. "The great thing is that you can mix it with other genres. You could imagine a Stone Age steampunk, or steampunk in Ancient China, or even better steampunk in a cyberpunk environment, now that would be perfect!"

RIGHT: *Royal Wings.*

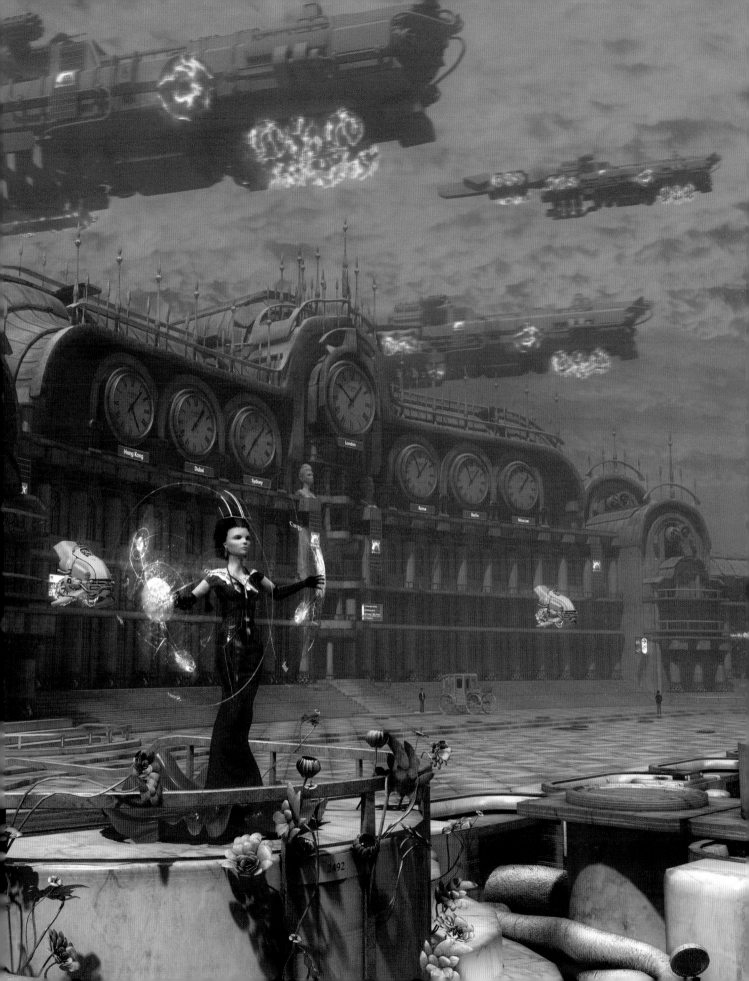

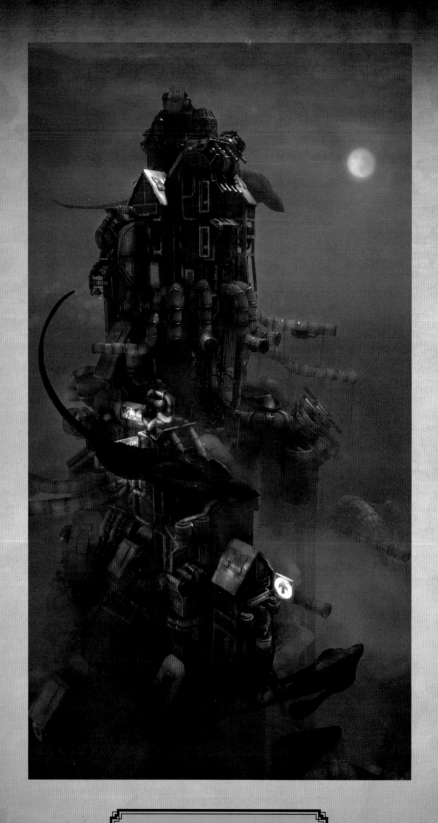

ABOVE: Habitable Zone.
RIGHT: Rusty Sky.

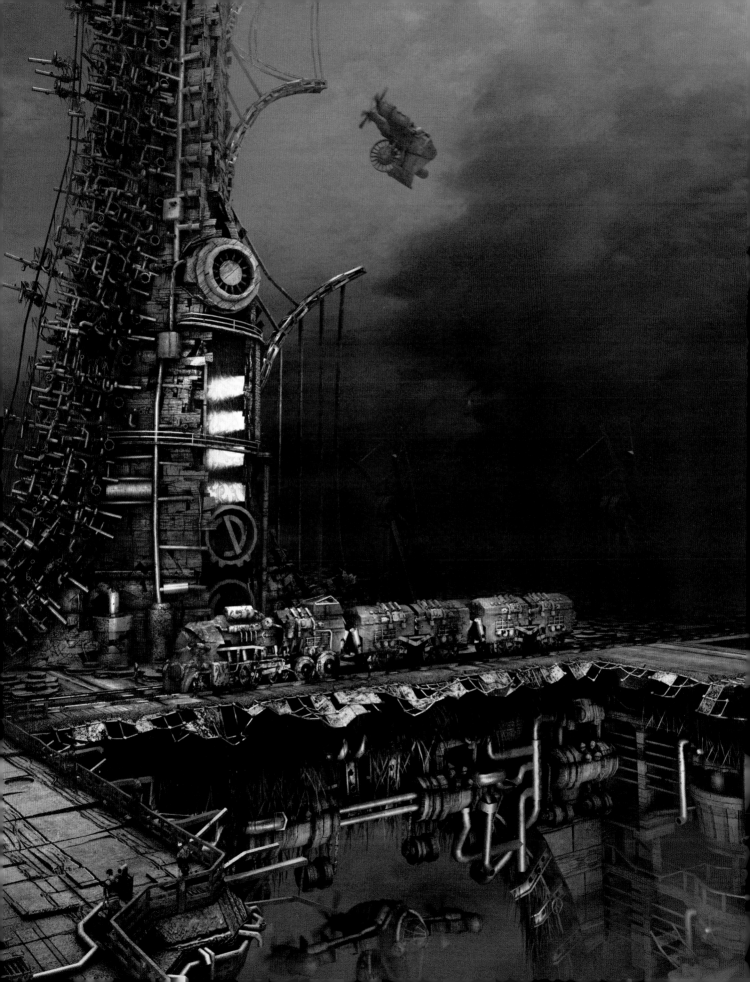

Jeremy Love

For me art was a private outlet until my mid twenties. It was only then that I started to think of myself as an artist; it was great to feel that sense of purpose." Jeremy, who hails from Australia, always knew he wanted to be a creative, but wasn't sure what sort. "Looking back I see that all the steps I took led me to where I am today. Being a graphic designer for a small design studio on the Sunshine Coast (back in '97) taught me layout and computer skills; sign writing taught me a work ethic, as well as client skills and how to use colours." Steampunk is one of the genres that fascinate Jeremy. "For me it's an alternative universe set around the time of the Industrial Revolution, where any invention seems feasible using the technology available at that point in time. It's really a tribute to the ingenuity of mankind, a world where Watt, Tesla and Einstein might create everything. And with all those cogs, steam and amazing inventions, it's damned fun to draw!" General artistic inspiration for Jeremy is from "anything that makes me stop and take notice and the random perfection in everyday things – the way shapes can communicate to us and what it is that really makes a design work." When it comes to specific pieces there is usually a story. "For instance, *Hermes vs Argos* is based on a tale from Greek mythology. The pistol concept came from a steampunk sky pirate game pitch I worked on, based on a world full of floating microcosms. Where there is plenty of reference to pull from, it's easier to shape the visual idea into a resolved form."

RIGHT: *Argos vs Hermes.*

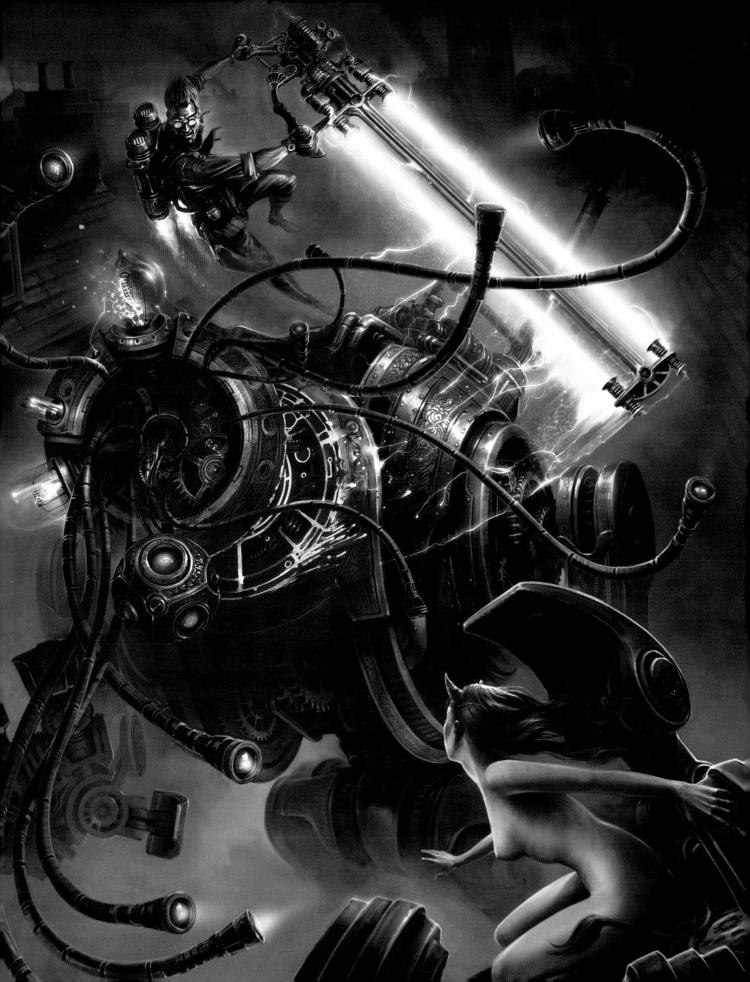

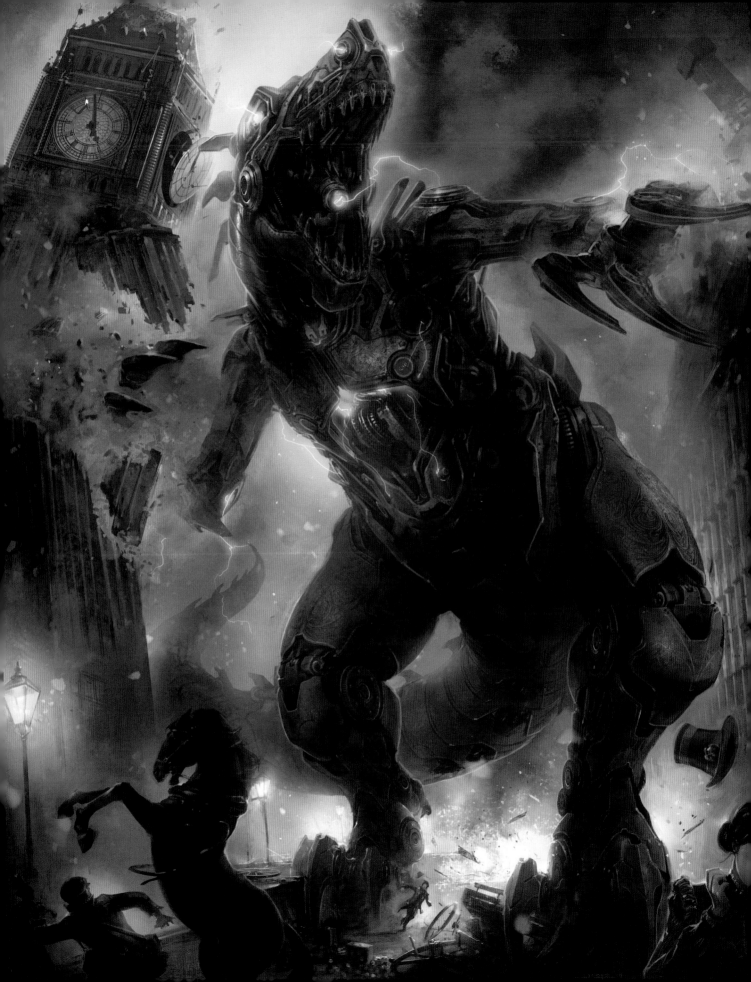

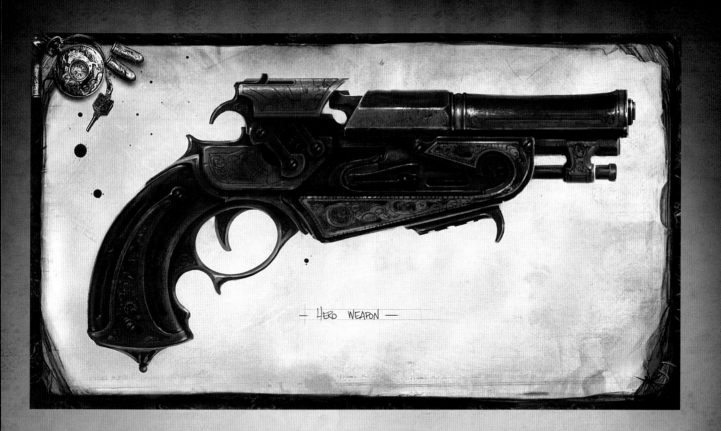

HERO WEAPON

LEFT: T. Rex.
ABOVE: Steampunk Gun.

STEAMPUNK LIGHT SA

o/E. 08

LEFT: *Steampunk Sabre.*

Luches

———— ◆◆◆ ————

Luches, a.k.a Okita, a.k.a. Leos Ng, hails from Singapore. Early on he had and interest in drawing and creating, a fascination for ironclad warships from the World War One era, and an admiration for Keith Thompson's art. He did attend design school where he studied animation – "that prepared me for how tough this business is" – but most of his digital skills in 2-D and 3-D are self-taught, through trial and error and by watching other artists at work. Leos worked for six years at Imaginary, a Singapore design studio, before setting up on his own. His steampunk works are personal enthusiasms. "I like to add a background story to my artworks. I think that gives them soul. One of the series I am currently working on involves an exploration of an abandoned city (loosely based on Singapore) with a steampunk/old world technology aesthetic." Leos likes steampunk because of its fusion of fantasy and real-world imagery. He thinks its growing populairty is that it stands out in an environment of common fantasy and sci-fi. His art has been extensively published, notably in *ImagineFX* and *Exotique* (numbers 3 and 6).

RIGHT: Empress.

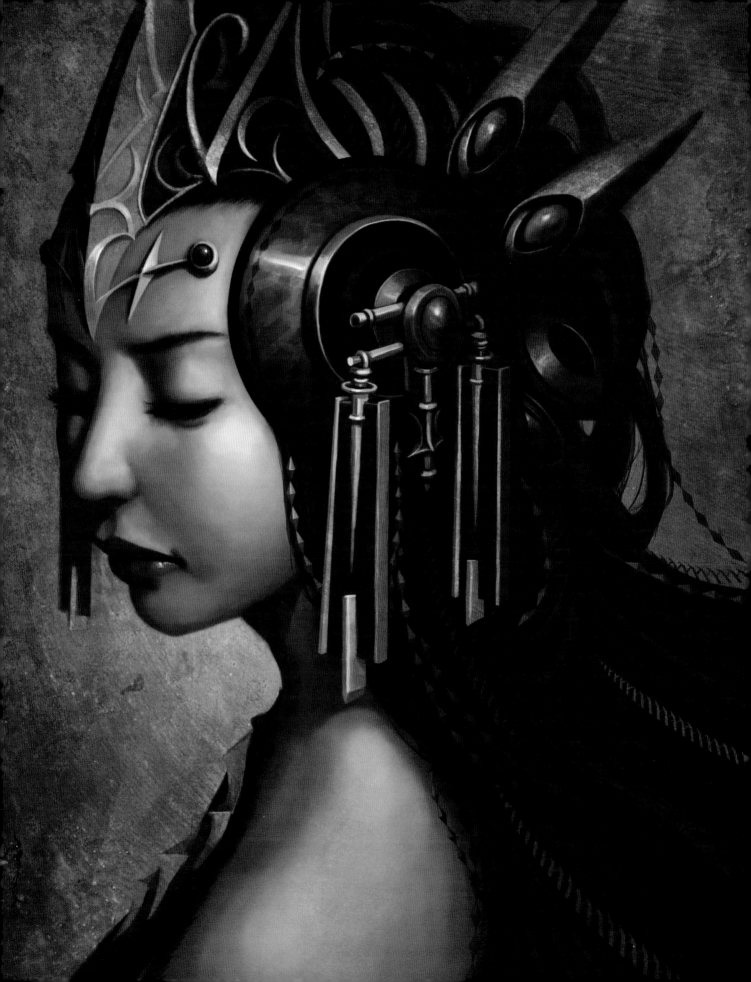

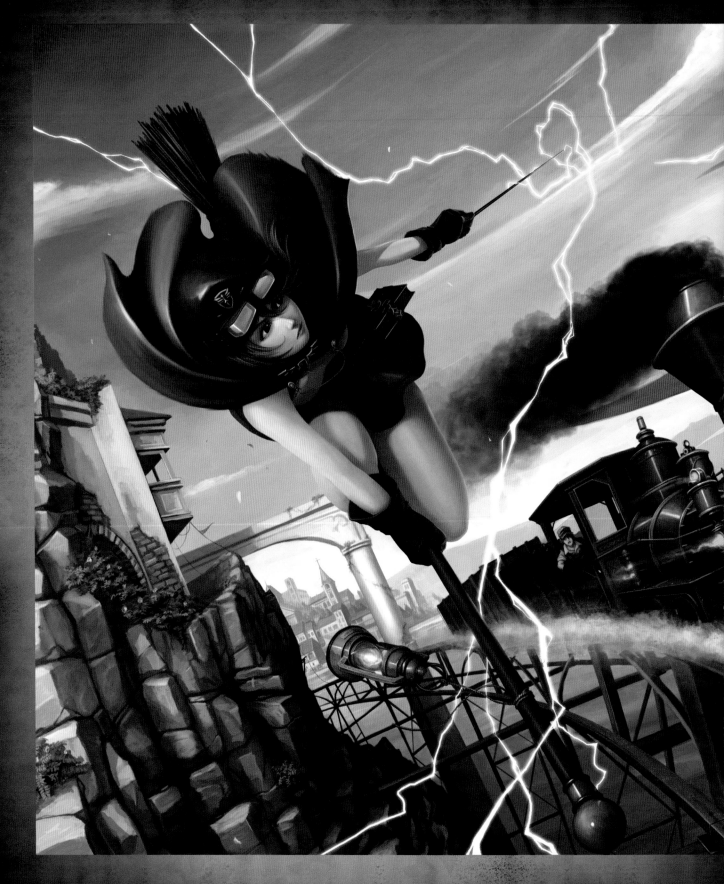

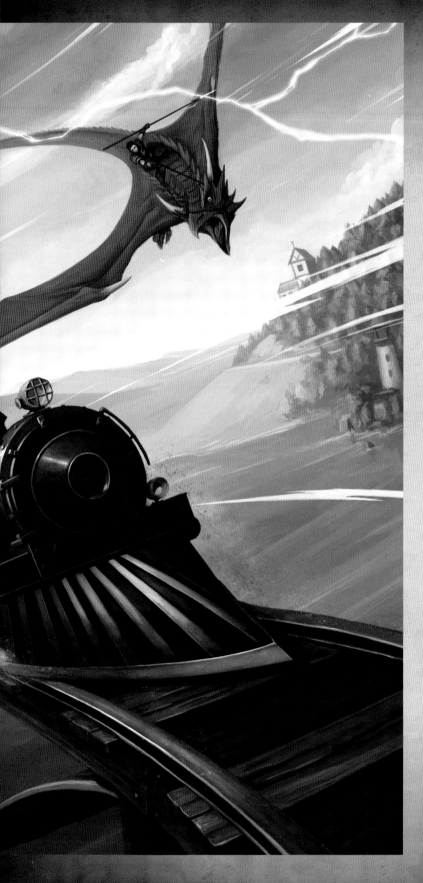

LEFT: *Alesia Grand Race.*

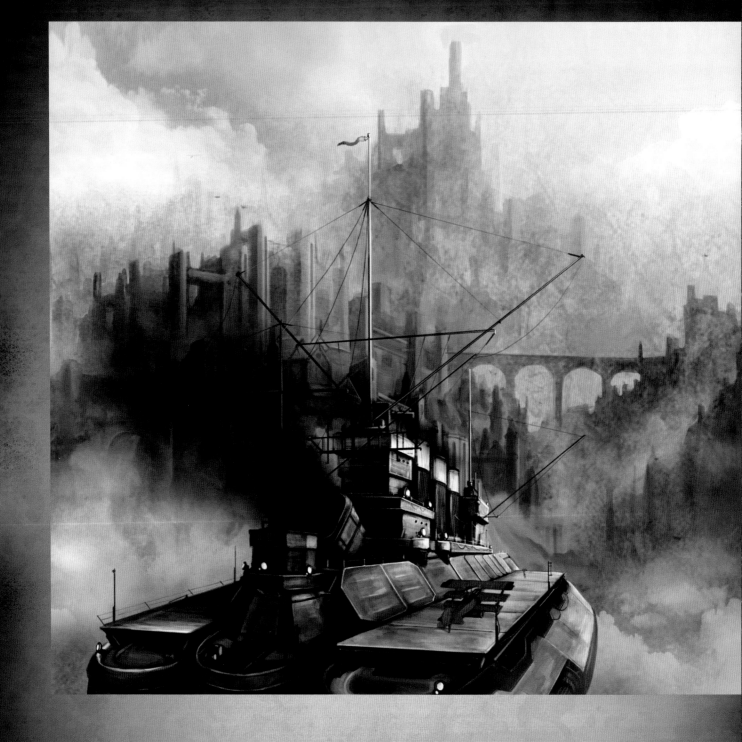

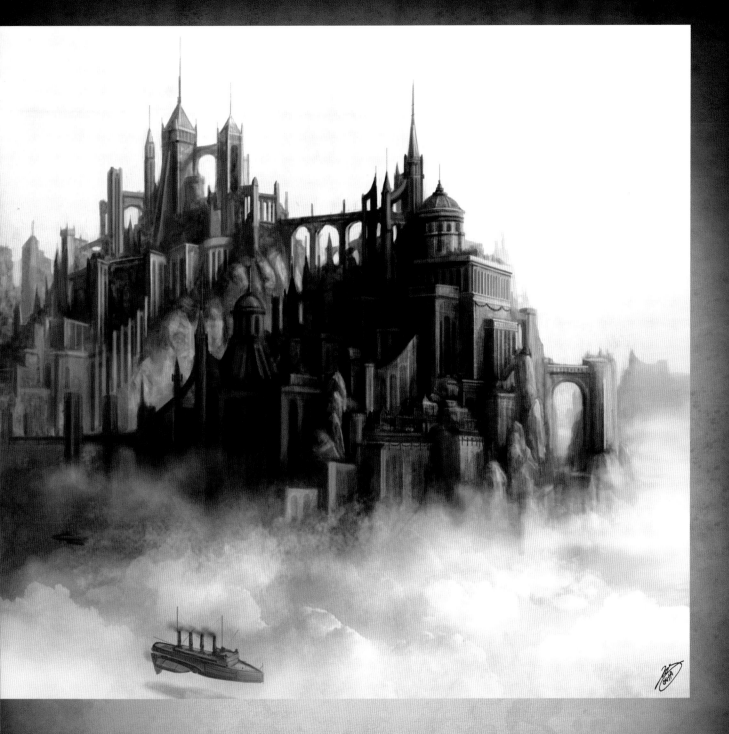

ABOVE: *The Cloud Castles.*
OVERLEAF: *Urban Explorer.*

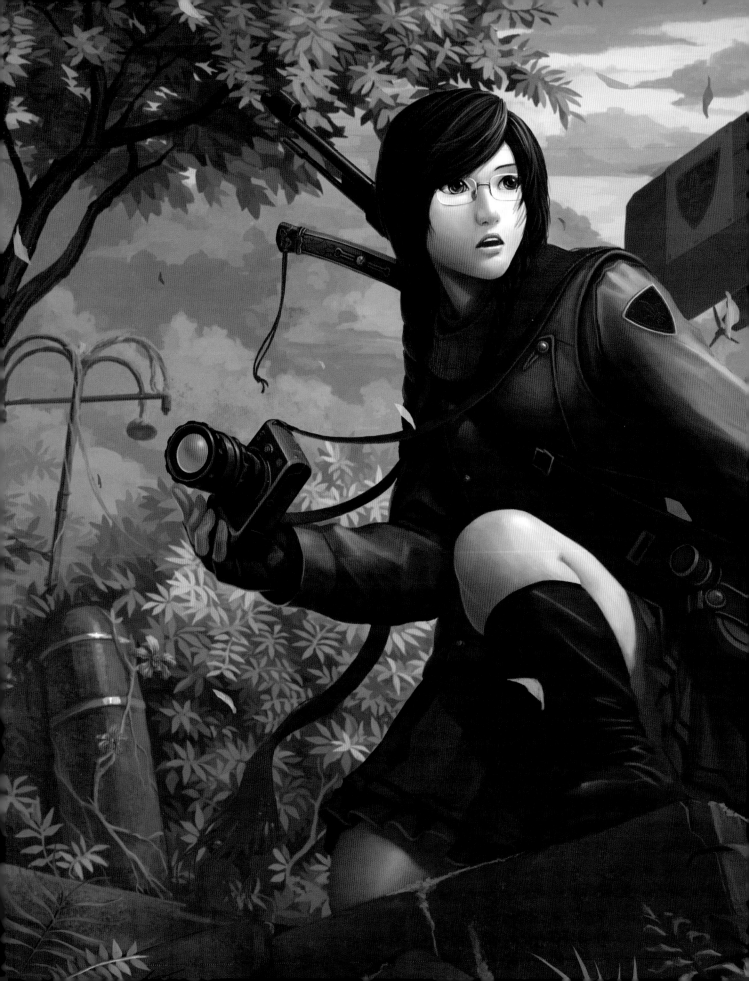

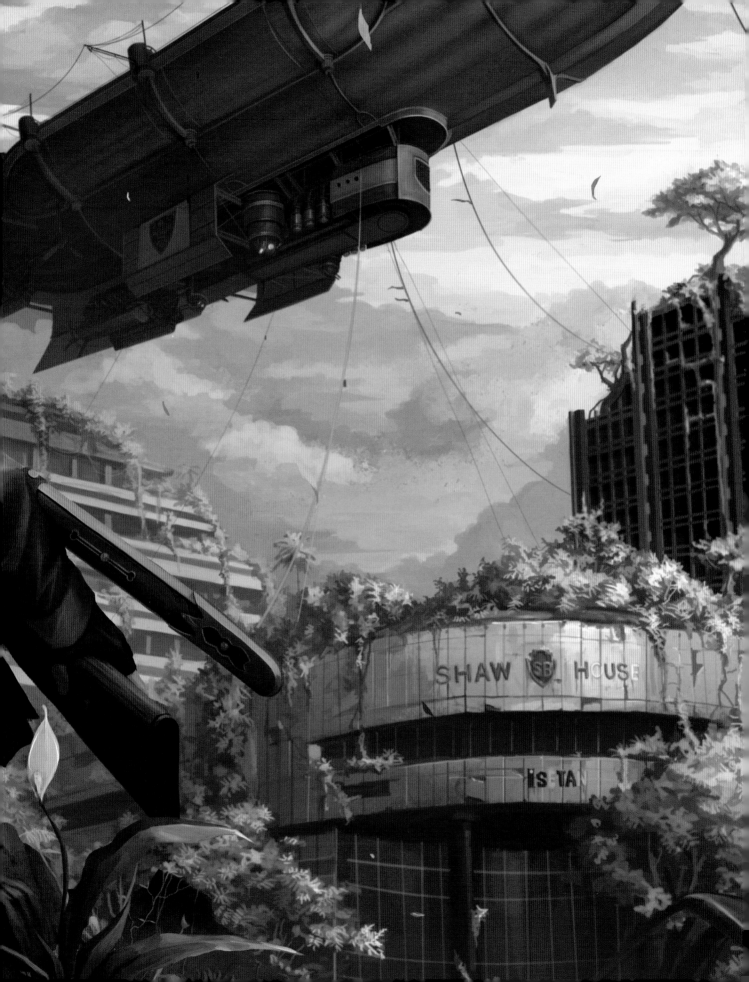

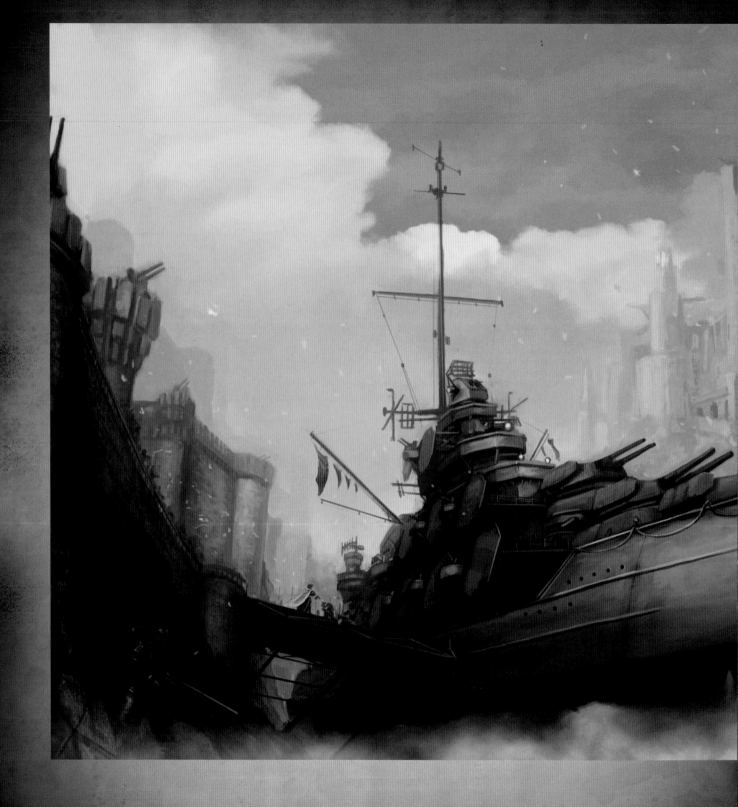

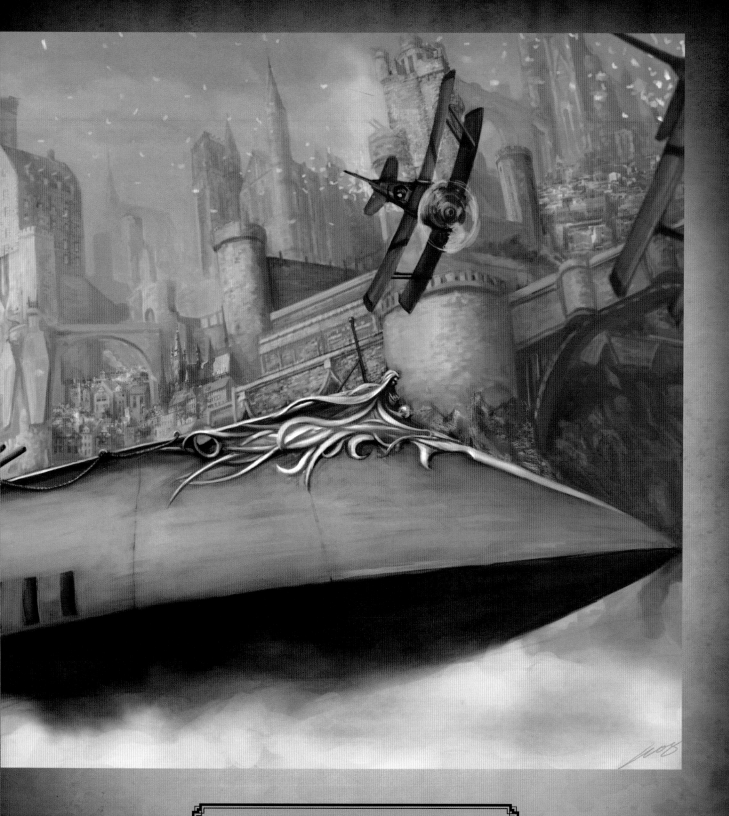

ABOVE: *The Last Knight.*
OVERLEAF: *Northern Base.*

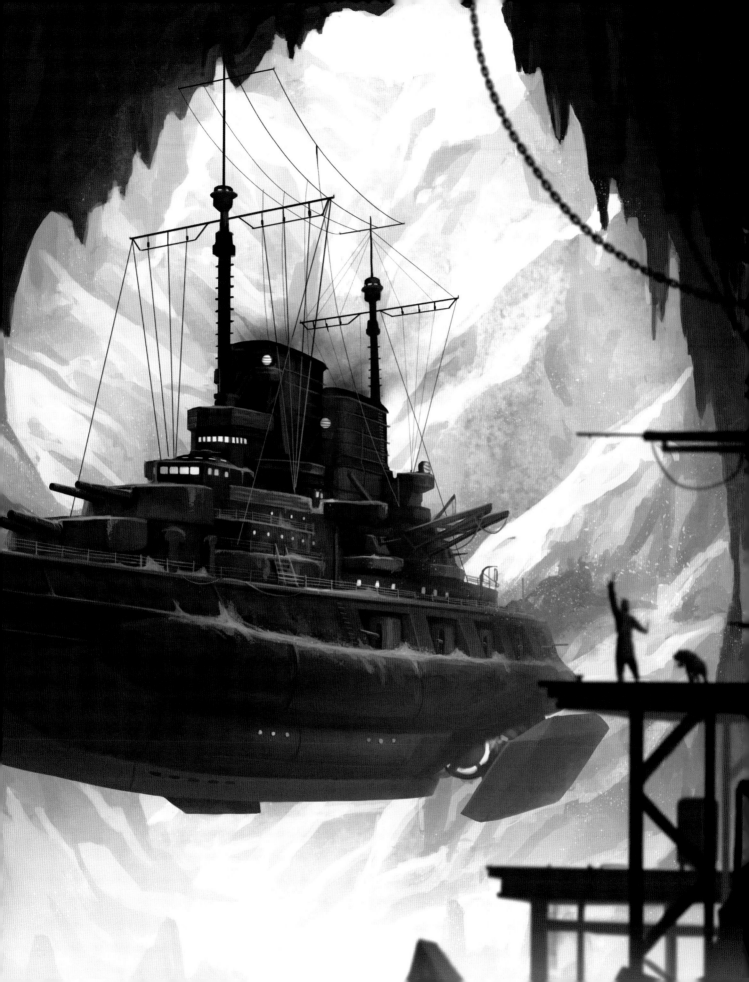

M3-f

I've used a number of pseudonyms," says Igor Vitkovskiy, "M3-f or Mef, or Mefko. It all came from my *World of Warcraft* name – Mefisto." Igor was born in Boryspil, near Kiev, Ukraine, and is still based there. He studied graphic design at Kiev National University of Culture and Arts, which he found boring – "I got no knowledge there, but I did make some good friends." He adds: "I think I was born an artist... always creating something. The steampunk thing came along in 2011, when I helped with the concept art for a steampunk game." Igor's credits as a concept artist include *Natural Selection 2* and a short movie, *Relics*. He works using both traditional and digital methods. "I like to firstly use pencil or pen sketches, and then import into Photoshop, where I add textures and finish with brushwork and special effects." In addition to inspiration from other artists (mainly surrealists or post-impressionists; his favourite artist is Beksiński), people and life, Igor says "I use my own emotions, including periods of depression, which I find are very good for dark themes or for work with a mystic element." The success of steampunk Igor thinks is partly due to the fact that people were tired of pure fiction and fantasy. "Steampunk is somewhere between the two, it looks cool and who wouldn't want to be on the deck of a huge steamship or airship hovering through the clouds?"

RIGHT: *Empress.*
Pen and ink, digital.

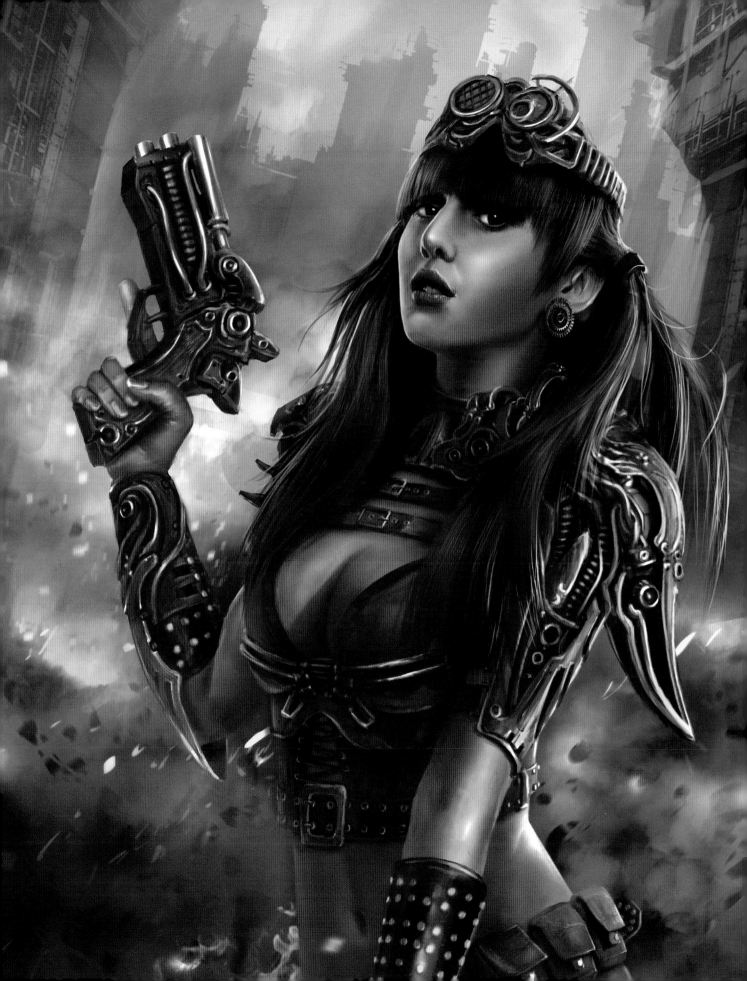

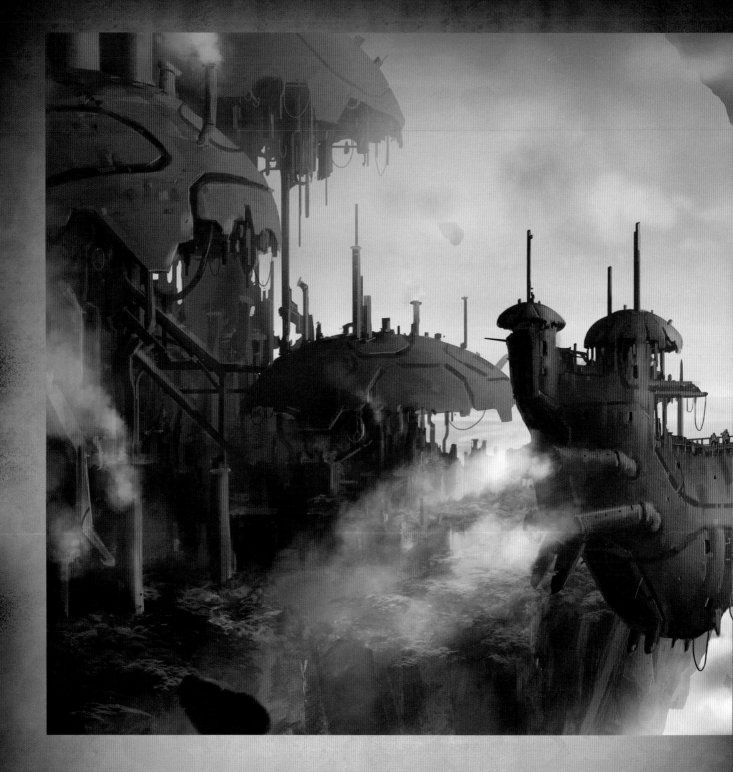

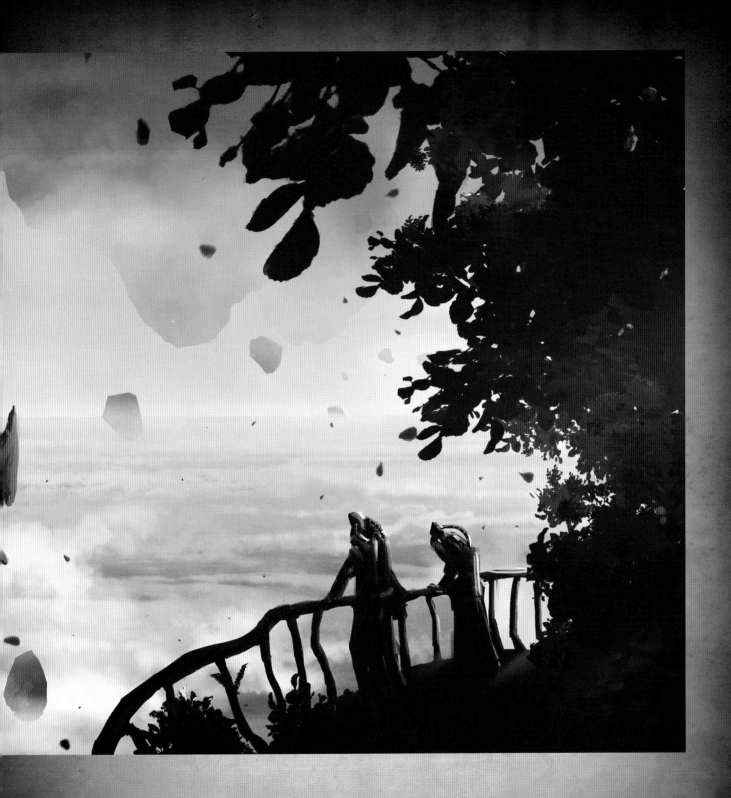

ABOVE: *High in the Sky.*
Pen and ink, digital.

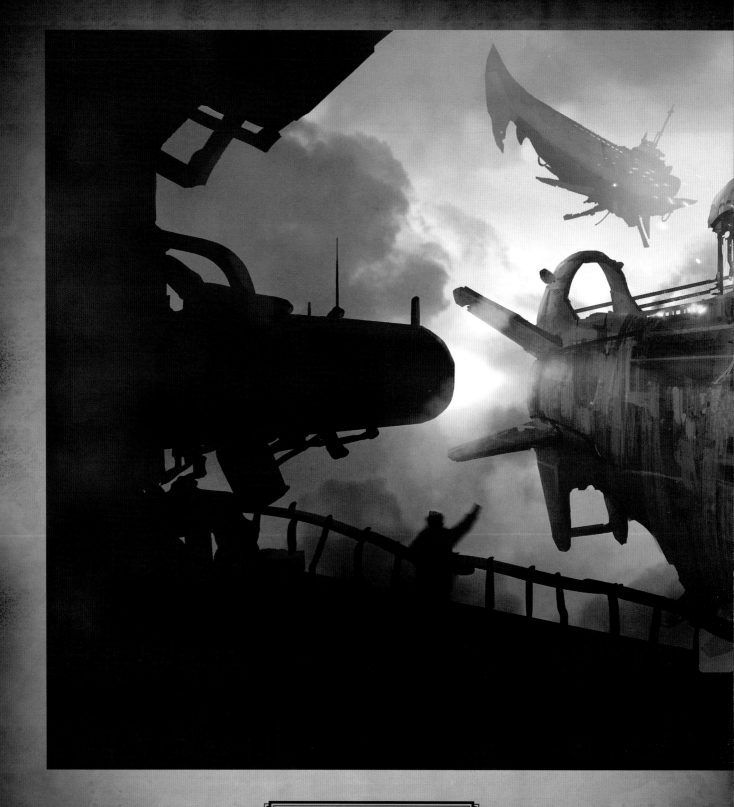

ABOVE: *Pirates.*
Pen and ink, digital.

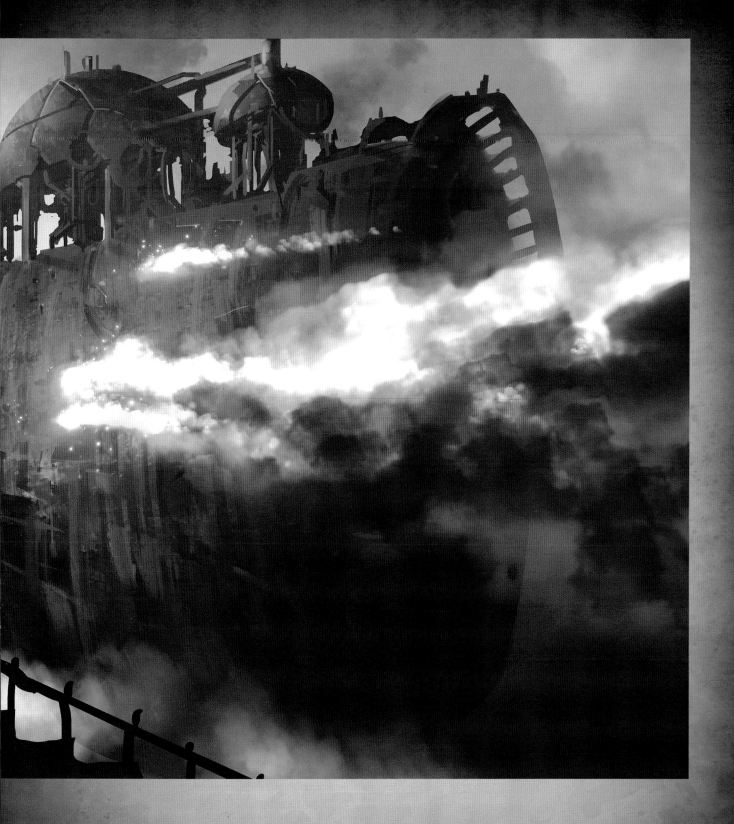

Matchack

———— ❖ ————

Matchack, a.k.a Michal Matczak, is a concept artist based in Warsaw, Poland. With a string of professional credits to his name, but with an attitude of constantly learning more about his art. "You can never stop in the field of games design and concept art. There are always new tricks, new techniques, new visions. If you stand still you slide behind pretty quickly." After studying art and illustration at Akademia Muzyczna, in Lodz, Matchack joined Reverie World, ending up as a lead concept artist. He followed this up with several years at SomeQuest and then YDreams, before joining People Can Fly. Today he is a concept artist at the celebrated Oscar-nominated studio (and Golden Palm winners at Cannes), Platige Image. Matchack's steampunk work has an intense sense of drama. "I'm a fan of Jules Verne, and of the sense of steam technology fighting storms or navigating hostile landscapes. Everything feels too safe now: I want to capture that 19th century sense of danger and of being up against the odds." He also like juxtaposing grand architecture and steam iconography, "like my piece where the most magnificent building in a great neo-baroque urban landscape is the dirigible station." Artists who have influenced him are "too many to list." Matchack is keen, however, to acknowledge his debt to other practitioners whose courses he has attended – James Pack, Jason Scheier, David Luong and Philip Straub amongst them.

RIGHT: *Mountains.*

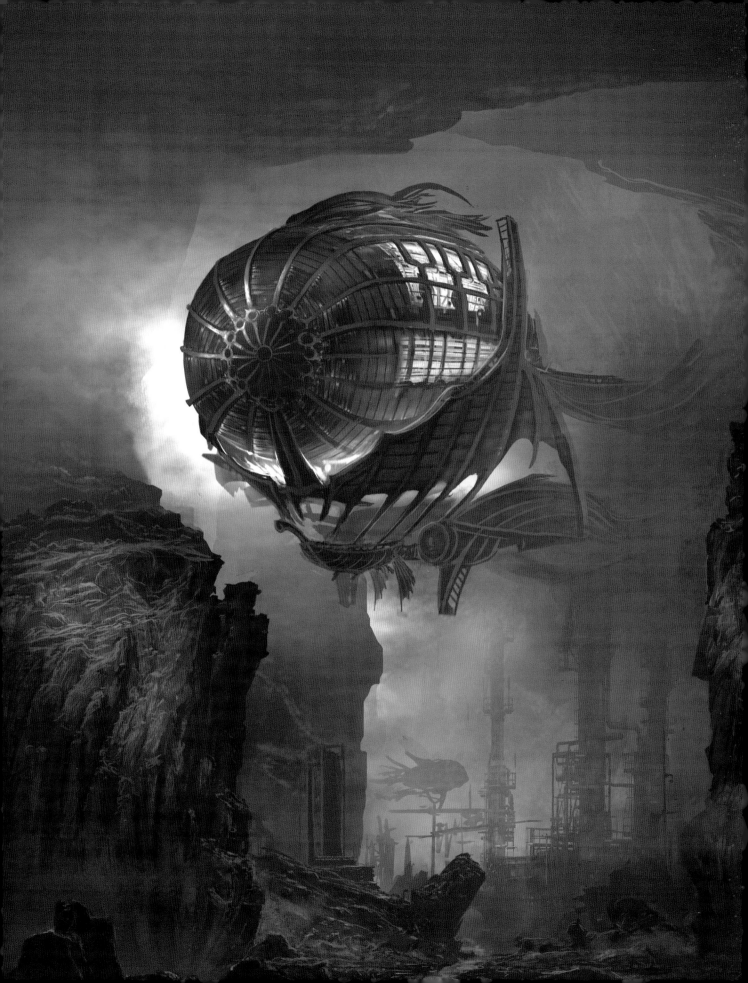

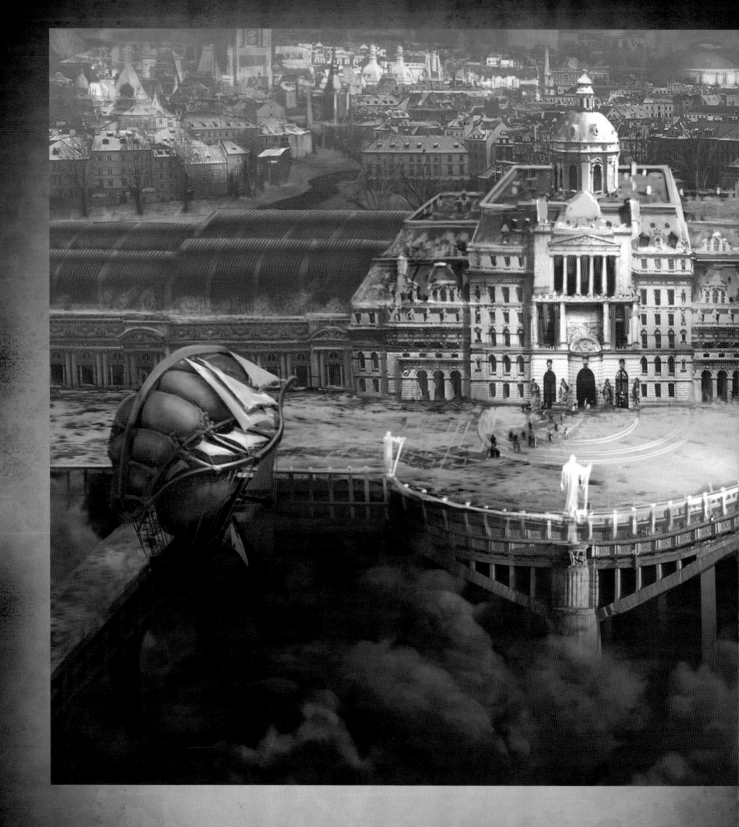

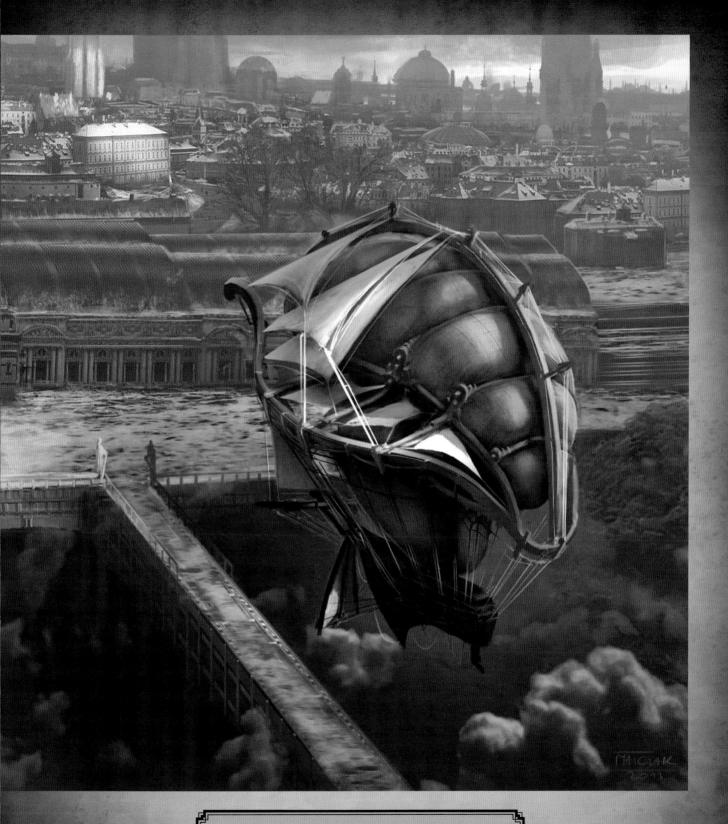

ABOVE: *Neo-Baroque Blimp Station.*
OVERLEAF: *Week 5.*

[109]

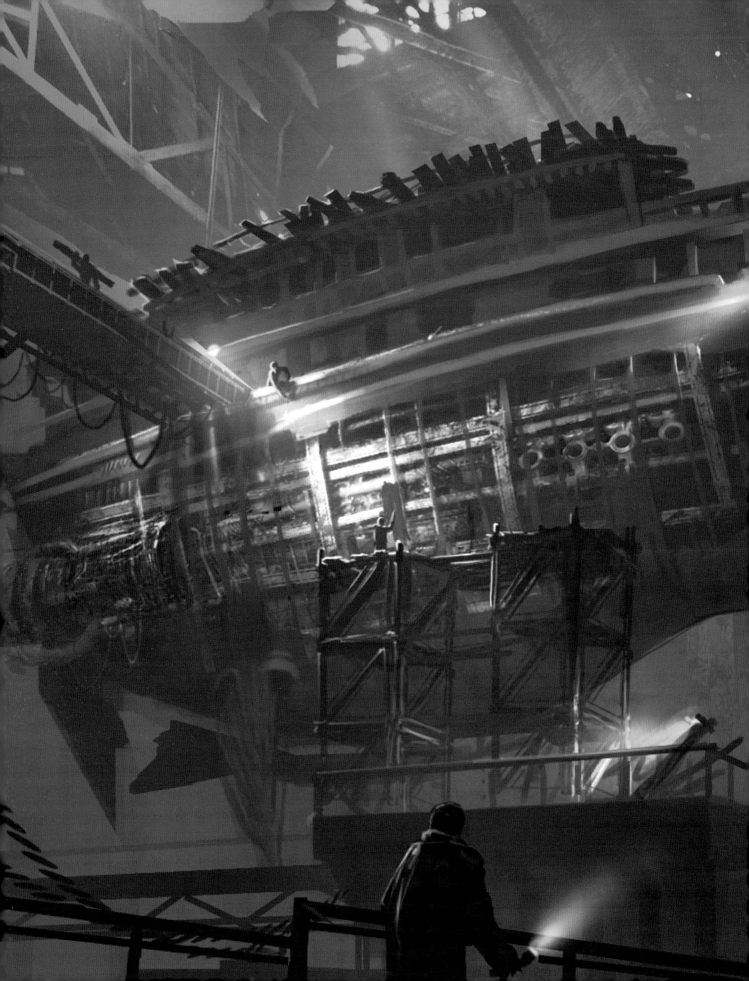

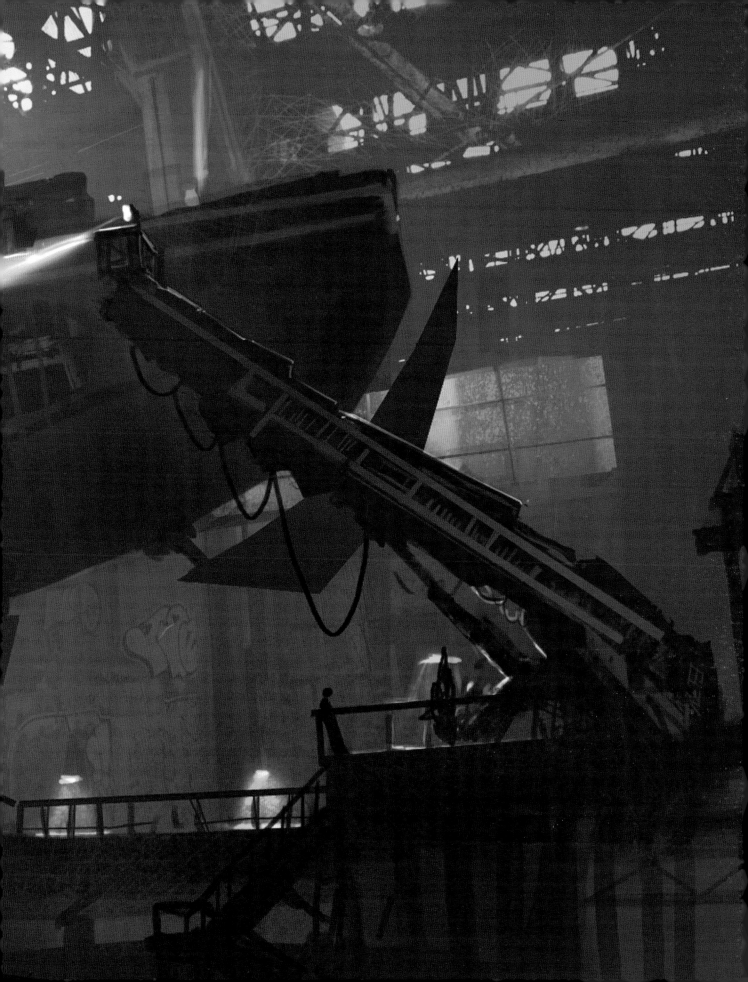

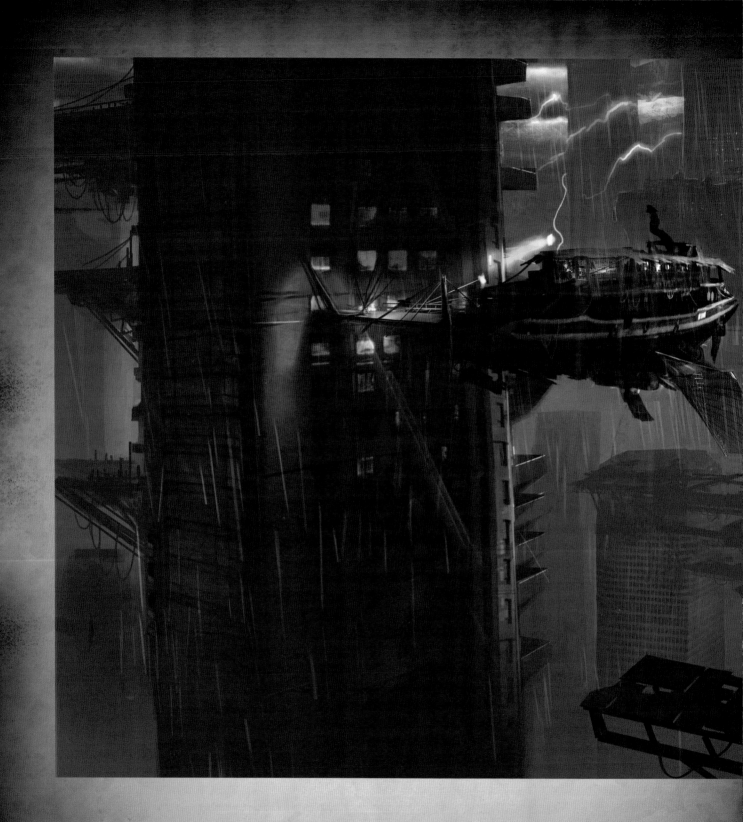

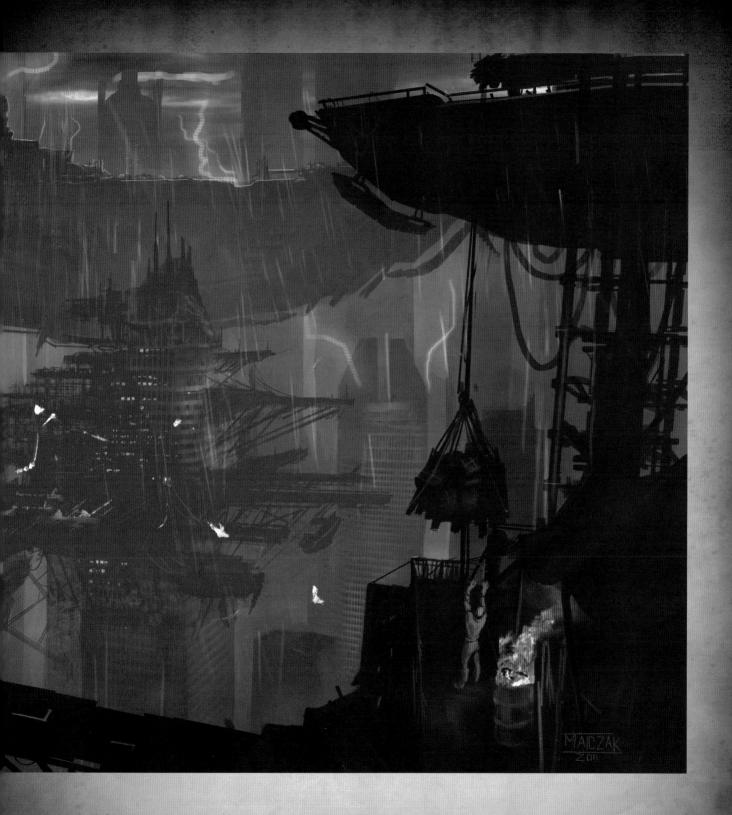

ABOVE: *Week 6.*

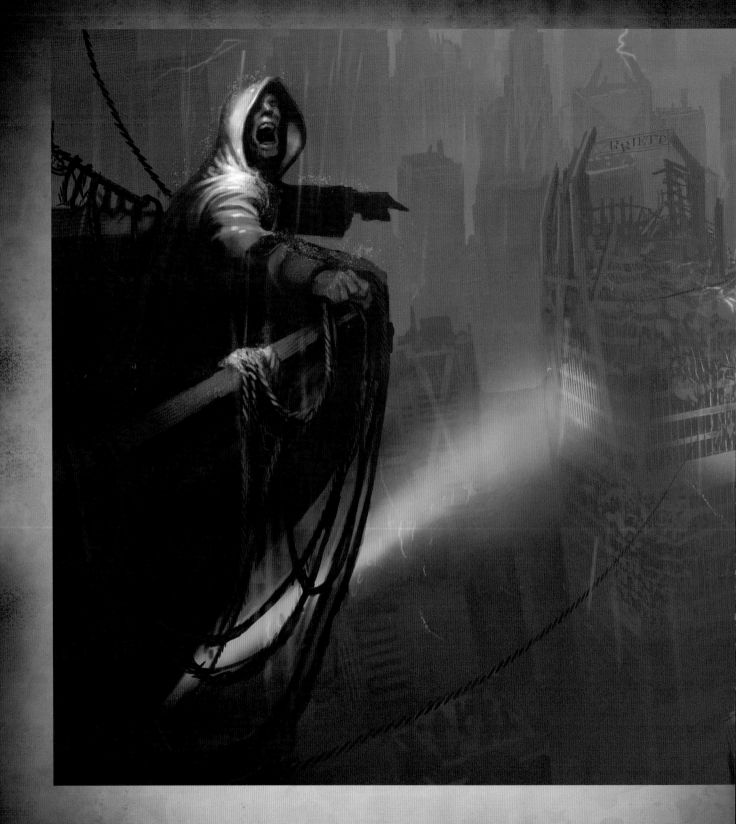

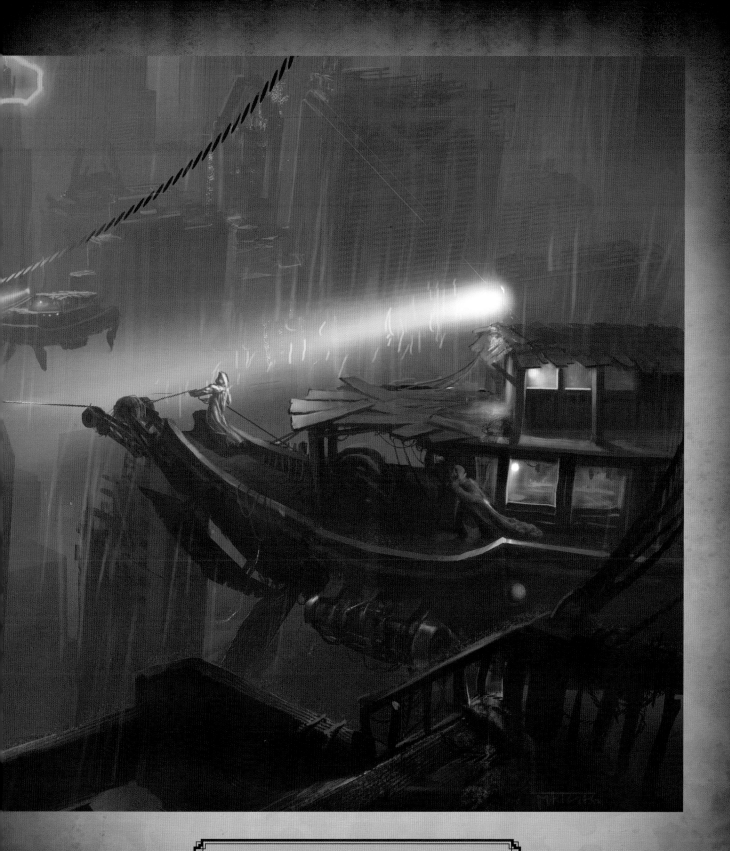

ABOVE: *Week 7.*

Tom McGrath

I t was watching Hayao Miyazaki's *Castle in the Sky* which got Tom, who also works under the pseudonym SpikedMcGrath, into airships and steam engines. Seeing Chris Riddell's illustrations in the *Edge Chronicles* made him decide to become an illustrator. Based in St Helens, formerly a major industrial town in north-west England (and site of the very steampunk Ravenshead Colliery), Tom studied illustration at university ("not a useful or positive experience"), and whilst there started posting images online and getting commissions for work in response. "Illustration is a passion. I am very lucky now to be able to do it full-time." He draws endlessly in a succession of sketchbooks, but once he decides to create a piece it is all done digitally, with the occasional use of 3-D modelling. He rarely has a clear image before he starts. "I tend to faff around a lot, and usually find that it's a linguistic idea or phrase, like 'The Great Race' which sets me off." Tom says "I like to sit in the corner of the steampunk world, over by the airships. What works about the genre is, I think, its whimsicality, fancifulness and a heavy dose of nostalgia. It's also a different place on the sci-fi spectrum to the time-travelling future, or the sword-and-sorcery medieval past. We've seen too much of those others. Steampunk is enjoying its time in the sun at the moment. Like most movements, however, it will reach saturation point. That's OK – something new and exciting will take its place."

RIGHT: *The Great Race.*

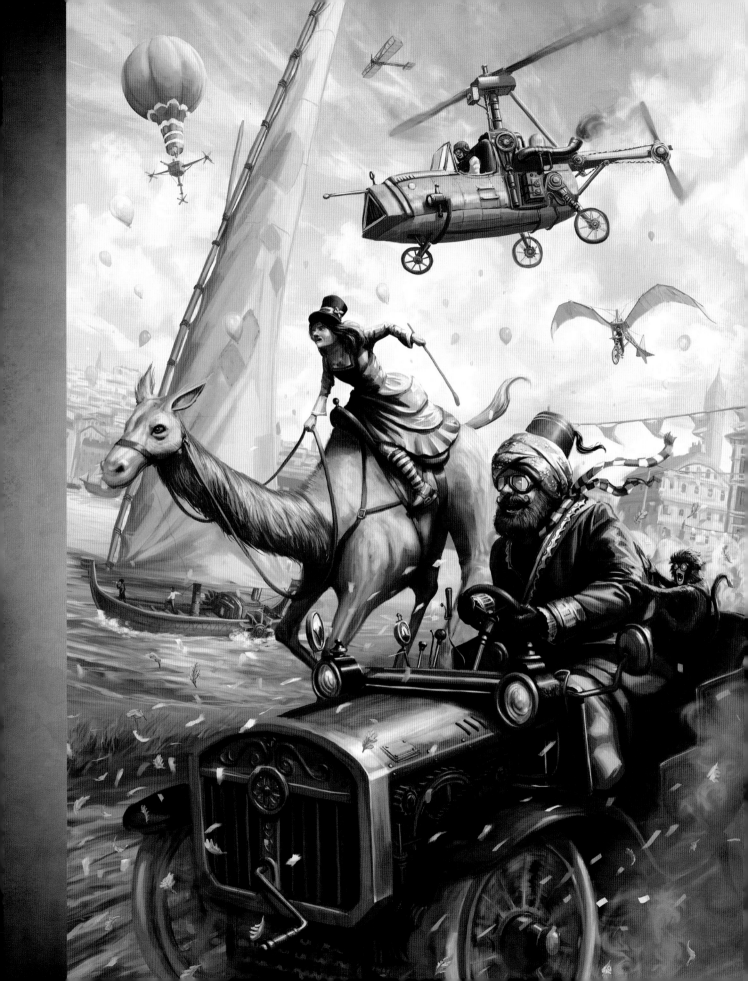

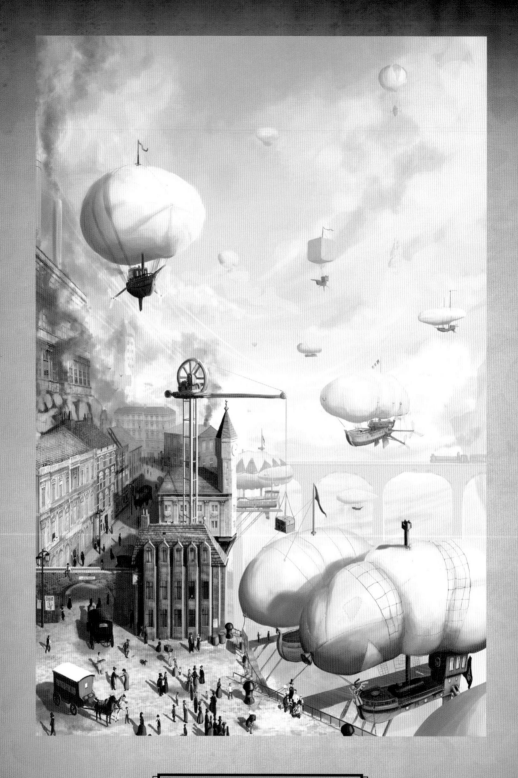

ABOVE: *Airship Docks.*
RIGHT: *The Long Voyage.*

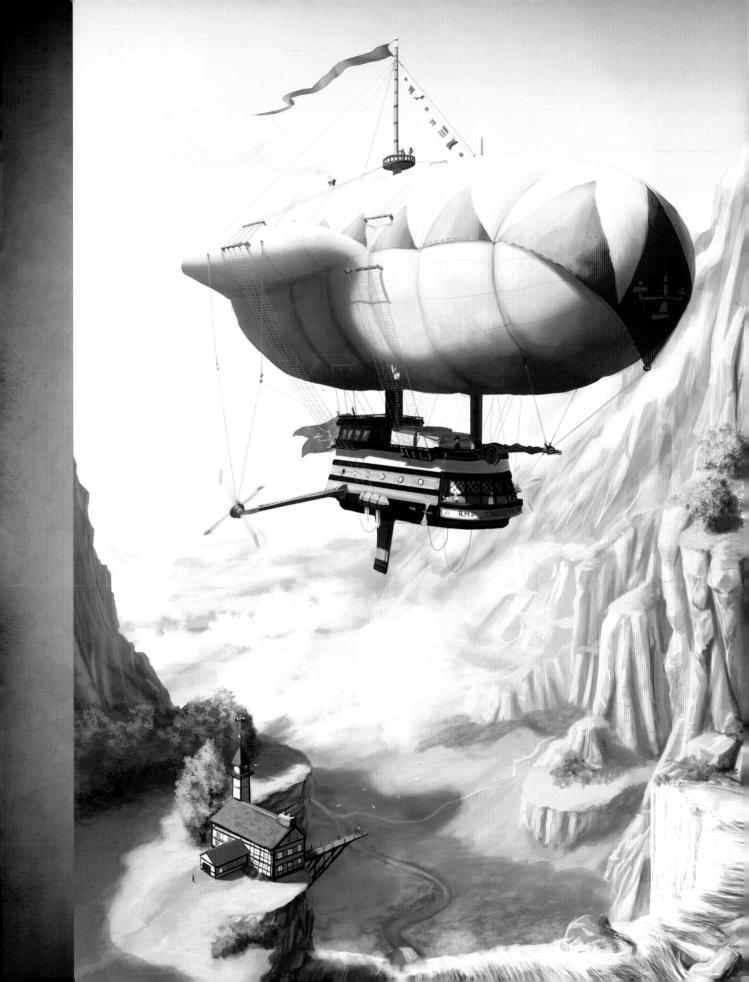

Luis Melo

Luis Miguel da Silva Melo has, apart from a year when he was based in Shanghai, been based in the same neighbourhood in Lisbon, Portugal, all his life. He trained as a graphic designer at the Lisbon Faculty of Fine Arts. Coming across digital art forums he says changed his life. "We didn't do any of this at university. Coming into direct contact, through the forums, with professionals in the games industry meant that I was suddenly learning at a tremendous rate. When I graduated I knew I wouldn't be touching any typographical jobs unless I was starving. Luckily I didn't have to." Steampunk is one of a number of genres he creates in – his ability to switch styles according to client needs is one of his strengths. He works almost entirely digitally, starting with a feeling for the picture – "I need to have a grip on the mood in order to fire my imagination." He doesn't like categorisations. "I'm not too concerned about whether something is 'steampunk' or not. Everyone approaches it differently. I don't like steampunk when it is treated as a decorative fetish or fashion trend, rather than as a literary idea. For me, steampunk represents a very interesting starting point for speculation about industrial civilization as a dystopia." In this vein, Luis likes things that defy straight-jacketing. "I admire J.G. Ballard (science fiction that isn't really science fiction), horror that isn't just horror (David Lynch, Cronenberg) and animation with deeper themes (Jan Svankmajer or Satoshi Kon). Not surprisingly, Luis, in addition to his art, is also writing science fiction short stories.

RIGHT: Ryplor.

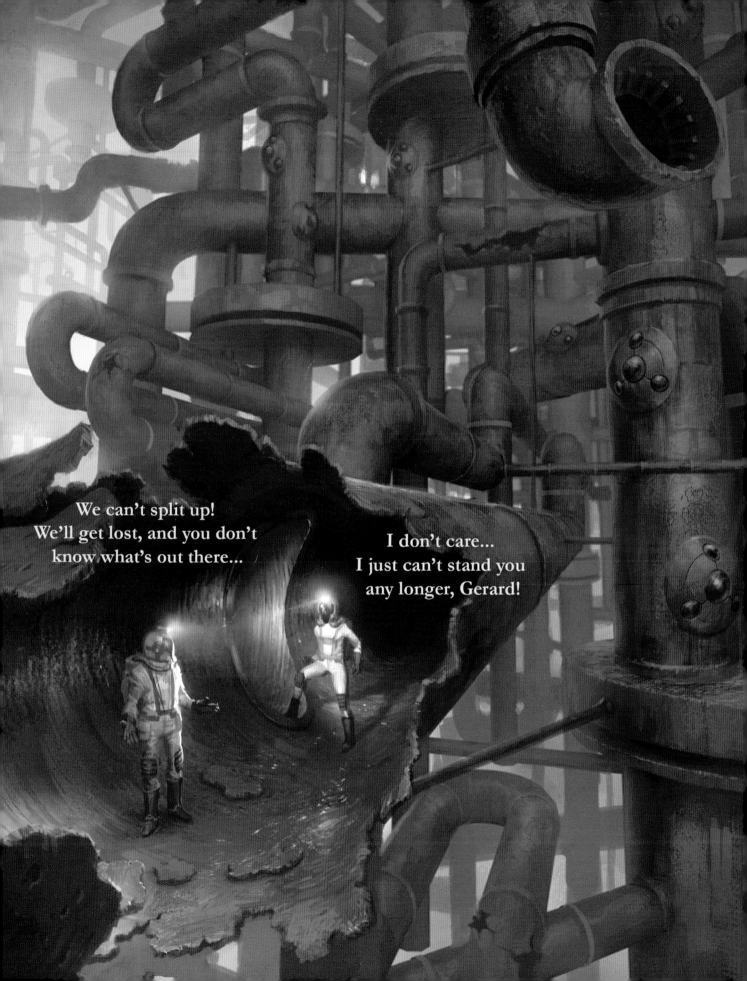

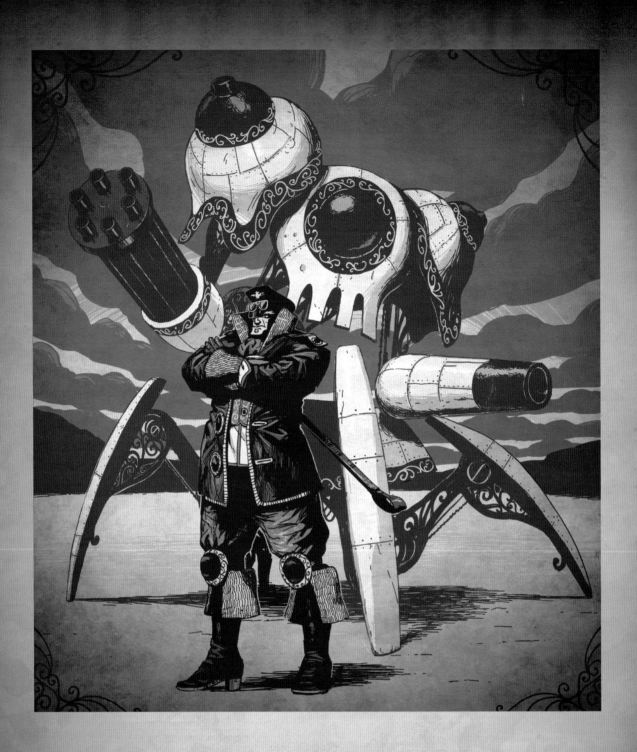

ABOVE: BMMD.
RIGHT: *Siege.*

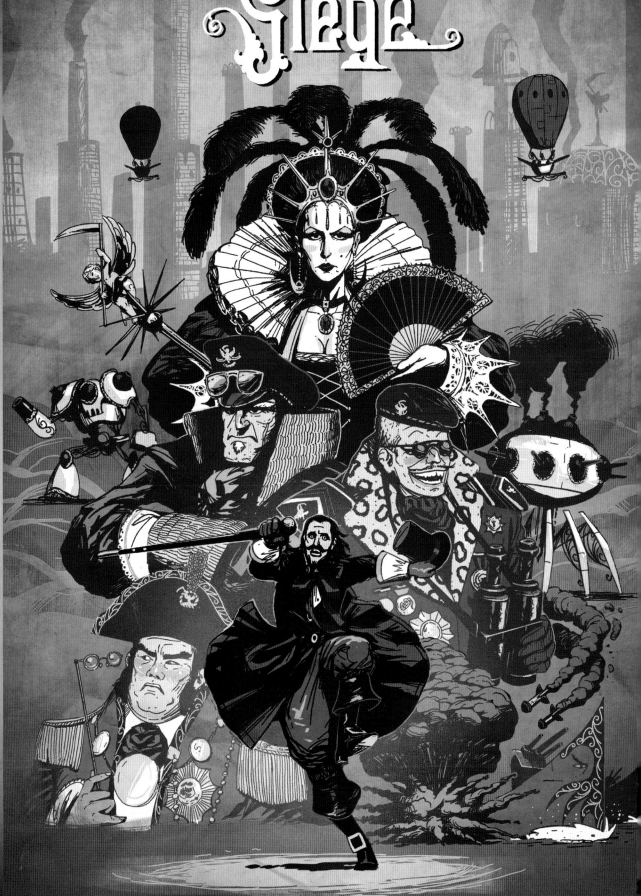

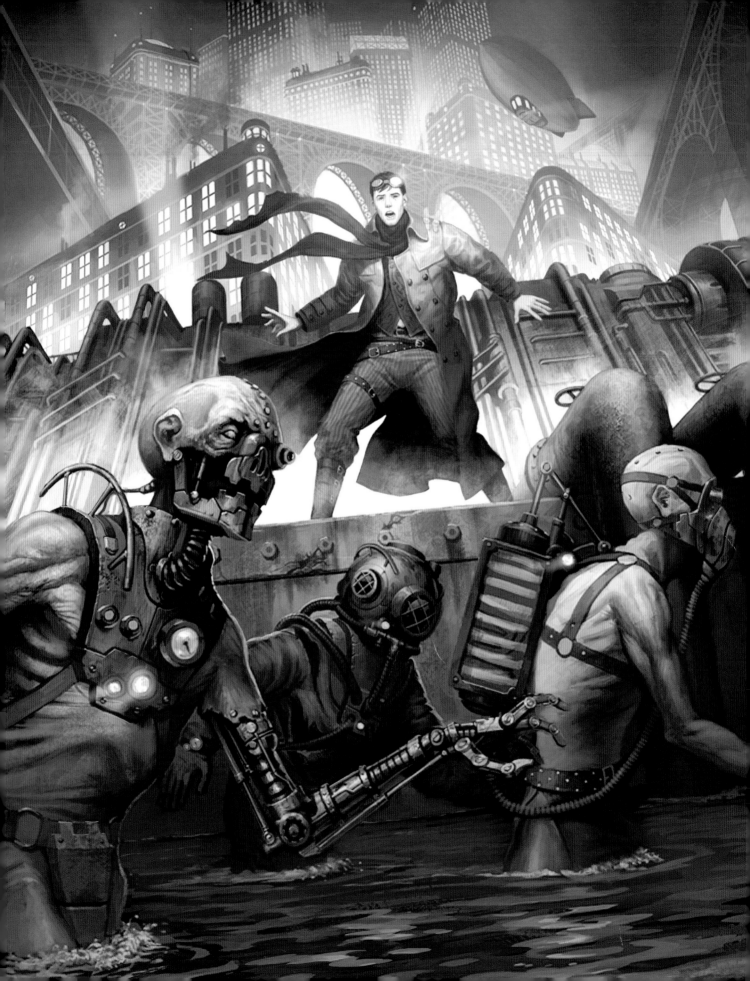

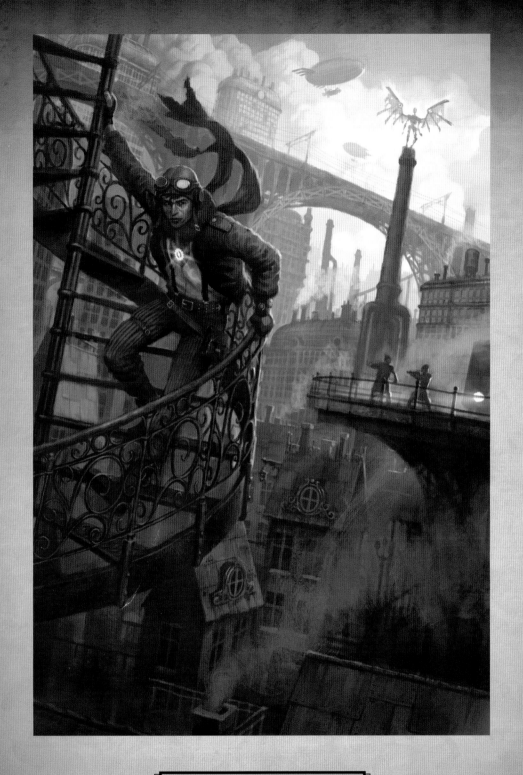

LEFT: *Undead of Veridon.*
ABOVE: *Veridon Final.*

Melanie Möller

Melanie's passions are fantasy, history and mythology, and "steampunk – it combines a little bit of all three." Based in Esslingen in Baden Württenberg, in southern Germany, she describes the early years of making it as an artist as being "rather horrible. It took quite a while before I could feel I could call myself 'an artist'." She is entirely self-taught, making use of online tutorials to learn programs like DaziStudio, with which she mostly works. "My images are created entirely in a digital environment. I start with an idea and a thought which I put into a picture. But then, as the creative process evolves, it takes a different direction. I don't know where the journey will take me. Sometimes it's straight to the virtual trash bin." Inspiration does not come generally from other artists but from life – "a chance song or painting I happen to see, or a book I have read which has moved me." Steampunk for Melanie is not just the reimagining of a Victorian future, but also "dirty and grimy and a place where you can escape everyday life. I like the fact that steampunk women are not passive as in Victorian times, but they wear trousers and work as pilots and smoke – and are as dirty and grimy as steampunk itself." Her main concern is that steampunk is not ruined by "false commercial interests. It must stay a somewhat mysterious and intriguing sub-cultural genre."

RIGHT: *Steampunk.*

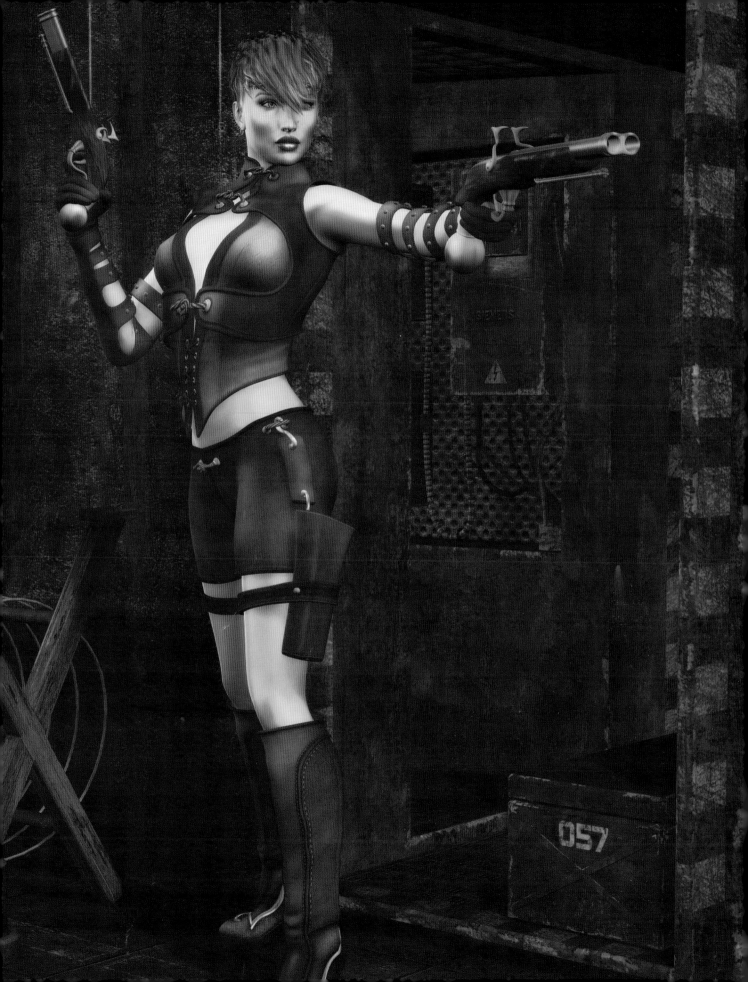

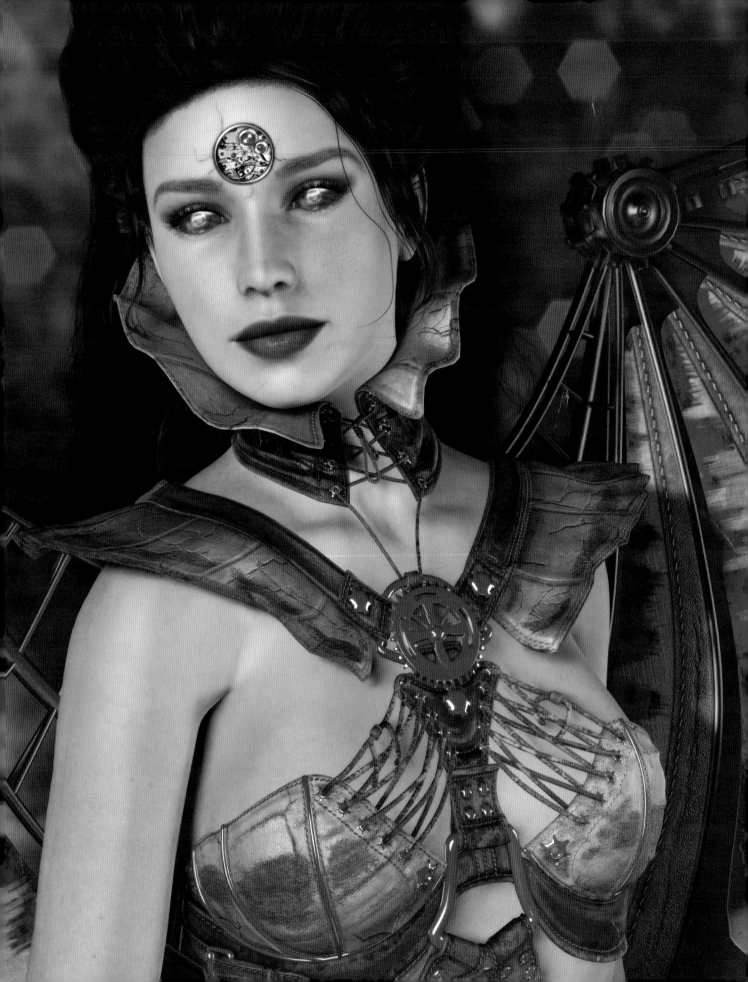

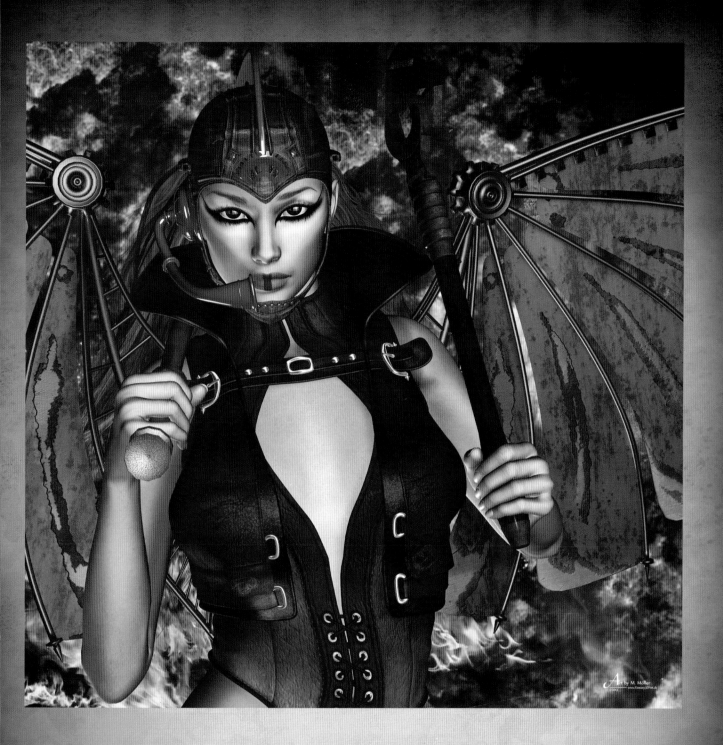

LEFT: *My Victorian Belle.*
ABOVE: *Catching Fire.*
OVERLEAF: *Past in Future.*

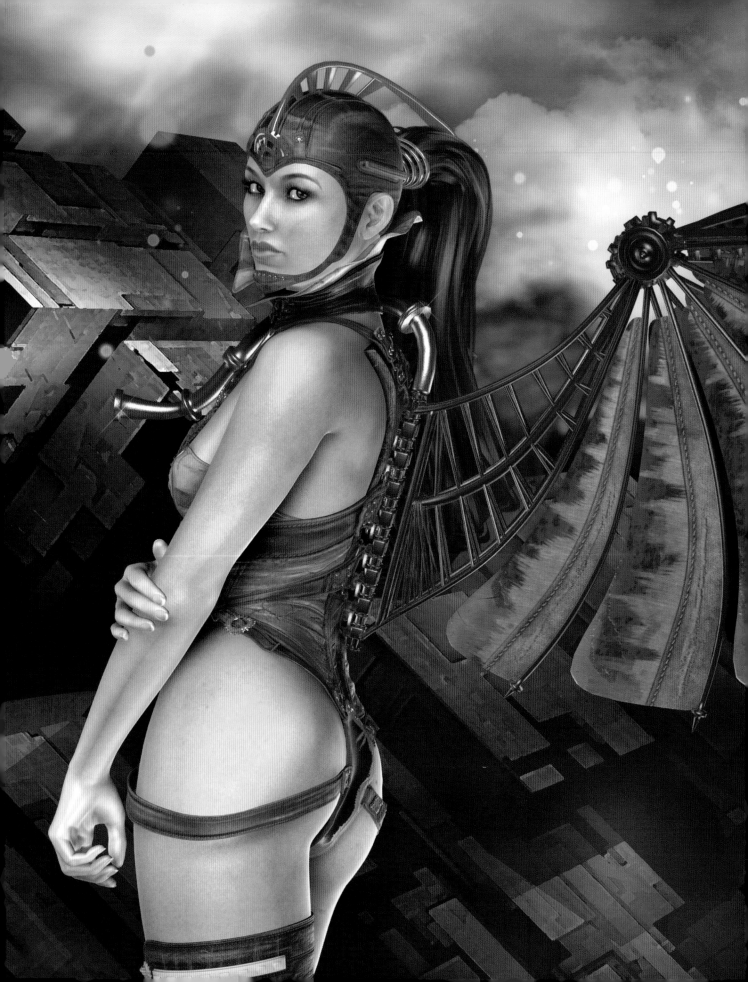

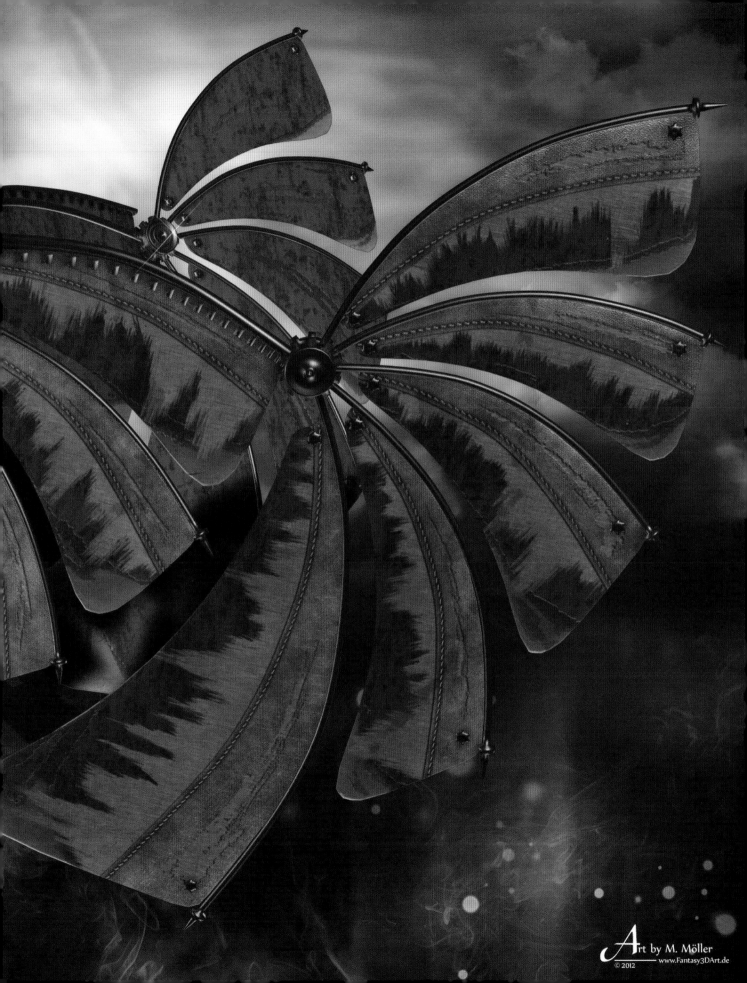

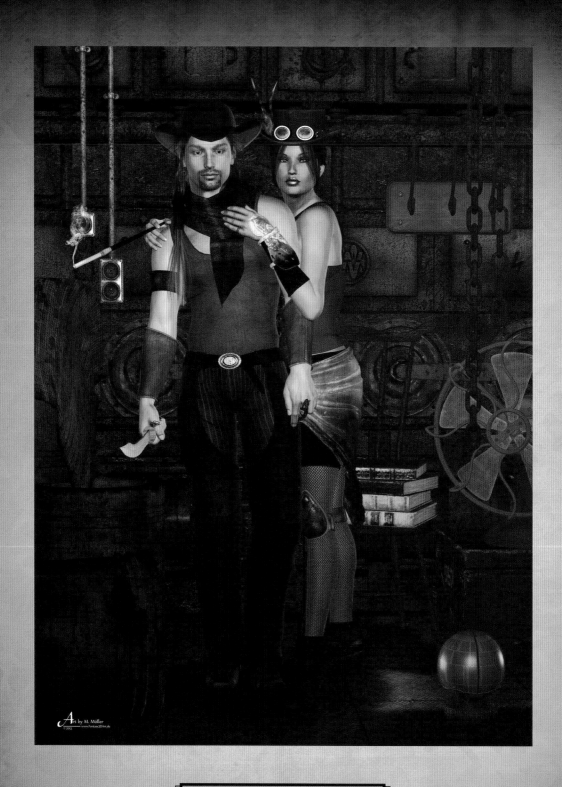

ABOVE: Steampunk Cowboys.
RIGHT: Your Choice.

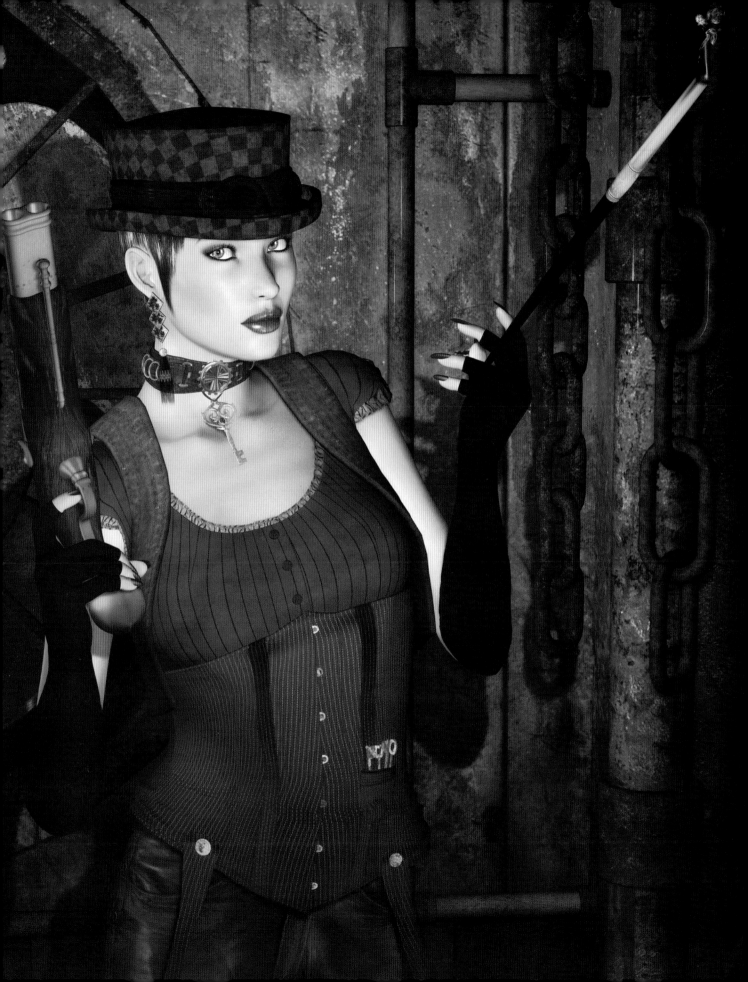

Kevin Mowrer

—◆—

Classically trained, with art degrees from the Cleveland Institute of Art in design, painting and silversmithing, Kevin has had an illustrious career both as a creative and as impressario. He ran Hasbro's R&D and started their entertainment division, The Fantasy Factory. As founder of The Tin Hat, he won two Emmies and a Gemini. Today, from Providence, Rhode Island, he runs Mowrer LLC, a company doing Meta-story© consulting for some of the world's biggest entertainment companies, including Dreamworks Animation, DC Comics and Warner Games. "They come to me," says Kevin, "because I am a thought-leader in the field of how and why audiences use stories in their lives." Becoming an artist was a natural progression for Kevin. "The big shift came when I began posting work openly. That's when the steampunk side of my art took off." Most of the images Kevin creates are part of a larger story. "My visuals are mostly narrative. For my steampunk work the driving theme involves Frahnknshtyne, a brilliant young student pulled from the industrial slums to attend a prestigious college controlled by The Sheperds (individuals made immortal by ingesting Aether). It's a work in progress." Kevin has been a steampunk artist since before the term was coined. "I love fantasy stories, illustrations and machines. I illustrate as well as write. Steampunk is where all these things come together for me." Kevin acknowledges the influence of other artists. "The classical artists amaze me with their control of light; Odd Nerdrum's work is intriguing; Kris Kuksi's sculptures are amazing; Vadim Voitekhovitch does stunning steampunk work; the motorcycle and watch designs by Chicara are remarkable. I am also a huge fan of the recent Sherlock Holmes movies – great sense of place and great fun!"

RIGHT: *Gabriel Thorne, Pinkerton Detective.*
Traditional media and digital.

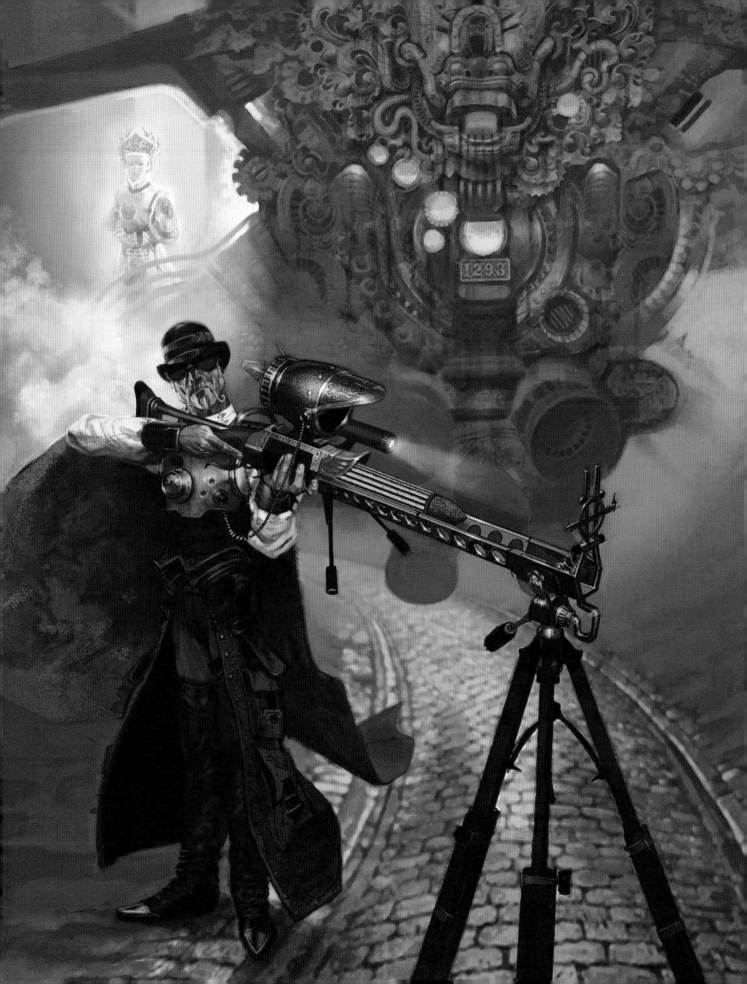

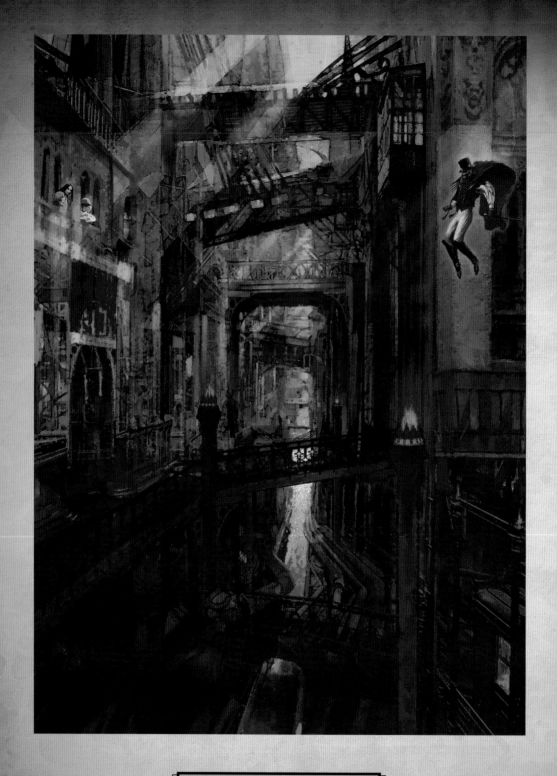

ABOVE: *The Slums of Travaille.*
Traditional media and digital.
RIGHT: *Vyctor's Motorcycle.*
Traditional media and digital.

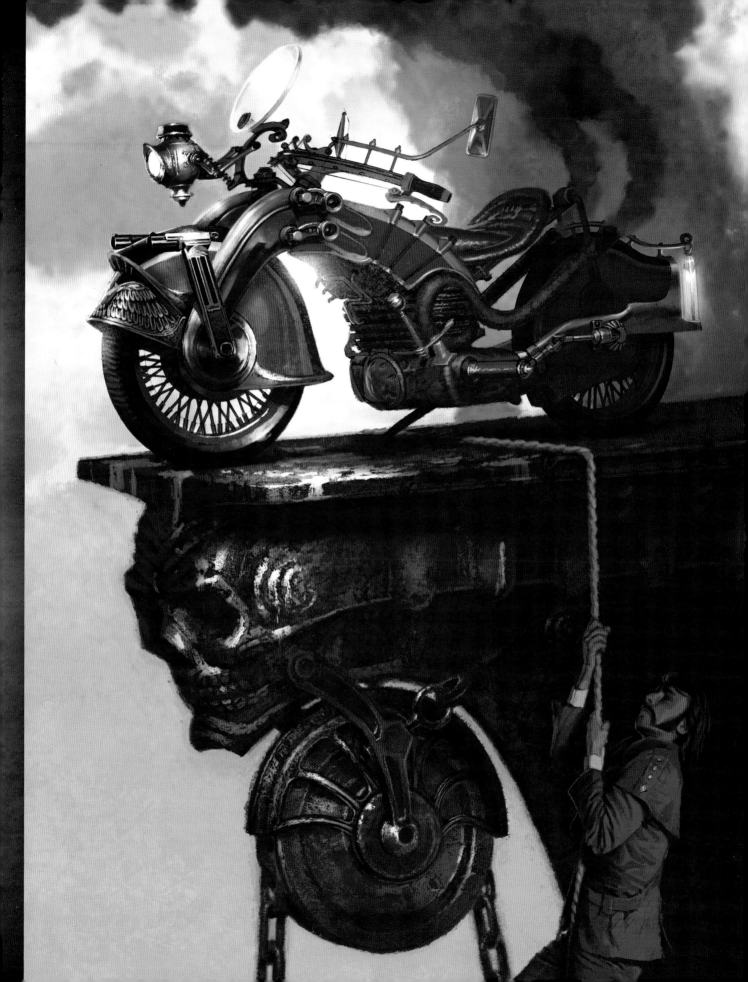

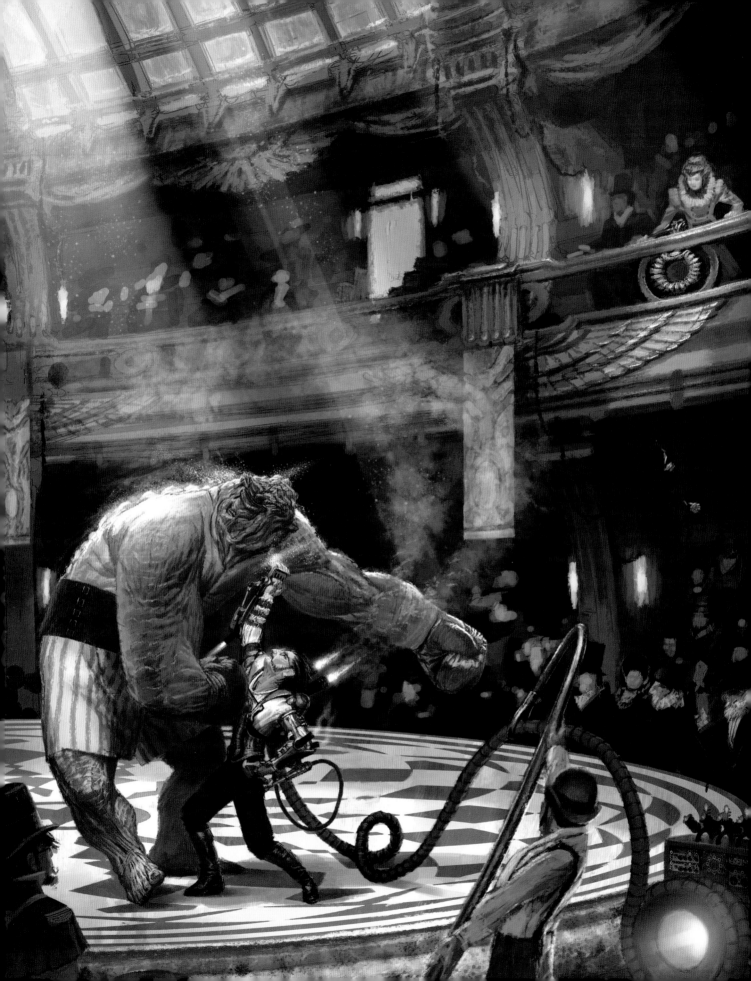

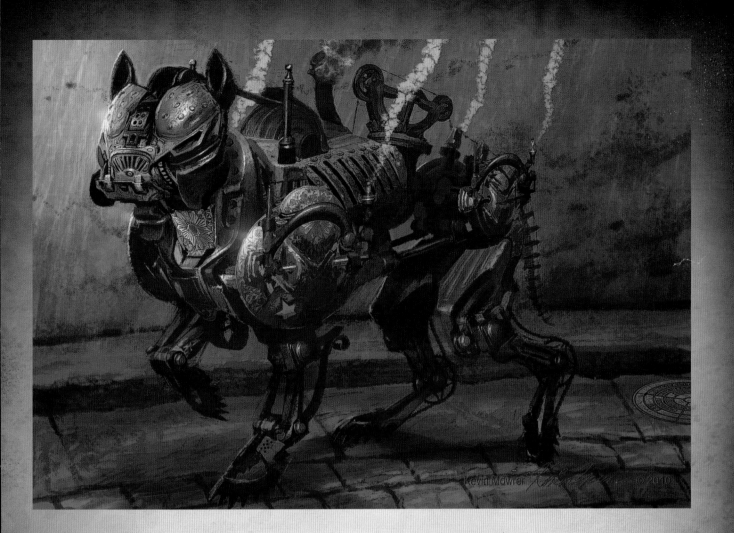

LEFT: *Fighting Golath, the Aether Giant.*
Traditional media and digital.
ABOVE: *Mechanical Baskerville Hunter.*
Pencil and digital.

AETHER RIFLE

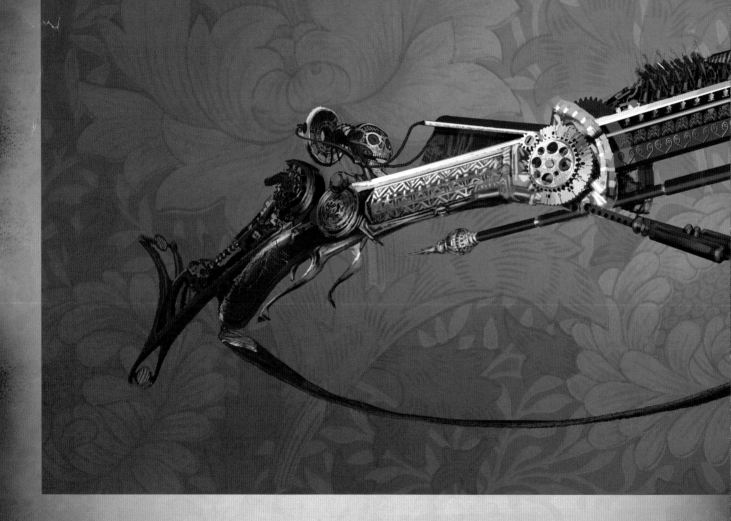

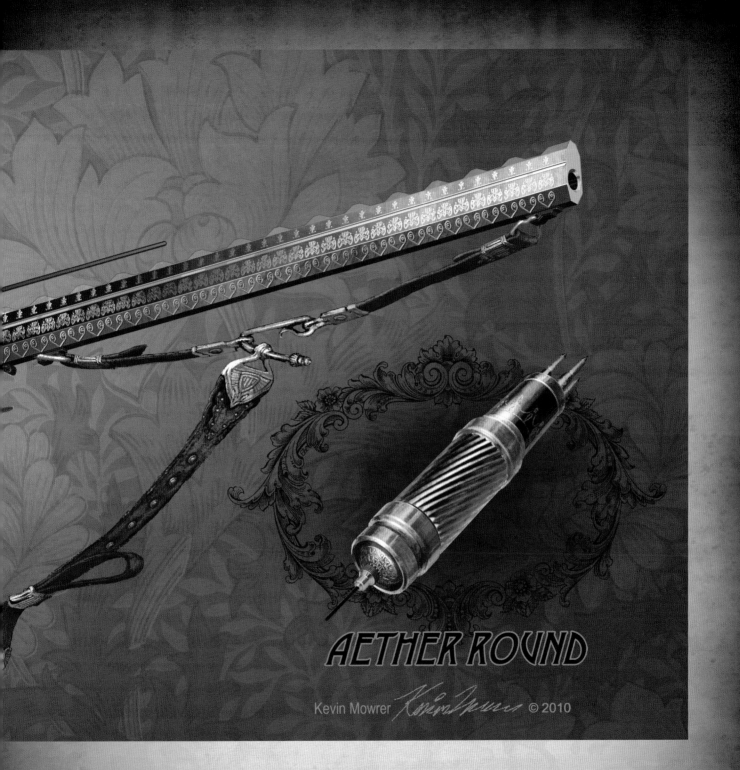

AETHER ROUND

Kevin Mowrer © 2010

ABOVE: *Aether Assassin's Rifle.*

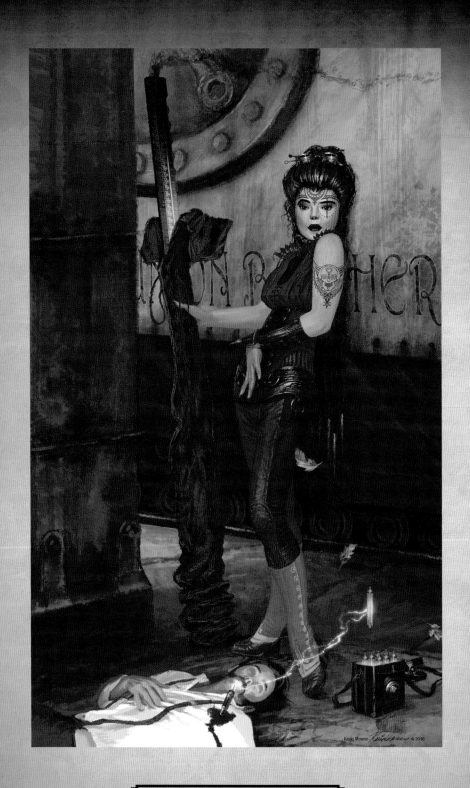

ABOVE: *Lacette, the Aether Assassin.*
Traditional media and digital.
RIGHT: *The Inspector/Gendarme.*
Traditional media and digital.

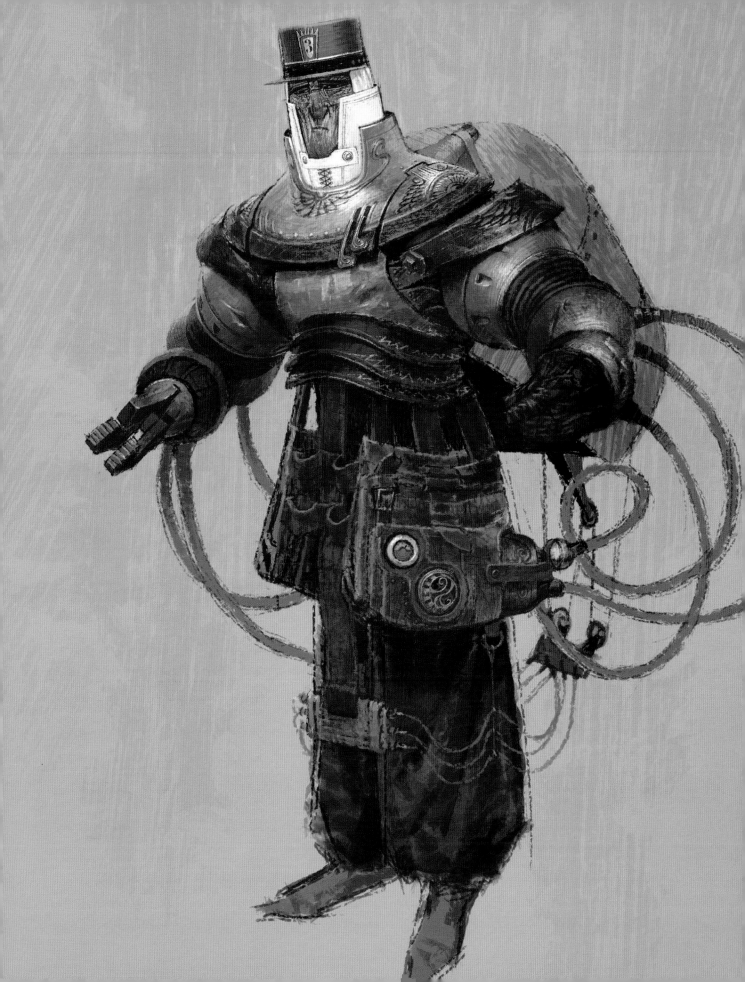

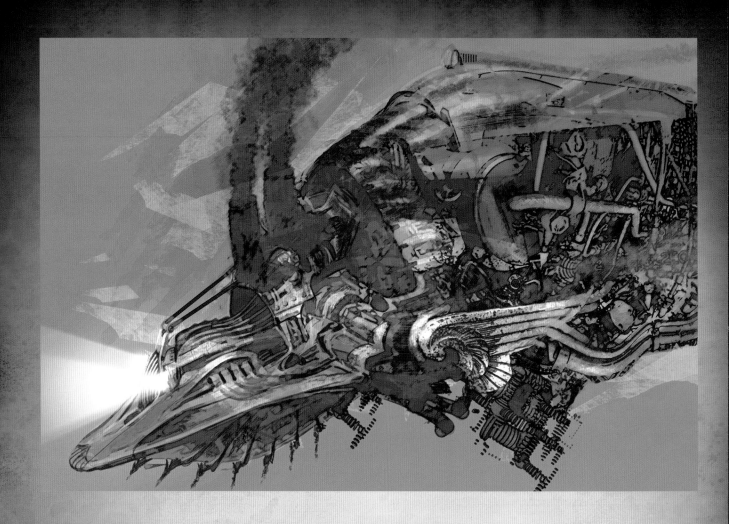

ABOVE: *Aether Air Car.*
Pencil and digital.

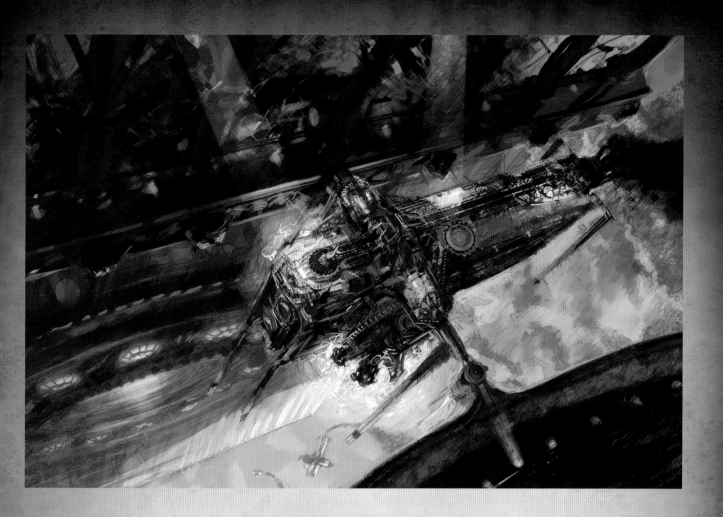

Kazuhiko Nakamura

Kazuhiko, (a.k.a. Almacan), was influenced by surrealism early on. When he started studying art at the Osaka Design School, he engaged in a quest to establish his own style. "I worked my way through drawing, painting in acrylics and collage. I then explored motifs which I had loved as a boy: armoured insects, shells, castles, old machinery. It became a passion to reconstruct these memories in a CG environment." On graduating he moved to Kawasaki-shi, where he joined the interior design company for which he still works, creating his personal art in slow steps in his spare time. "It's a Jekyll and Hyde existence." Finding that there were few opportunities to show his astonishing creations in Japan, Kazuhiko began submitting his work to 3-D art sites in the US and Europe. He received a fantastic response and is now widely published in numerous books and magazines. Kazuhiko draws on many sources in the creation of a work. For *The Tower of Beetle*, he was influenced by German expressionism, and the peculiar characters in the movies *The Cabinet of Dr Caligari* and *Nosferatu*. The hat, a tower of babel, is reminiscent of the Bruegel painting. "The theme," he says, "is scientific delusions of grandeur." Kazuhiko also admires Ernst Fuchs and H.R. Giger, French movie *The City of Lost Children* and the computer game *Riven: The Sequel to Myst*. His work was described as being steampunk before he knew the term. Today he has a specific take on the genre. "I seek to convey the strange fantasy characteristics of machinery, but also the human sorrow that comes from co-existing with these machines."

RIGHT: *Antlion.*

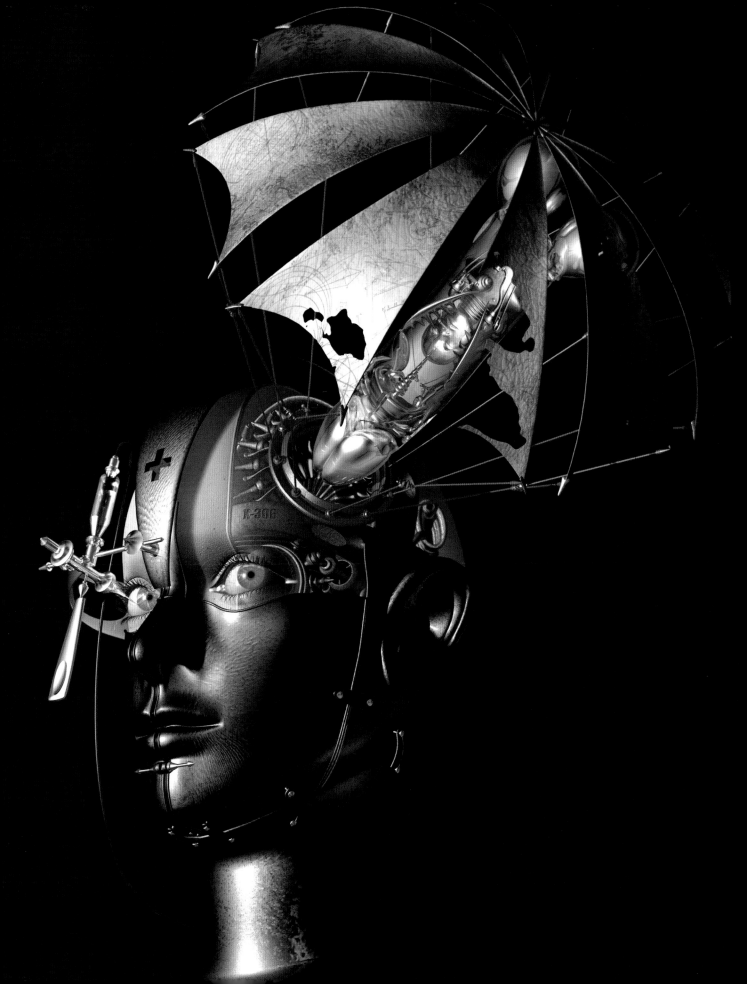

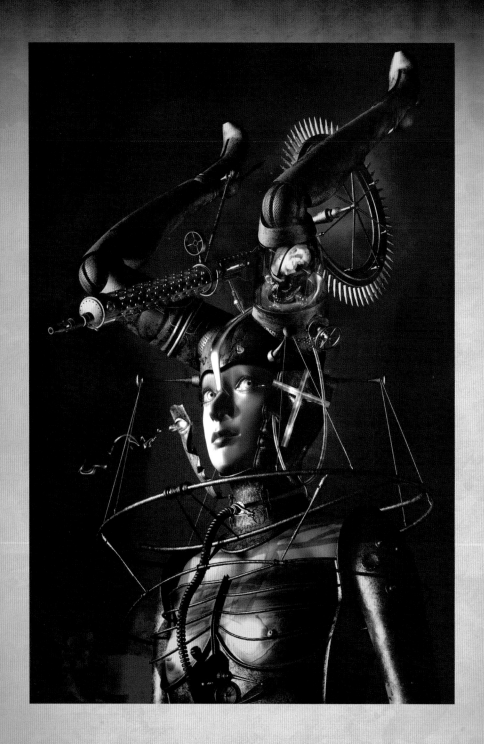

ABOVE: *Shelldarkness.*
RIGHT: *Zygosis*

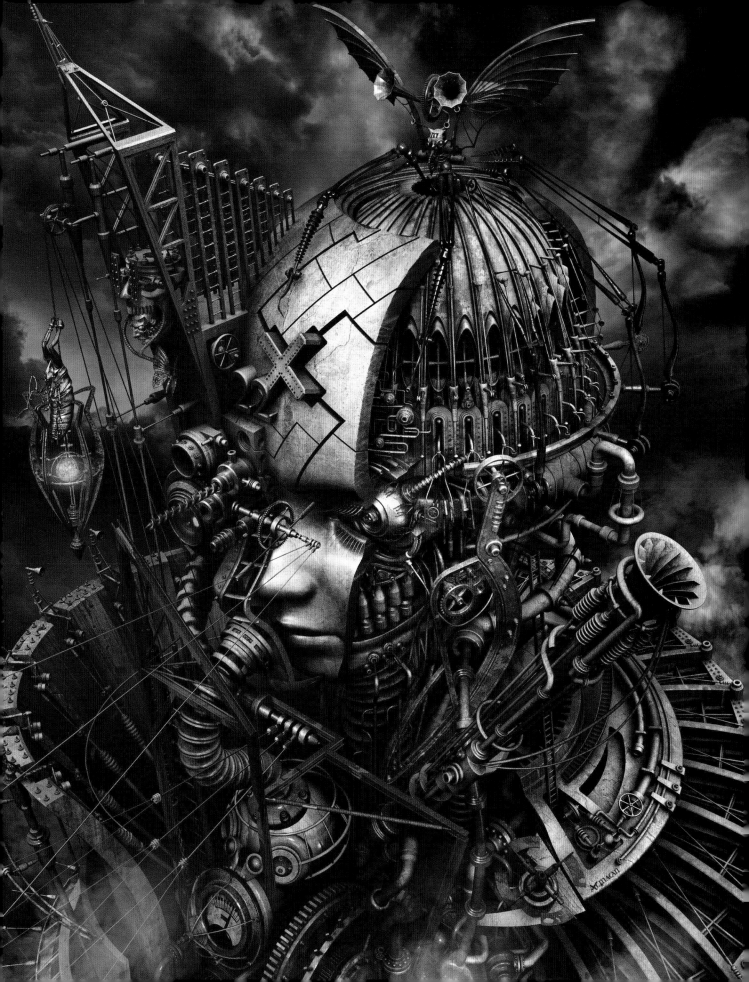

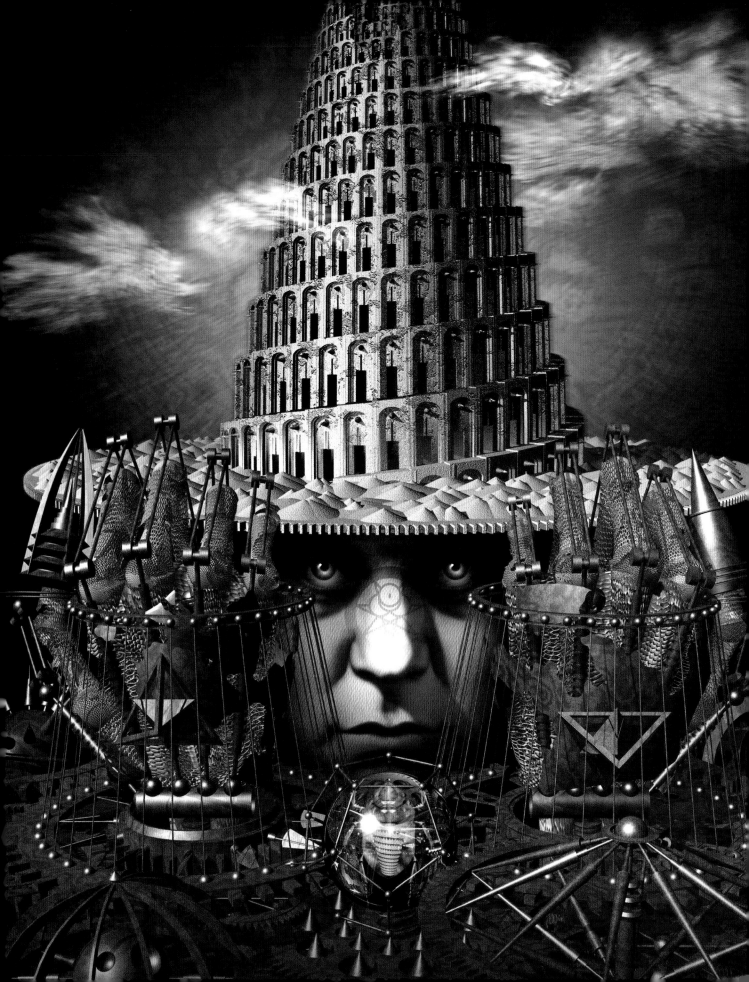

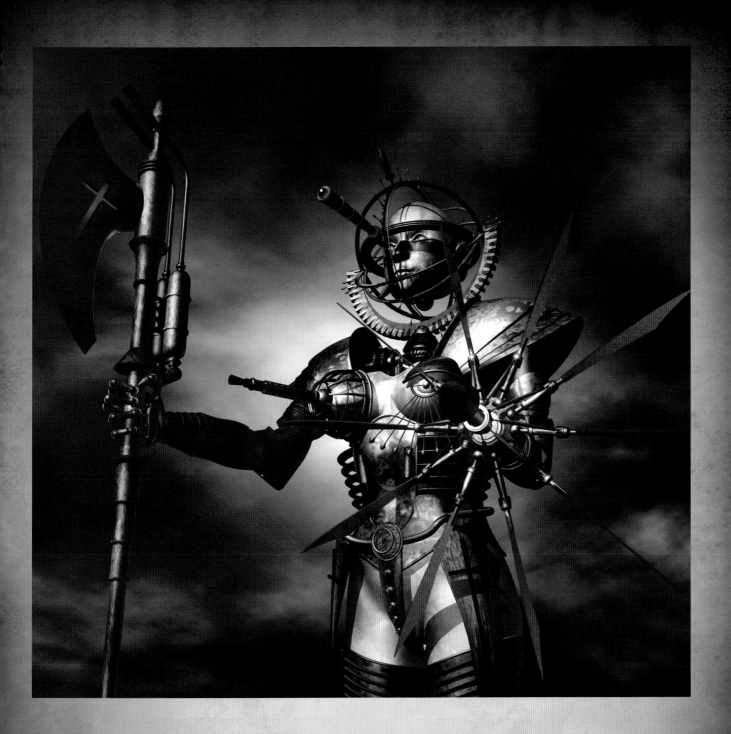

LEFT: *The Tower of Beetle.*
ABOVE: *The Armed Maiden.*

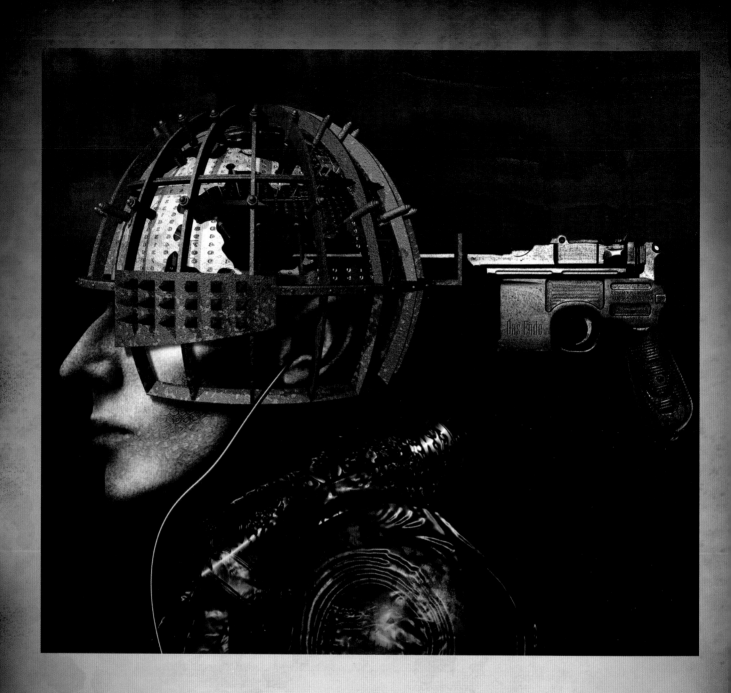

ABOVE: *Headdead.*
RIGHT: *Metamorphosis.*

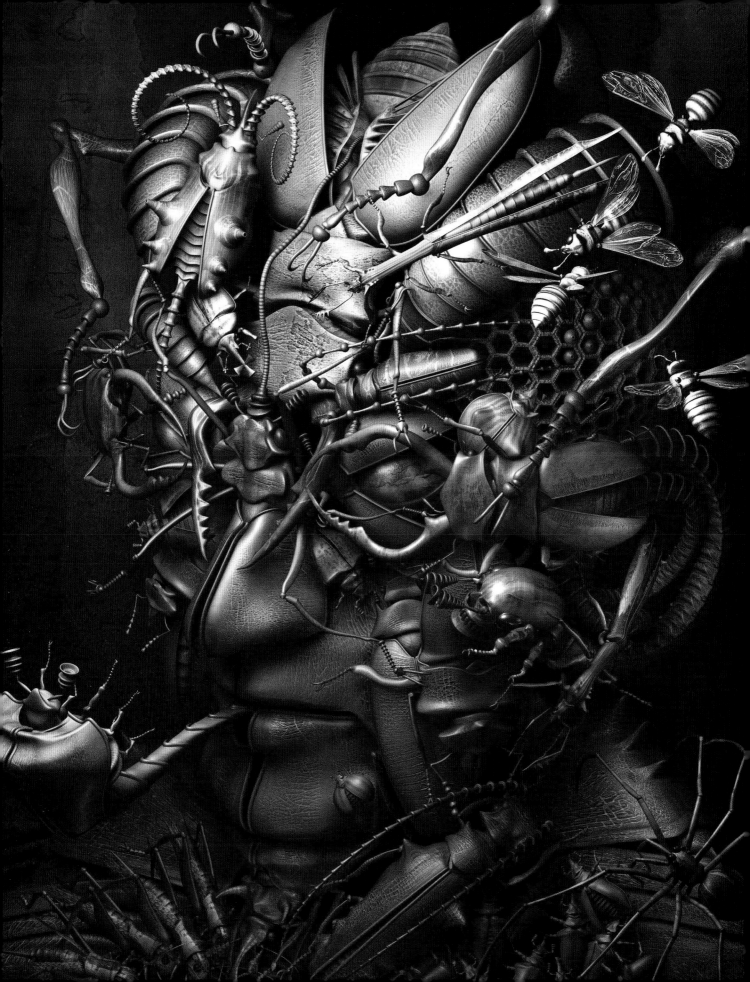

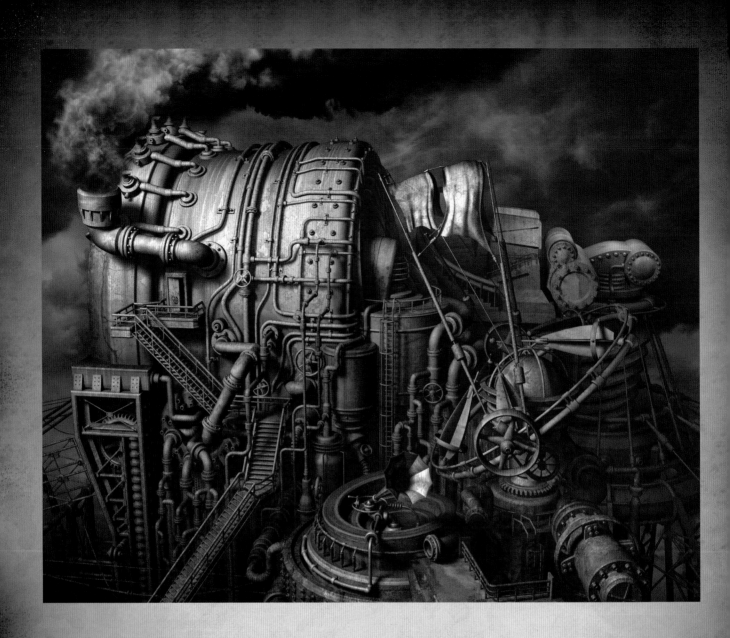

ABOVE: *Requiem for Industry.*
RIGHT: *Monorogue.*

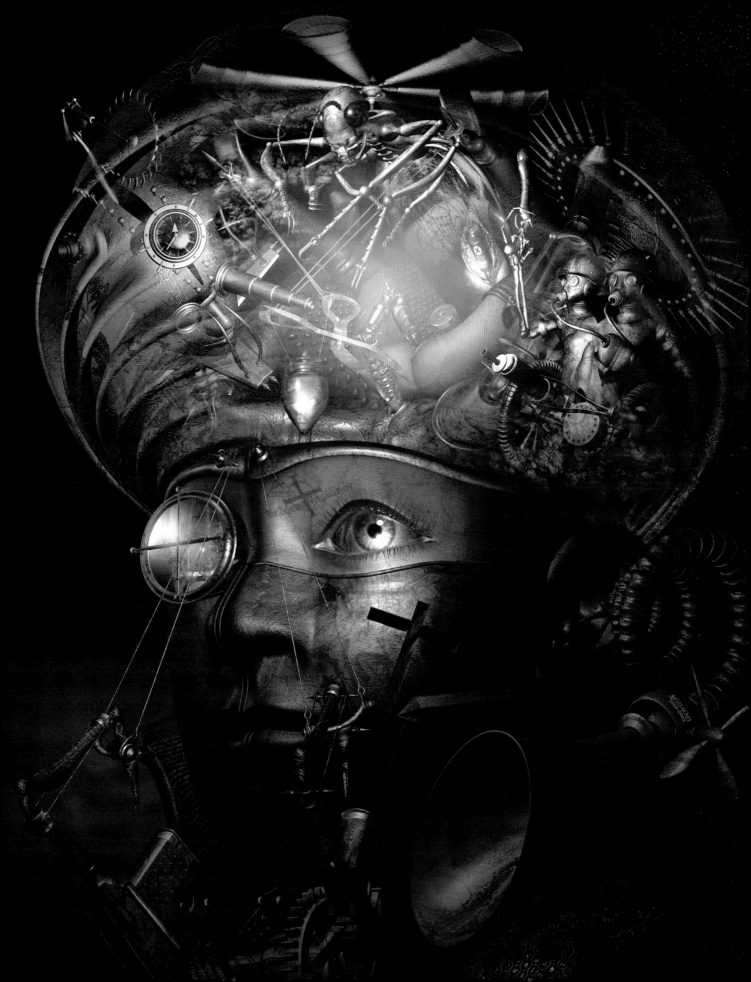

James Ng

Born in Hong Kong, James Ng (pronounced "ing") now travels between the former British colony and Vancouver, Chicago and New York, working as a concept artist and illustrator. "Travelling has been great for my work, inspiring me to combine Eastern and Western visual cultures." As a kid James spent all his free time drawing, usually monsters and robots, even though his ambition was to become a soccer player. "Then, as I got older I realised I really sucked at soccer, so it was natural I should go to art school." His art was labelled as 'Chinese Steampunk' when he first posted work online. He hadn't heard the term, so he googled 'steampunk' and fell in love with the imagery. James got the idea for *Imperial Steam and Light*, the series of images featured here, when pondering the way in which Hong Kong was becoming Westernized. "China has only itself to blame for falling behind, by signing unfair trade treaties, whilst the West grew ever stronger. Now, when cities like Hong Kong become more modern they are essentially becoming more Western. I began to wonder, what if Chinese culture had been the first to modernise during the turn of the last century? What would that look like? These images are the result." Most of James's clients are from the games industry or book publishers. He has exhibited extensively, in New York, Lecce (Italy), London, Seattle, Santa Clara, Vancouver and at the International Steampunk Exhibition in Seoul, South Korea.

RIGHT: *Immortal Empress.*
Inspired by Qing Dynasty Dowager Empress Cixi.
Pencil, charcoal, ink and digital.

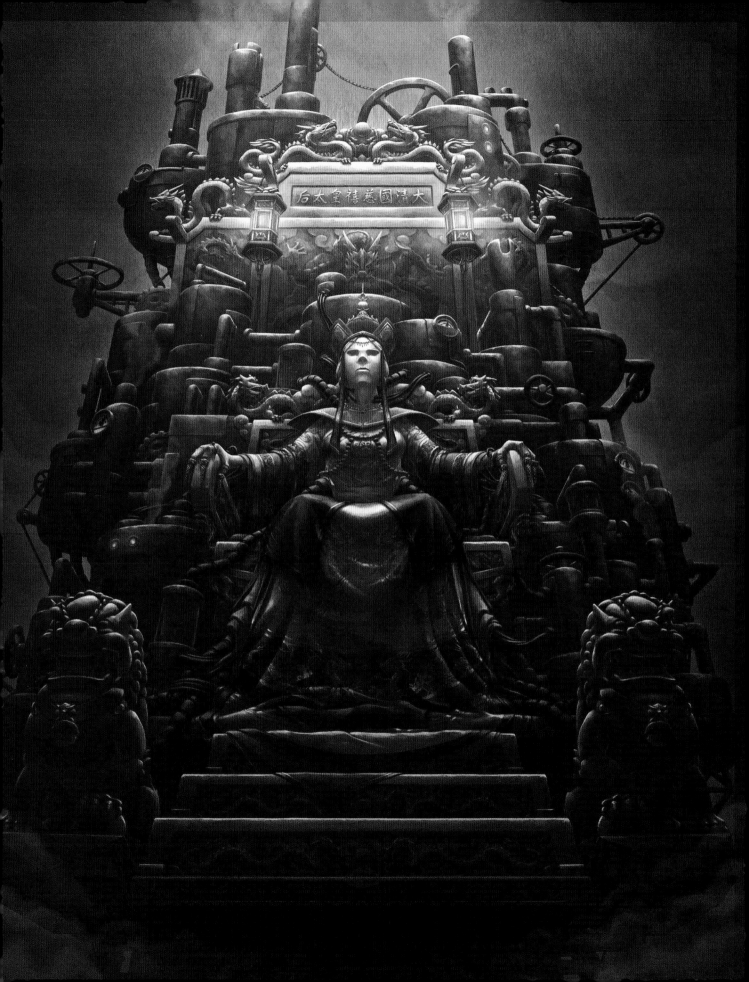

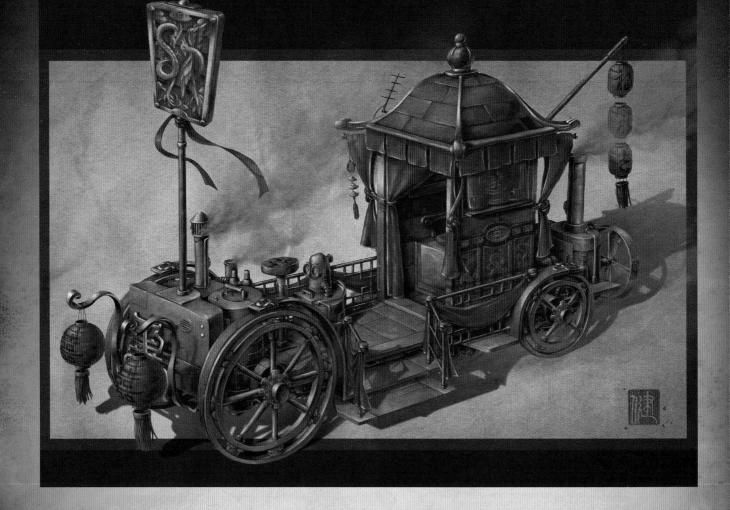

ABOVE: *Bridal Carriage.*
Steam-powered to ensure safe carriage of bride to the groom's home.
Pencil, charcoal, ink and digital.

RIGHT: *Harvester.*
A mix between tractor, robot and other tools. The ultimate farming solution.
Pencil, charcoal, ink and digital.

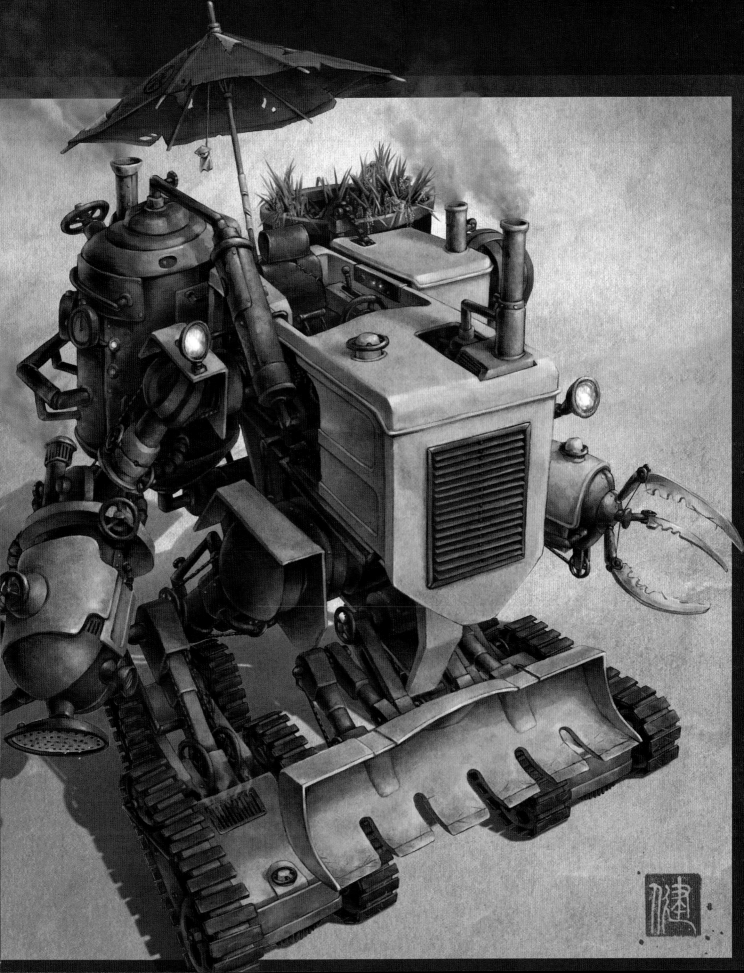

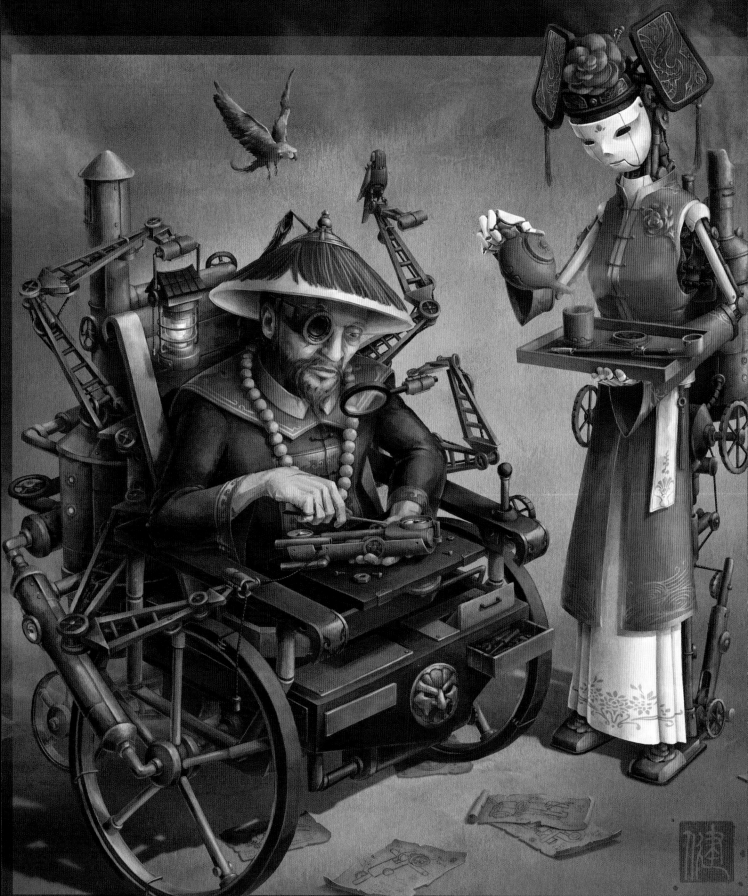

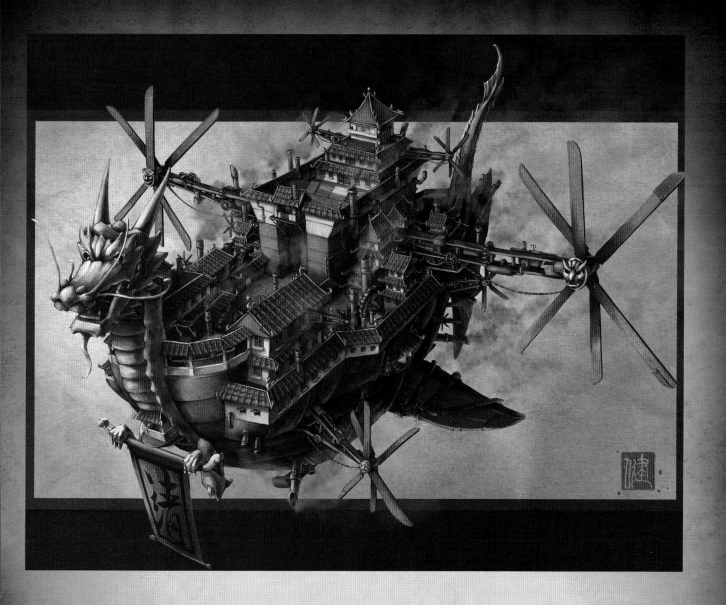

LEFT: *Imperial Inventor.*
The inventor works exclusively for the Imperial family.
Pencil, charcoal, ink and digital.
ABOVE: *Imperial Airship.*
The Empress's personal transport. Generates massive pollution in its path,
showing the power of the Imperial family.
Pencil, charcoal, ink and digital.

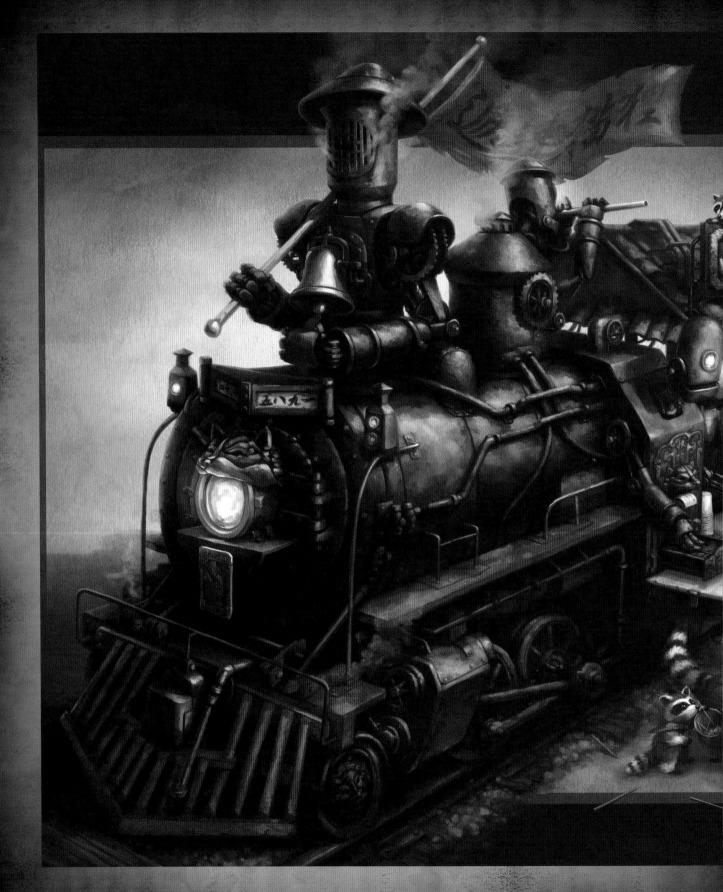

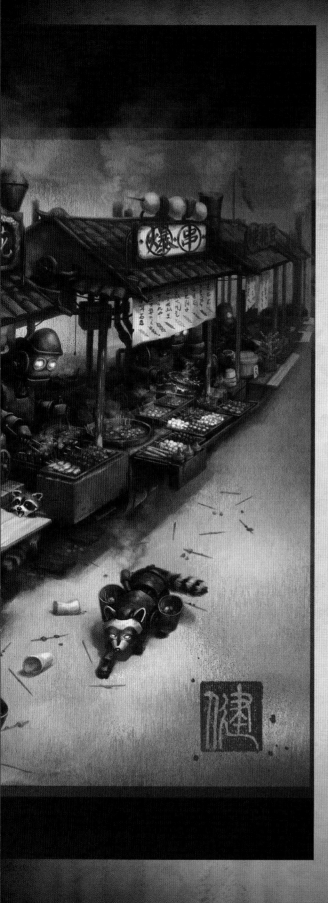

LEFT: *Raccoon Express.*
A famous attraction in the Imperial city, combining steam
ingenuity and street food. The raccoons trail the express,
cleaning up any food scraps.
Pencil, charcoal, ink and digital.

Mike Penn

"It was seeing the work of Frank Frazetta as a teenager that made me realise I wanted to be a fantasy artist. Steampunk came along later, but I've enjoyed the genre since before it had a name, watching re-runs of *Wild Wild West* as a kid." Born in Albuquerque, New Mexico, Mike moved around a lot as a kid, before returning in 2000. "I don't feel like moving again. Thanks to telecommuting, a digital freelance artist can exist almost anywhere now." After his kids were born he worked in advertising and graphic design, but his passion remained illustration. In 2013, he was made redundant, and was finally able to turn to illustration full-time. "I'm strictly digital now," he says of his technique, "I don't even sketch on paper." Mike has a clear picture of the end result before he starts an image – "I find the process of sketching a composition for a client a bit tedious. I much prefer to jump straight in. The initial idea can then change – art has a way of taking on a life of its own. You just have to let it evolve." In addition to Frazetta, Mike's influences include Ken Kelly, Joe Jusko and early Boris Vallejo. Amongst current digital artists, he admires the work of Marko Djurdjević, Ross Tran, Kekai Kotaki, Marta Dahlig and Daarken. Of steampunk Mike says "I get the feeling the genre is just exploding. There's a continued longing for simpler times and for an elegance which has been lost in the sterile present; and Webster's Dictionary recently added 'steampunk' to their work, so it's safe to say it isn't going anywhere soon."

RIGHT: *Wizard of Oz.*

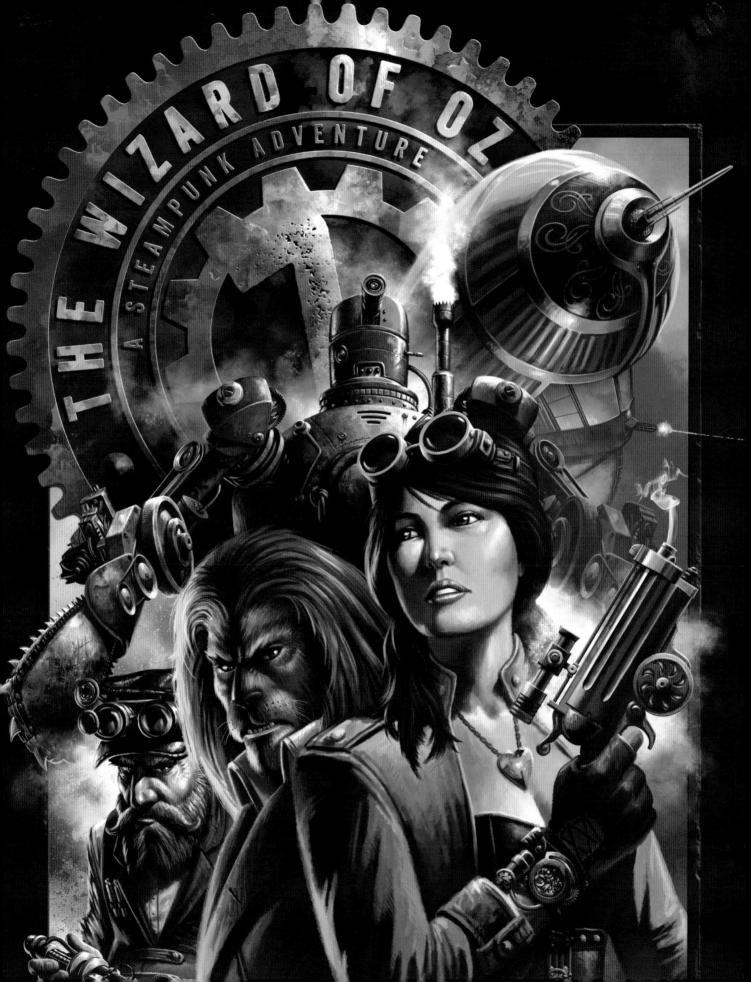

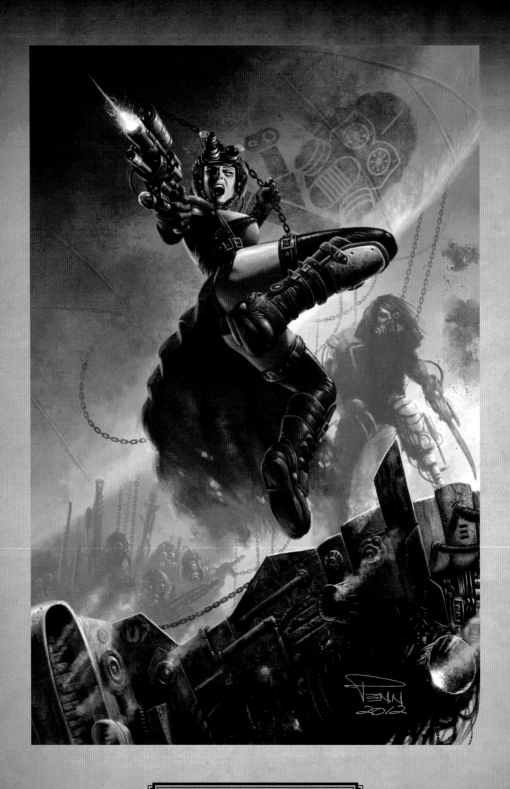

ABOVE: *Steampunk Pirates.*
RIGHT: *Steampunk Cowgirl.*

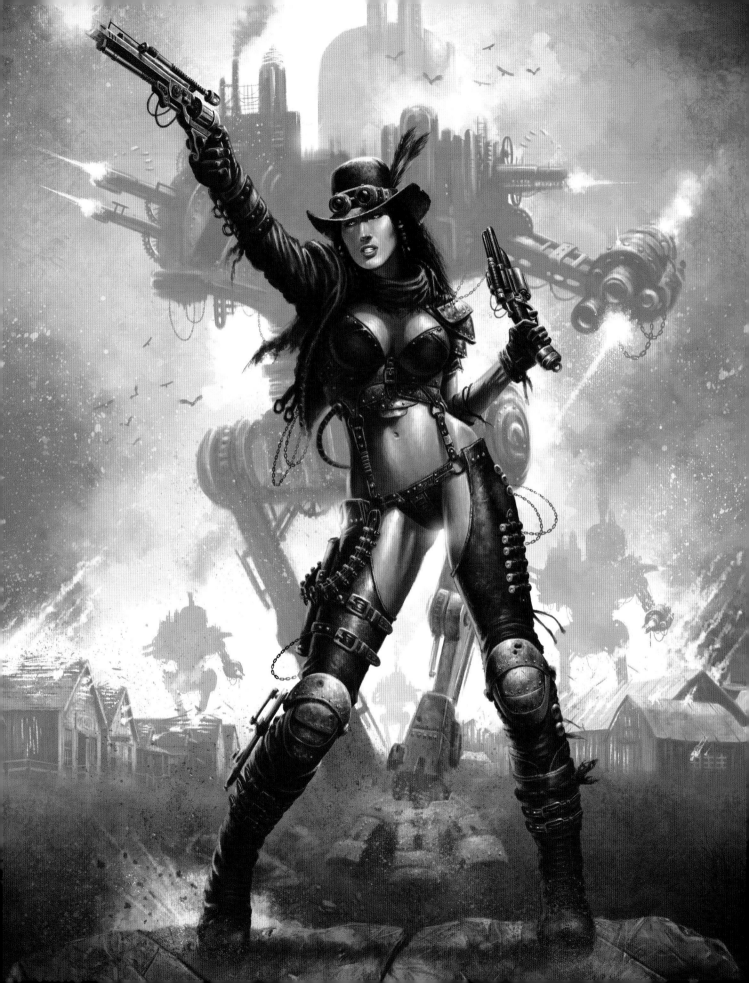

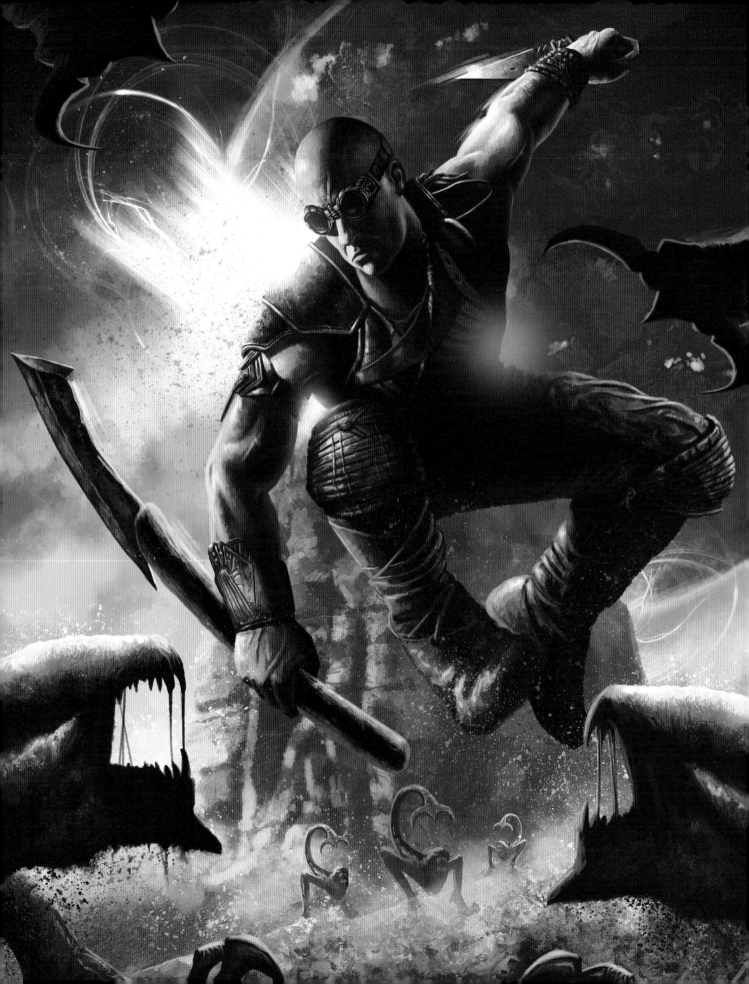

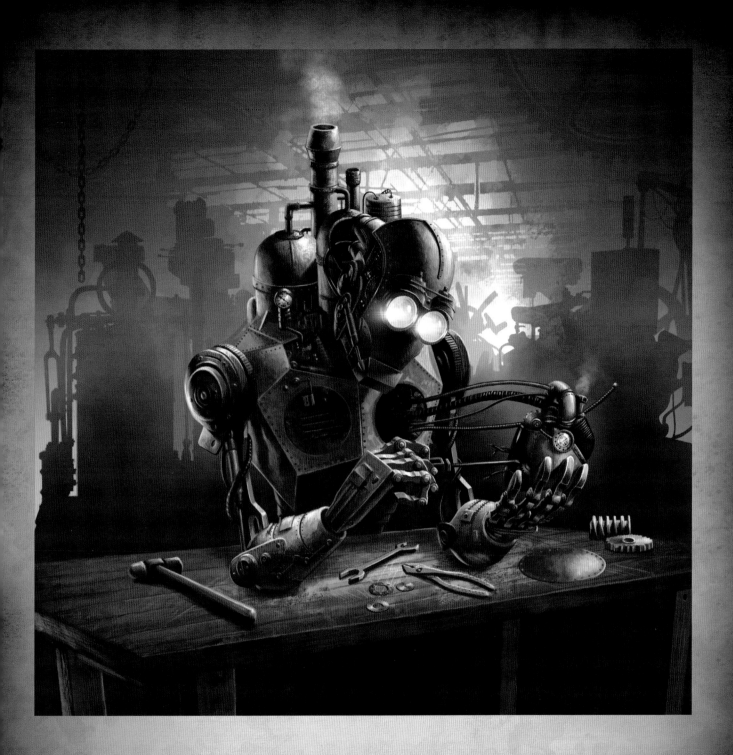

LEFT: *Monster Attack.*
ABOVE: *Altered Sky.*

Laurent Pierlot

Laurent's dad, an architect, enthused him with a love of the arts from a young age. His introduction to steampunk came from anime movies such as *Steamboy* and the movies of French directors Marc Caro and Jean-Pierre Jeunet. Laurent studied art in France, at ESAAT in Roubaix and Supinfocom in Valenciennes – "it was a great experience, I learnt a ton" – before moving to California, where he is now based. Laurent worked for a few years at Blur Studio, the visual effects and animation company, and is now with Blizzard Entertainment (creators of the *World of Warcraft* and *Diablo III* computer games). His steampunk works are therefore a spare time enthusiasm, often created for contests. His works share common themes. "Most of my images have the same unsettling, creepy atmosphere. It's a style that I like to explore. I will often design around mad scientists and fairies. One of my steampunk works featured a tooth fairy – that always struck me as creepy: a fairy that collects teeth!" He sees steampunk in a similar vein: "For me it's that perfect mix of organic creepy characters with old tech novelty machinery." Laurent's sources of inspiration are perhaps surprising. "I like the German expressionists like Egon Schiele, Gustav Klimt and, amongst classical artists, Caravaggio and the sculptor Bernini."

RIGHT: *Dreamscape.*

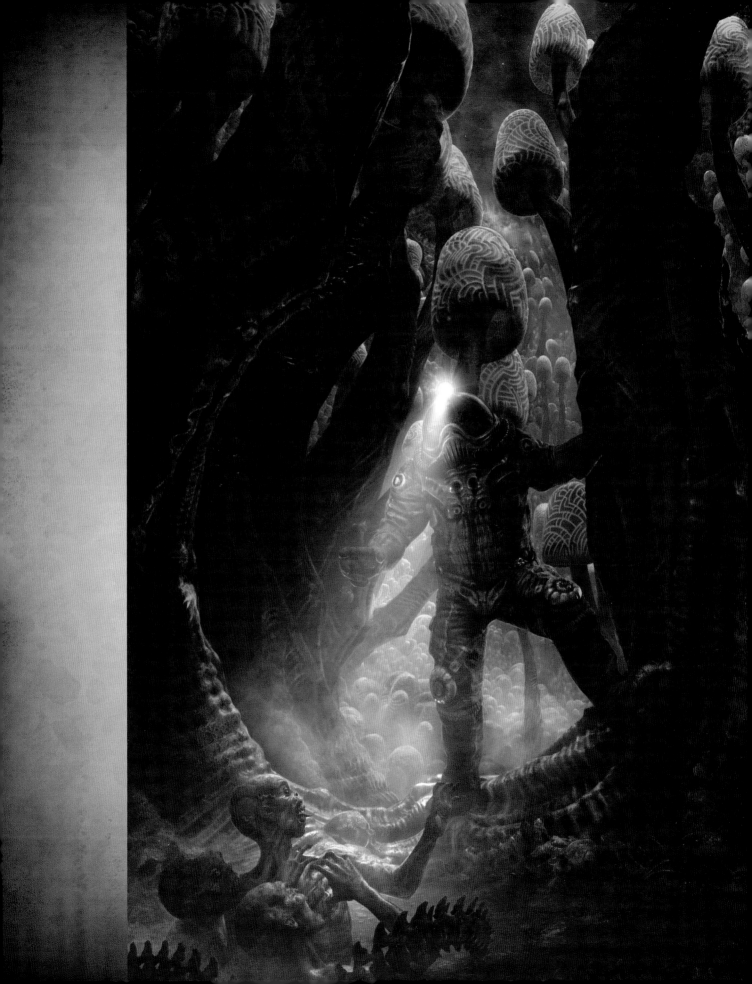

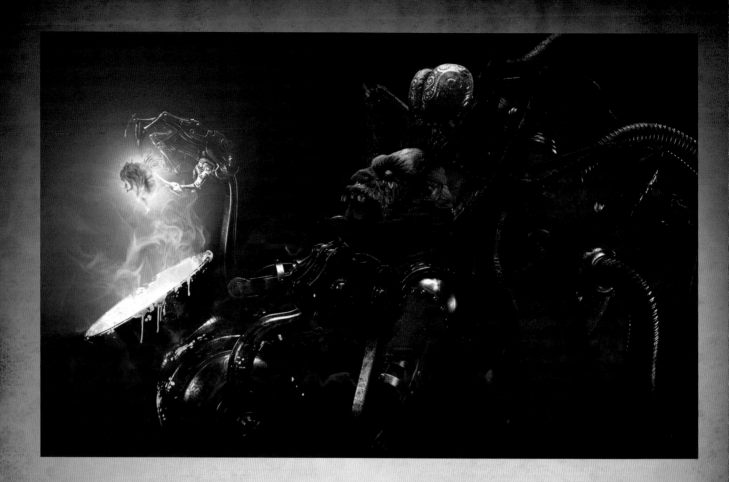

ABOVE: *Harvest.*

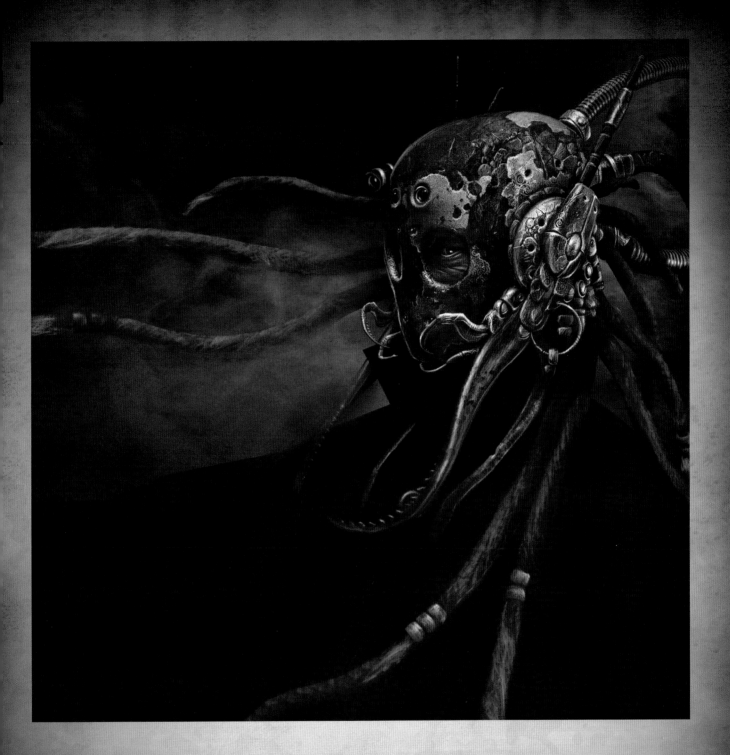

ABOVE: *Araignée.*

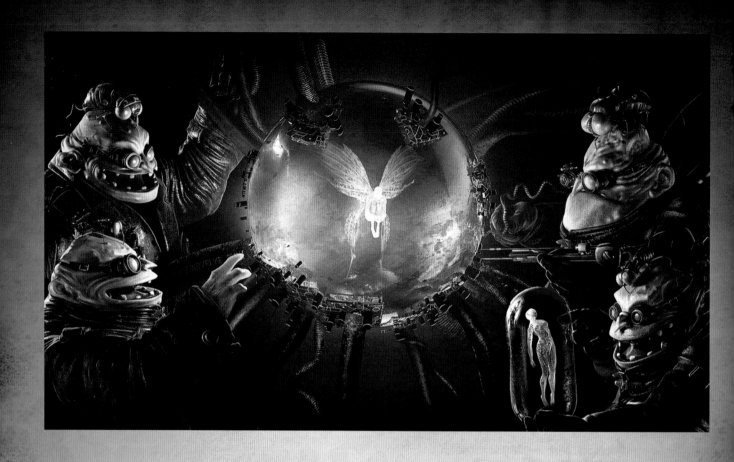

ABOVE: *Baektokado.*

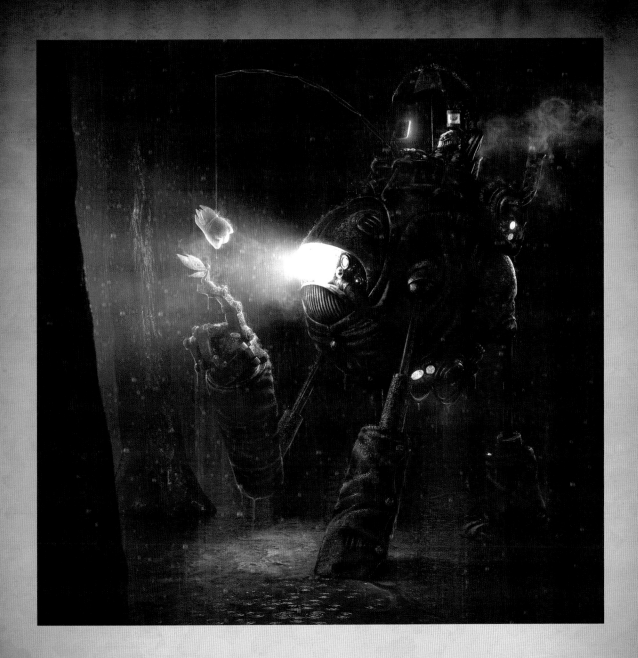

ABOVE: Steam Fairy.

Igor Rashkuev

For Rashkuev, a.k.a. Oxeren, steampunk "isn't really about steam or all those other typical Victorian traits, but a special feel – you know what it is when you see it, even though it's hard to grasp in words." He grew up in Siberia, in Novosibirsk – "it's quite a big city, one no one has really heard of" – and then studied applied mathematics and information science. "It was a wrong turn. I knew I wanted to study art. All the time I was studying I was dreaming about an art job and drawing in my free time." It all worked out okay in the end. Rashkuev is now based in St Petersburg, where he works for a video games company. He works in both 2-D and 3-D and both to commission and for pleasure. "I work mostly in digital. Occasionally I use pencil and ink, but probably not as often as I should." He continues to do extra-mural courses at a local art college. "It's a little half-hearted. I don't really know why I do it. I doubt the course really helps with much." Rather than having specific artists as sources of inspiration, Rashkuev skips around, always looking for new influences in "everyday life, music, games, whatever else. My favourite things change constantly."

RIGHT: *Astronaut Big Daddy.*
OVERLEAF: *Steamtank 6000.*

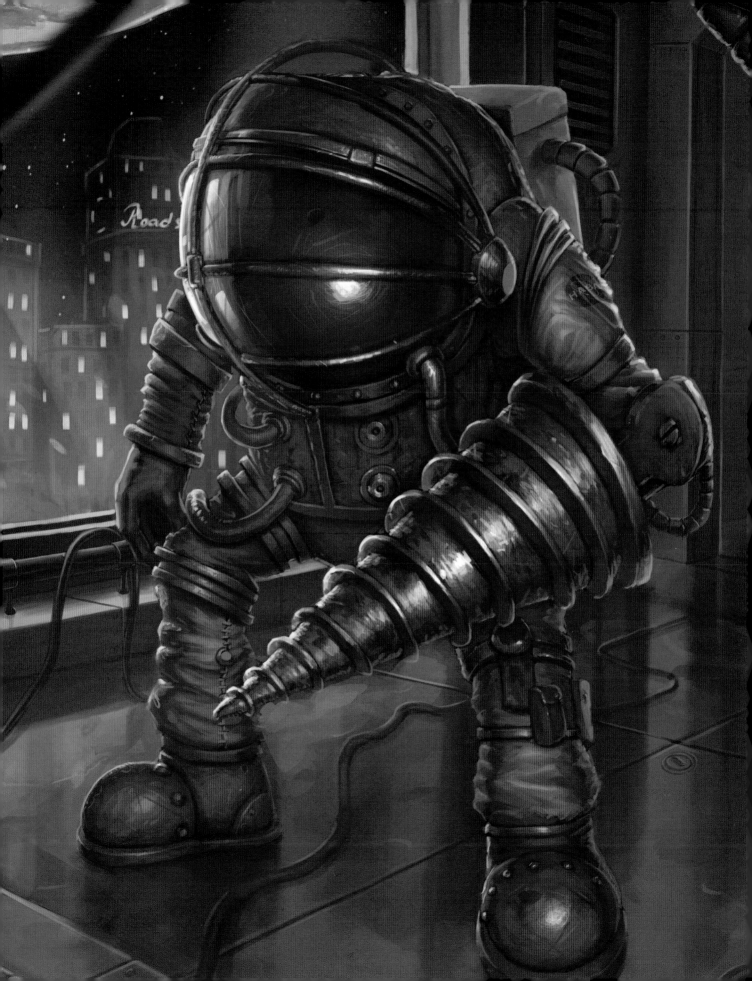

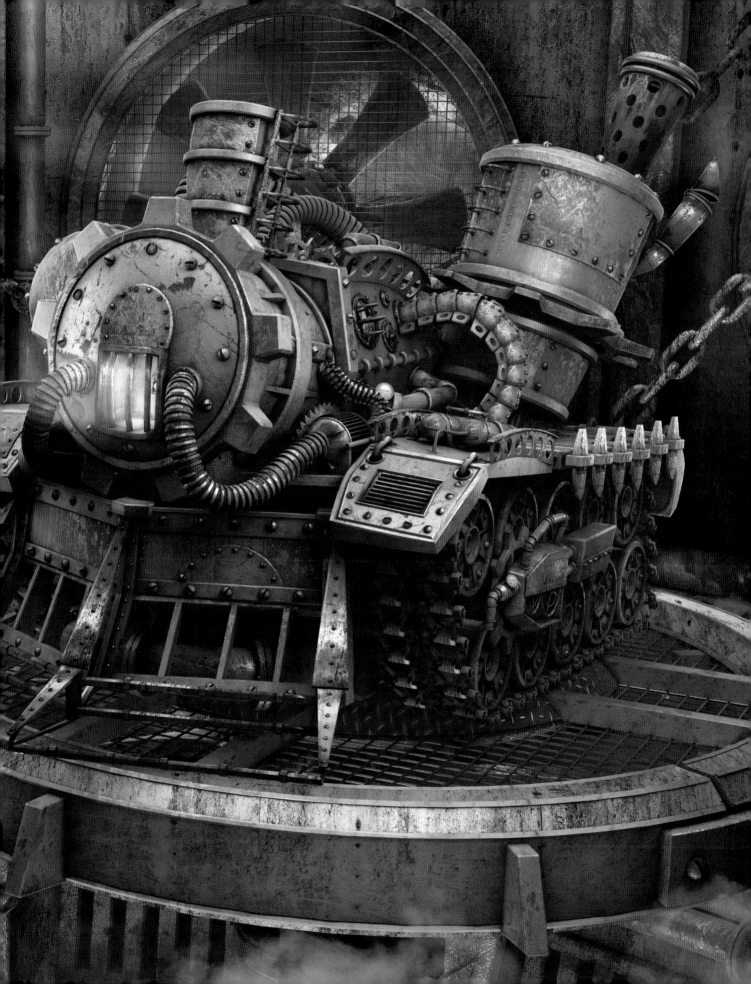

Redkidone

❖

Born in New Zealand, but now based in Bristol,
England, Redkidone, a.k.a. Matt Pitt, was inspired to
become an artist by watching *Star Wars* and other sci-fi
and fantasy films from the '80s. Reading *The Difference Engine*
by Bruce Stirling and William Gibson "showed me a 'fork'
in fictional history, where fantasy and sci-fi were combined.
From then on I was hooked." Matt studied design at Victoria
University, Wellington. Initially he thought he might become
an architect, then an industrial designer "until I realised I
was terrible at making things in the real world." He then
switched to animation and graphic design. "I was very lucky
to have a degree course that gave me so much latitude."
Currently working as an animator full-time, Matt creates
his steampunk works for himself. "Most of my steampunk
stuff now is for a passion-project: my animated web series
Nuut." Matt's two biggest artistic influences are, somewhat
surprisingly, Art Nouveau (particularly Mucha) and Japanese
art in general. His steampunk art is guided by his 'steampunk
laws of physics': "...where alternative sciences have developed
a superiority which is manifested mechanically. Steampunk is
a super-science which you can use a spanner and screwdriver
to mess with. Think of it as an inversion of Clarke's Law that
'any sufficiently advanced technology is indistinguishable
from magic'; in steampunk you see the pumps and levers that
make the magic happen." Matt loves another aspect of the
movement: "I am stunned by the incredible maker culture
out there, it's both heartening and impressive."

RIGHT: *Edge of the Map.*
OVERLEAF: *Incursion.*

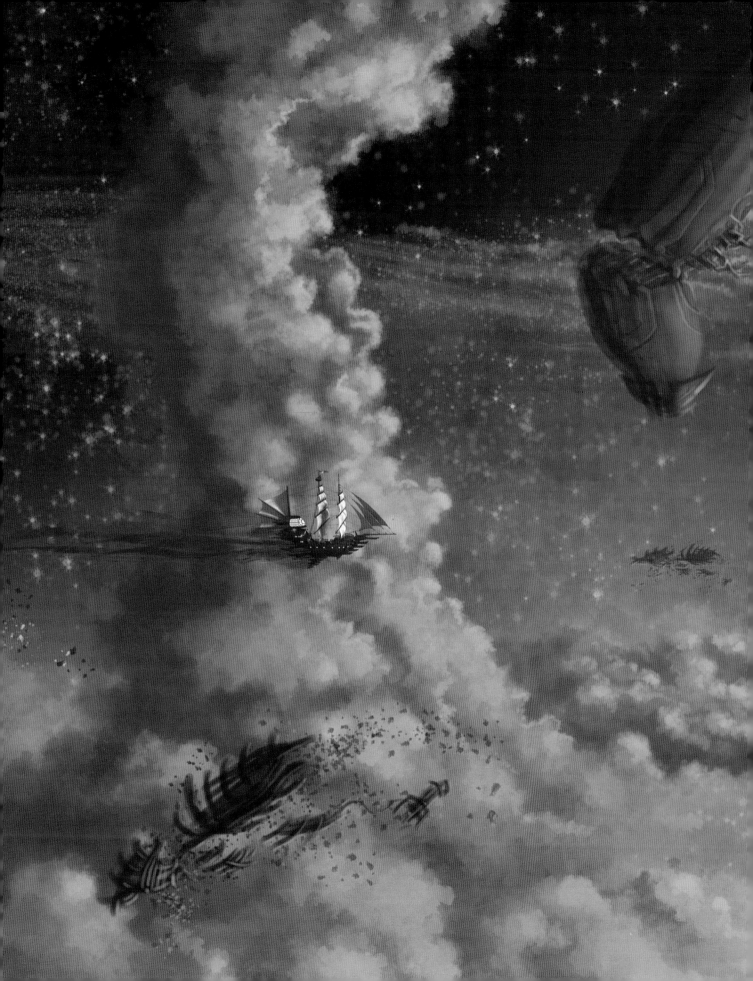

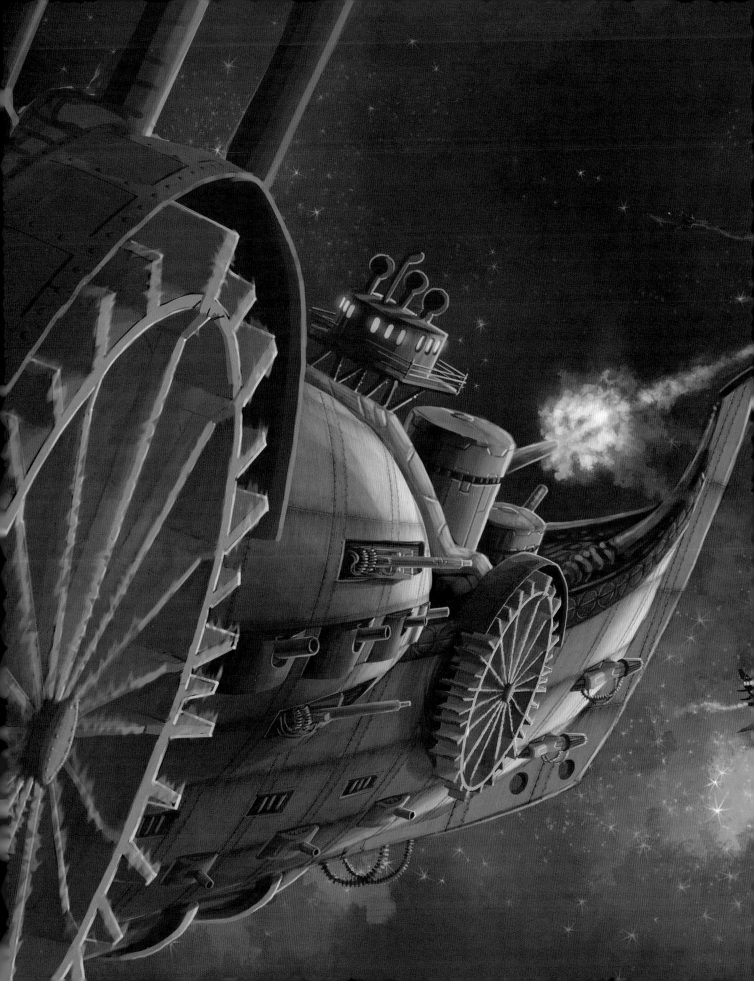

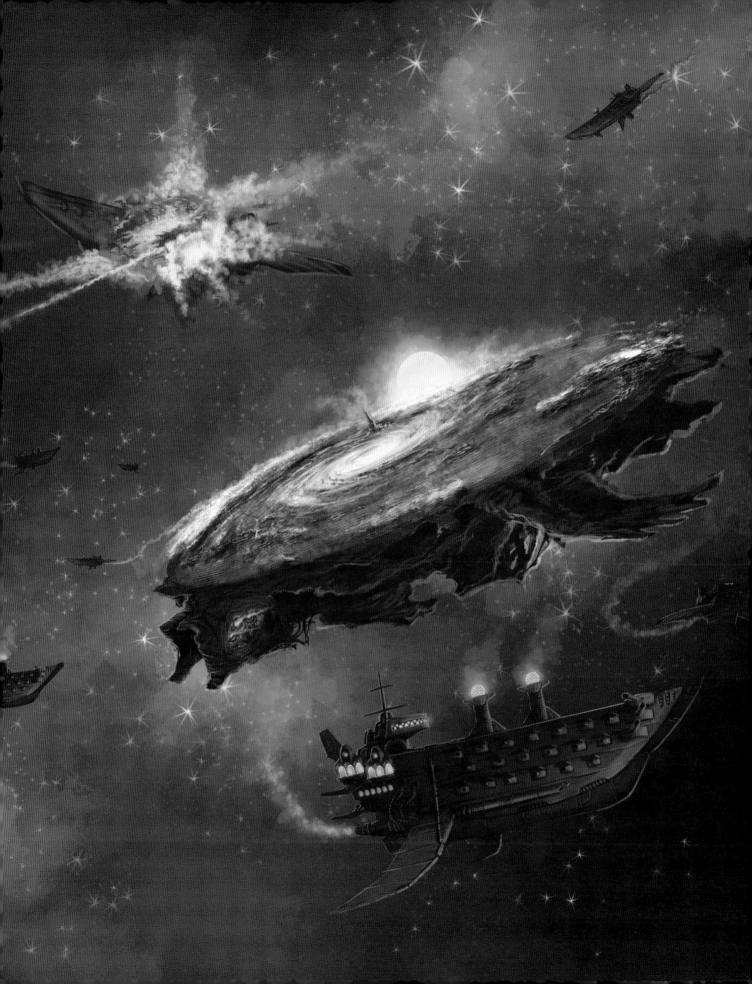

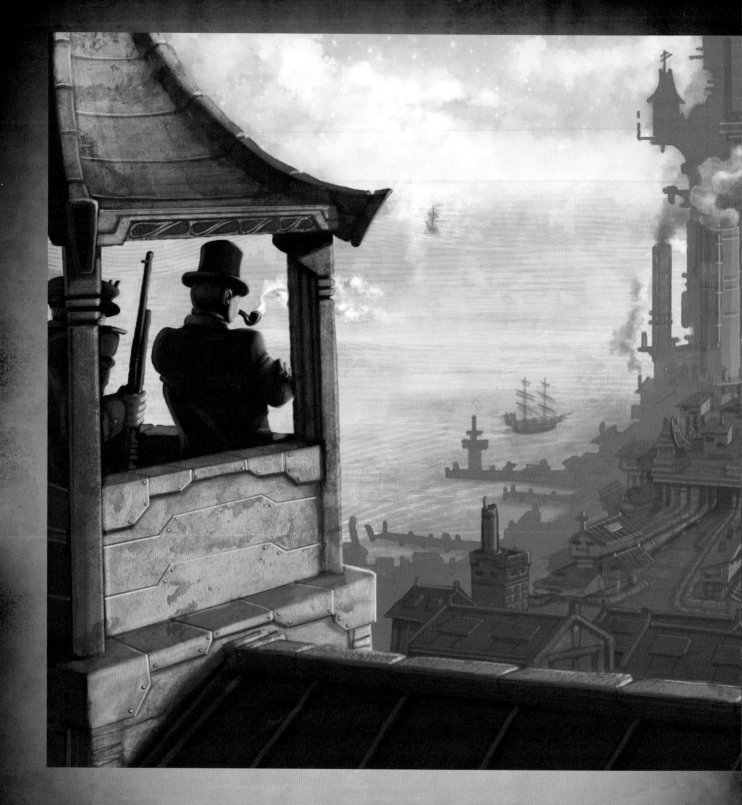

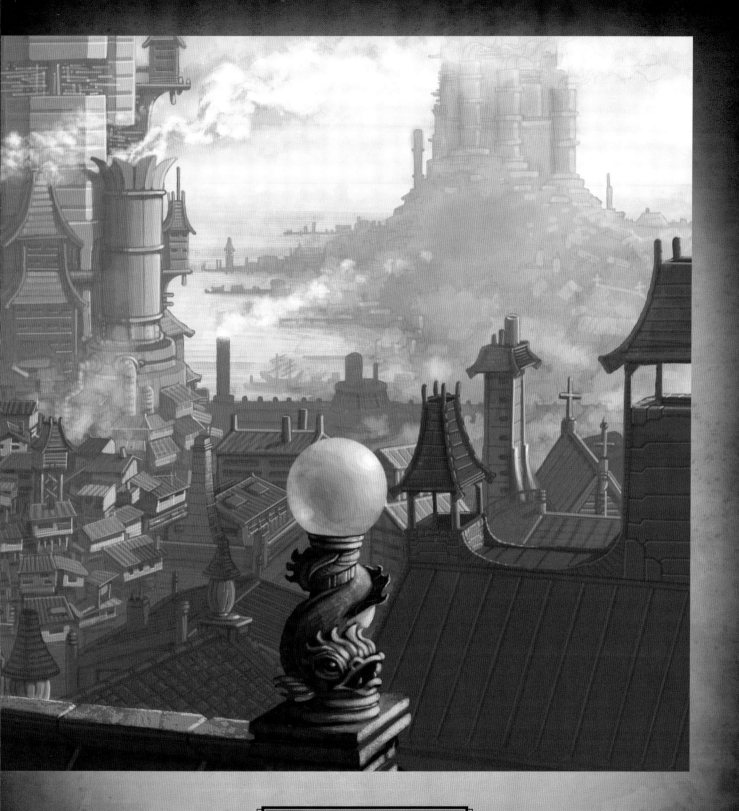

ABOVE: Dignity.

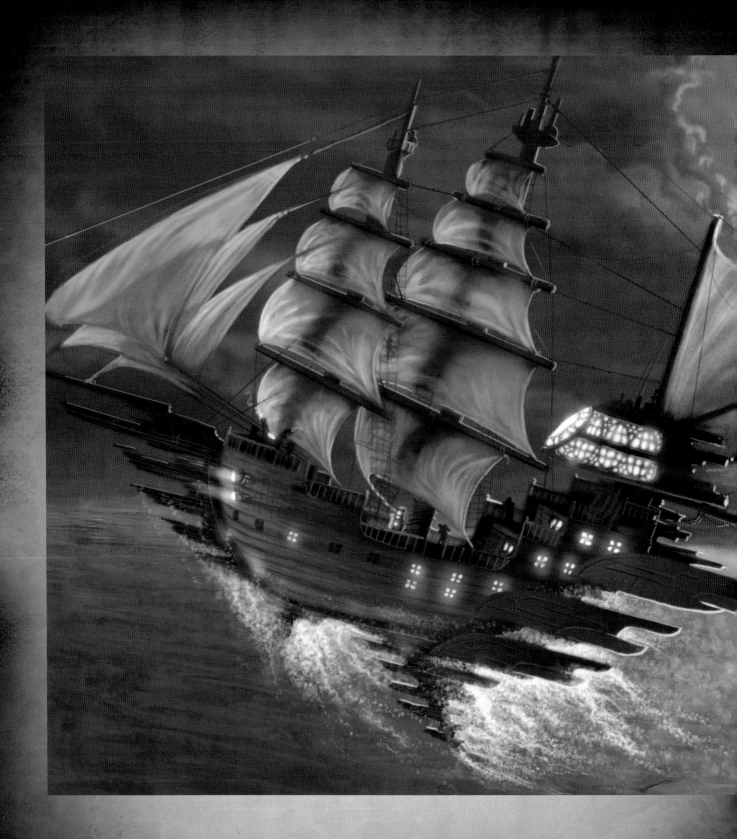

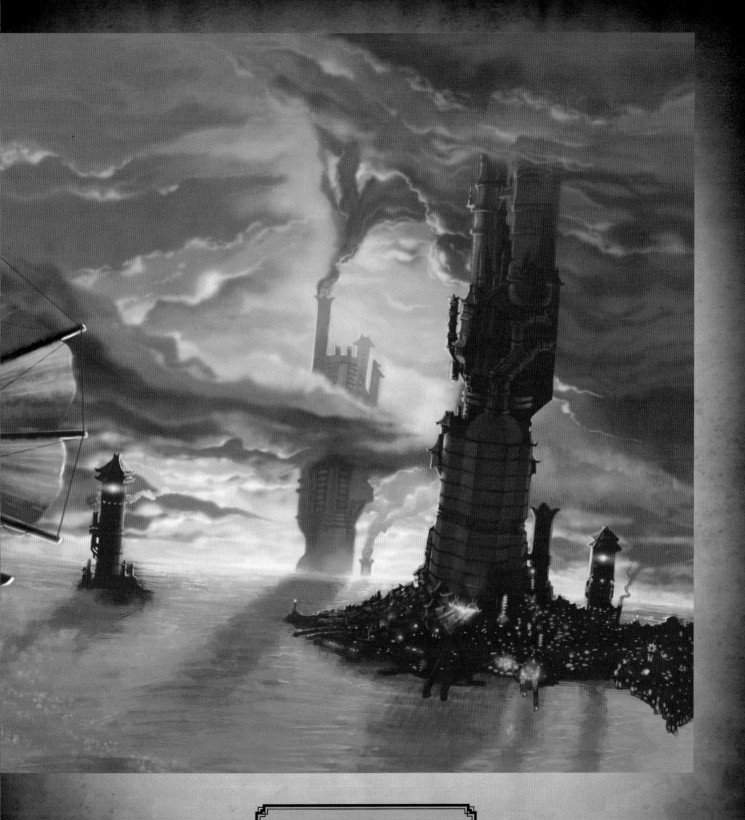

ABOVE: *Voyage of the Corvus Carrone.*

Remton

Remton, a.k.a. Rémi Le Capon, was born in Grenoble in the French Alps, and is based today in a small town nearby. From a young age he was winning art competitions and later attended a private art school – "great for its training in drawing, but tiresome when it came to intense and pointless competition between students" – before establishing himself as a freelance. He doesn't see himself specifically as a steampunk artist; it's one genre amongst many that he explores. "For my steampunk works I have in mind a land outside chronological time, with a setting at around the time of the Russian revolution and towards the end of the First World War, with steampunk and fantasy elements, inspired by Slavic legends and myths. I like to create a slightly different interpretation of steampunk to what I generally see out there." Most of Rémi's works are created digitally, but he still occasionally likes to turn to traditional watercolours, oils, acrylics or inks. His inspiration comes from most of the art historical spectrum. "I like celtic ornaments, medieval art, the Romantics, surrealism; when it comes to specific artists it could be Hieronymus Bosch just as much as H.R. Giger."

RIGHT: *Steamcity.*
OVERLEAF: *Luftflotte.*

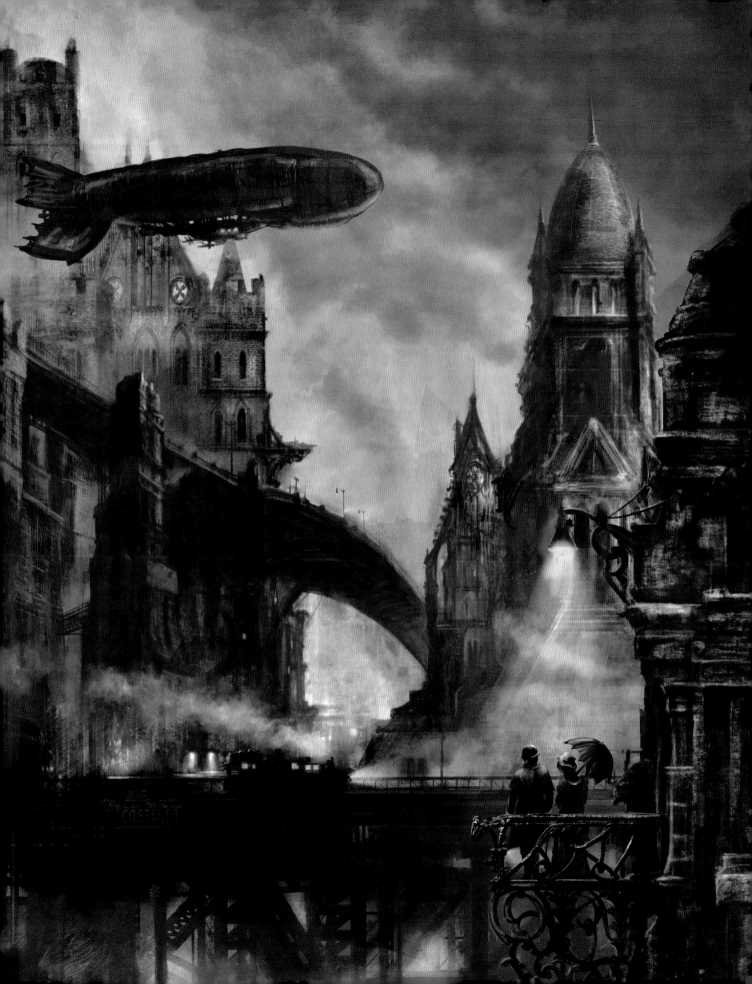

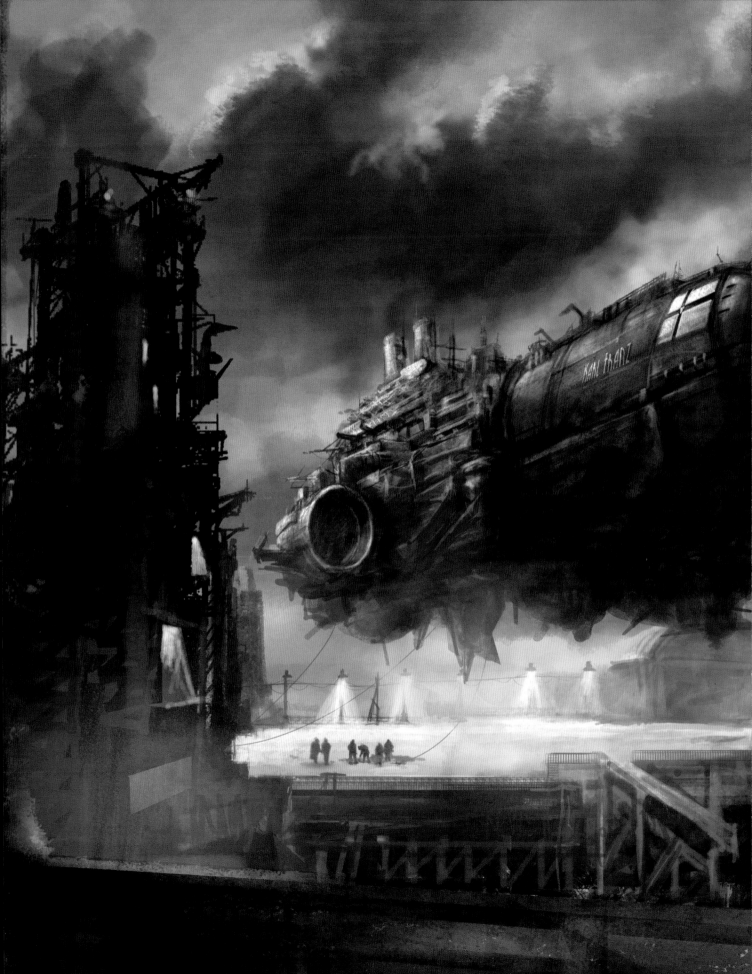

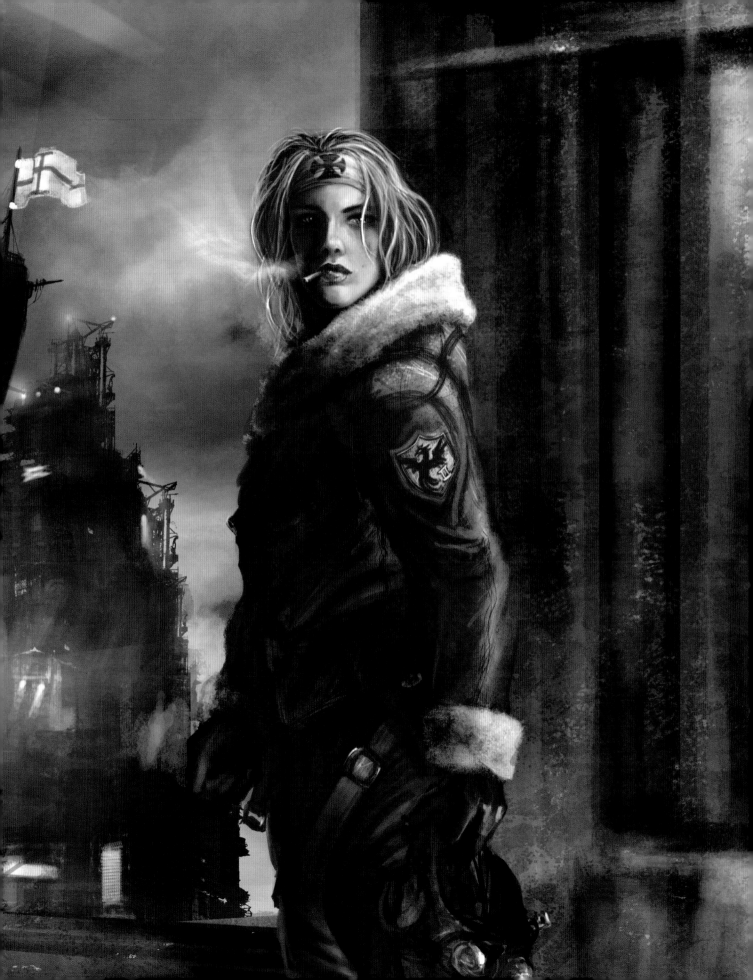

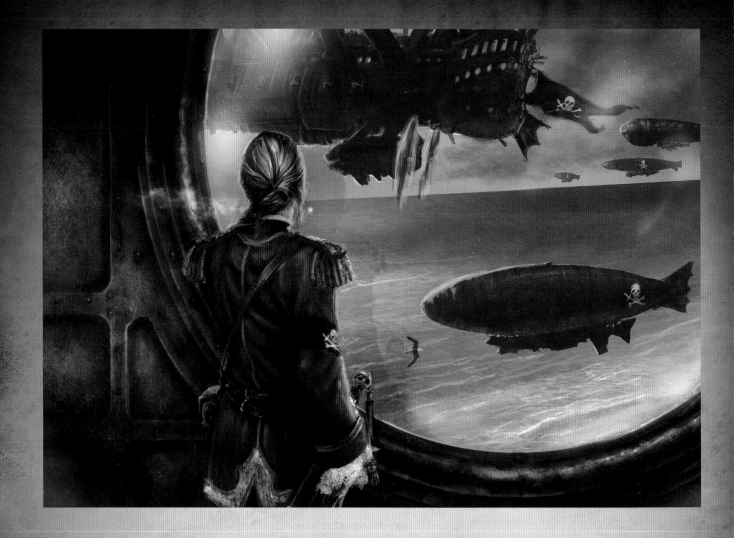

ABOVE: *Armada.*
RIGHT: *Steampunk Captain.*

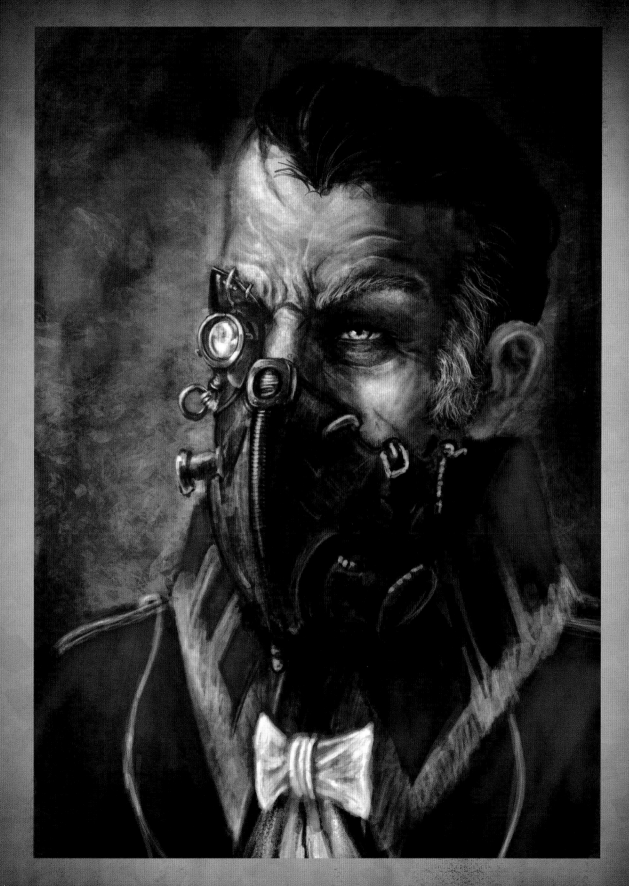

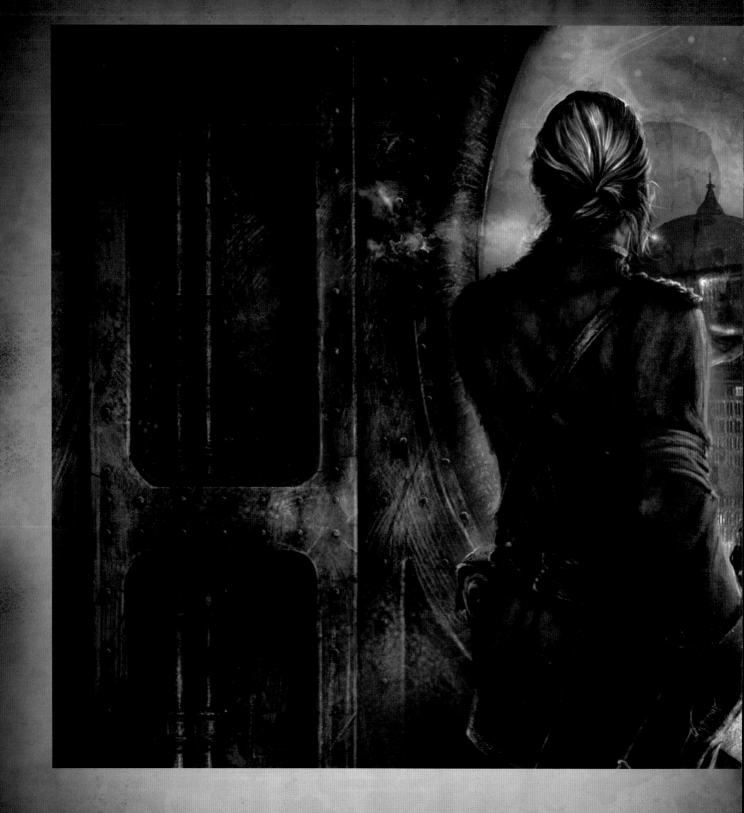

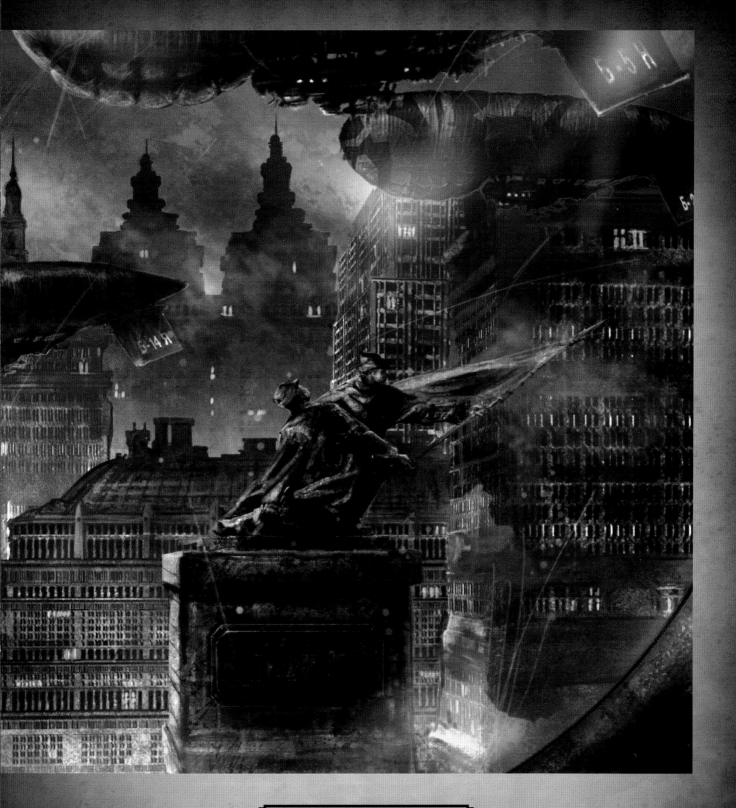

ABOVE: *Sybera.*

Lorenz Ruwwe

———◆———

Lorenz Hideyoshi Ruwwe (he uses his Japanese middle name on artists' forums) was born in Germany, but is currently based and working freelance in NYC. He got into drawing manga as a kid and progressed into concept art. Steampunk is one of his favourite genres in which to create. "I think it's just my response to the aesthetics that pleases me." He used to have many more art idols than he does today. "I used to admire Katsuhiro Otomo or Tsutomu Nihei for their manga, and Toriyama and his *Dragon Ball* series. I have long admired the work of Craig Mullins. Now there are so many great artists out there it's hard to pick. Movie-wise I remain inspired by the classics: *Blade Runner* and *Aliens*." Entirely self-taught, Lorenz likes to mix his genres and also to invent back stories or characters for certain illustrations – "It adds depth and interest to an artwork." He sees steampunk as being "retro sci-fi. For me it's about creating an alternative universe with steam engine technologies. It's the mix of historic and futuristic flair that is key."

RIGHT: *Junkyard Golem.*
OVERLEAF: *Time Machine.*

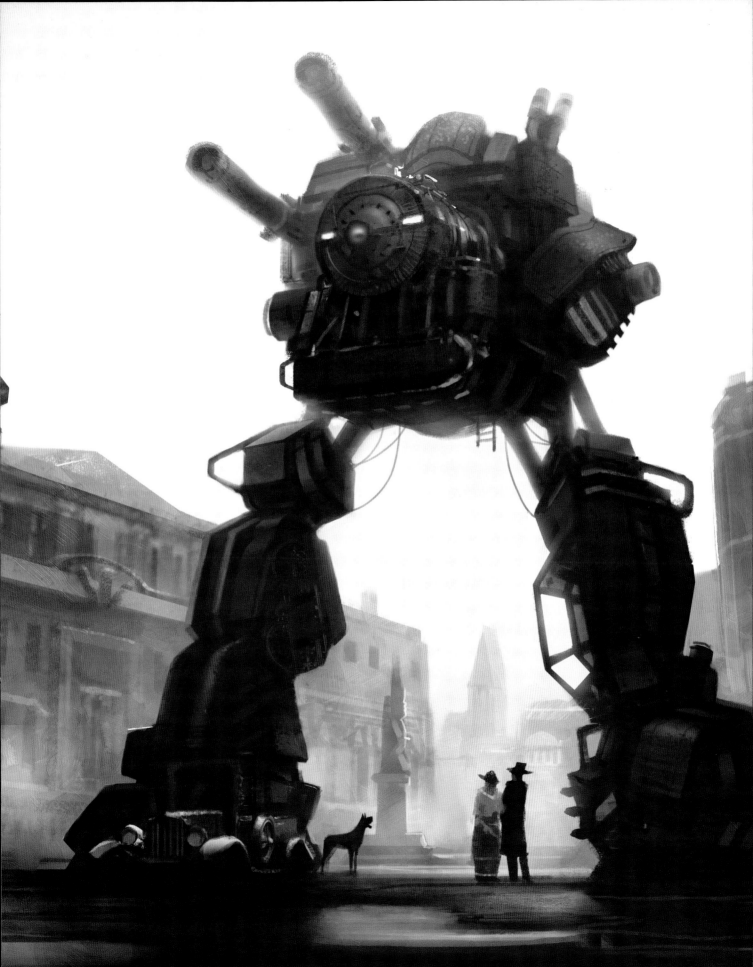

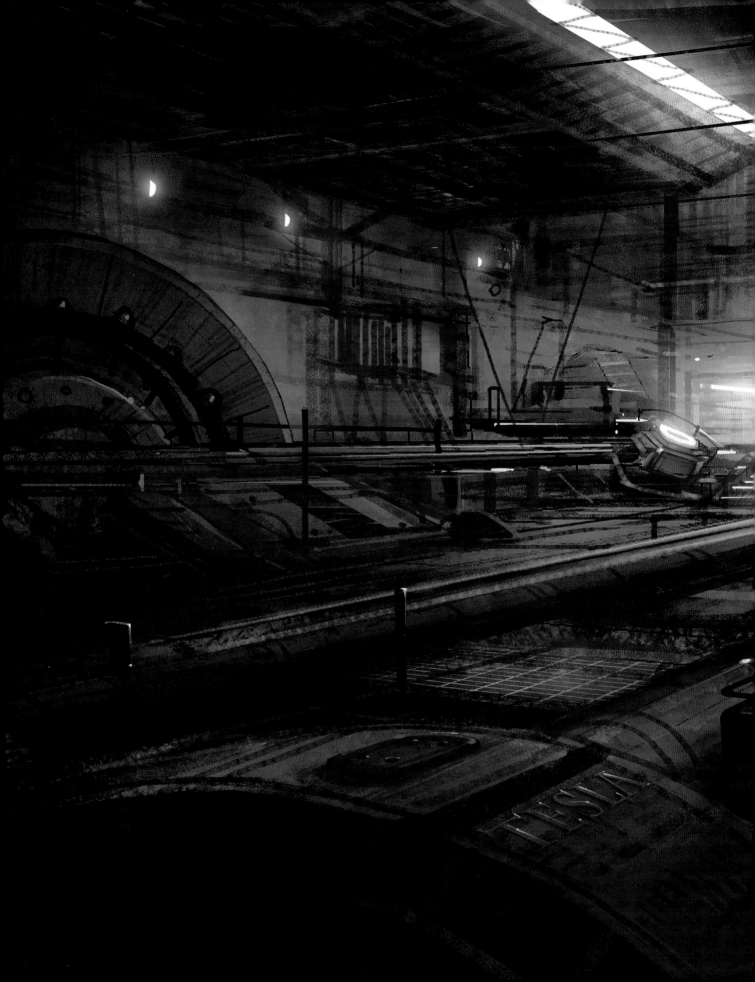

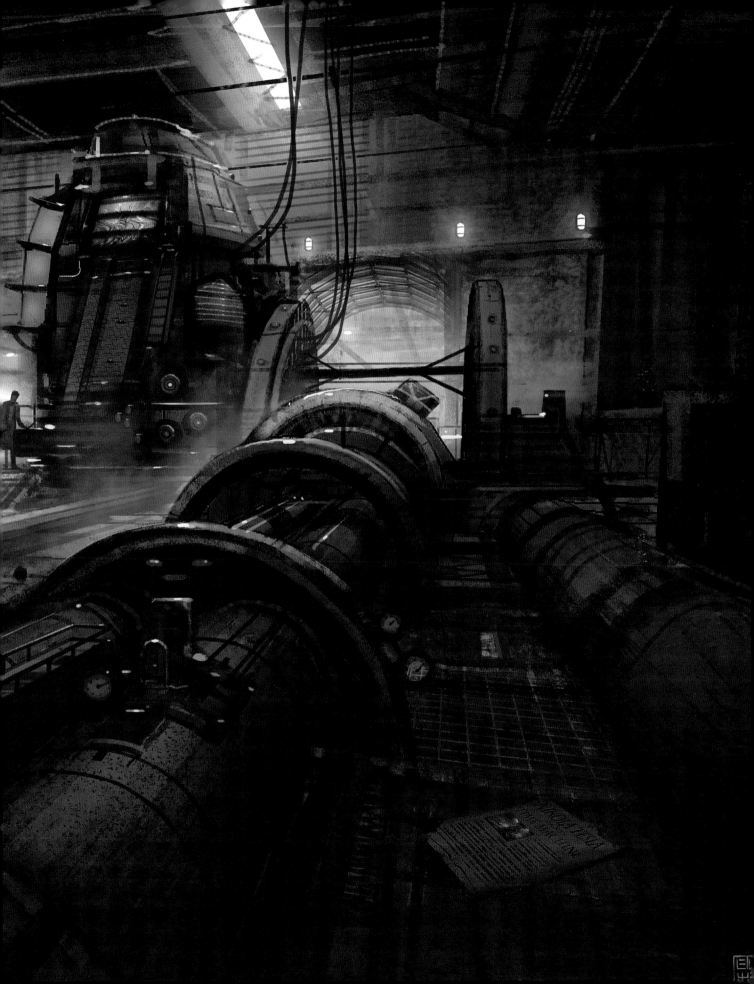

Sensevessel

———◆———

The *Bioshock* games series got Sensevessel (a.k.a. Enggar Adirasa) hooked on steampunk. From Jakarta, Indonesia, where he is still based, he works as a freelance artist and graphic designer for smartphone games companies and traditional publishers, for the latter he creates cover designs. His pieces start with a sketch. "I usually look for some vintage machine reference point, and then imagine what a design mechanic would have done at a more advanced stage. My pictures don't really have a back story, it's more a case of how a piece of machinery can dramatize a landscape or scene." His client base is growing, probably a result of his flexibility. "As a designer you have to be able to adapt your style. I can turn my hand to pretty much anything – steampunk or fantasy or sci-fi." Amongst other artists Sensevessel find Moebius particularly inspiring – "he has the ability to add crazyness to even the most mundane activities." He also admires art deco and the Bauhaus and Fritz Lang's *Metropolis*. "Not the most steampunk of sources, I know." Sensevessel credits the growing popularity of steampunk to people now being more open to fantasy visuals." *Lord of the Rings* had a lot to do with it. It showed that you didn't have to be a nerd or geek to enjoy that aesthetic." For the future, he says he is still waiting for a really great steampunk movie, "where every detail has been perfectly researched."

RIGHT: *Perfect Flaw.*

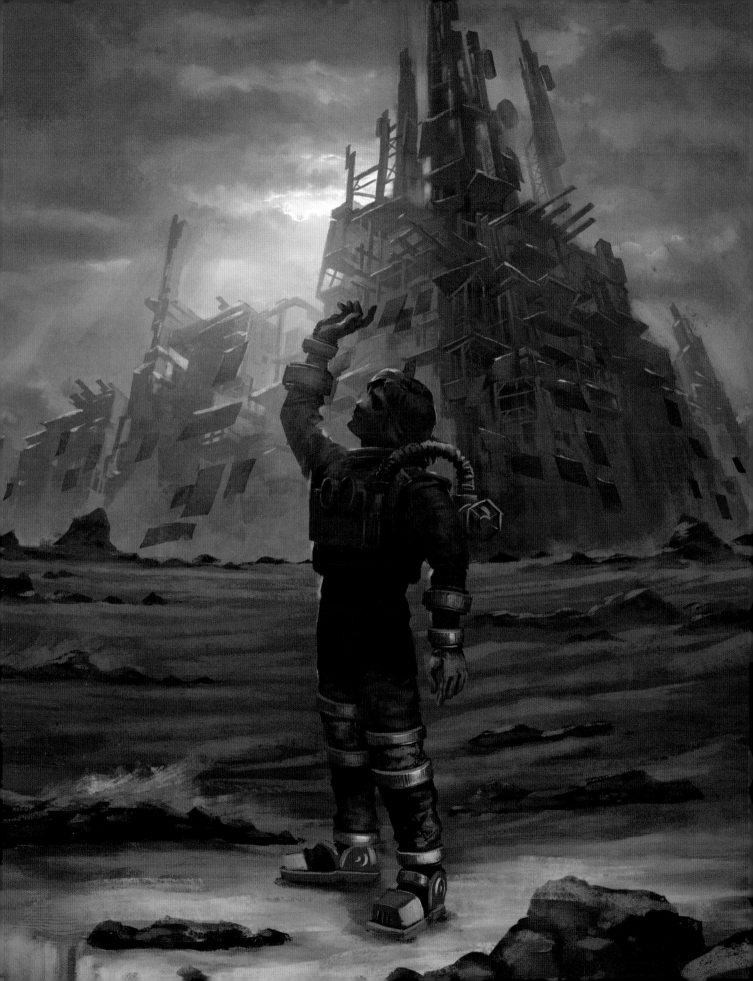

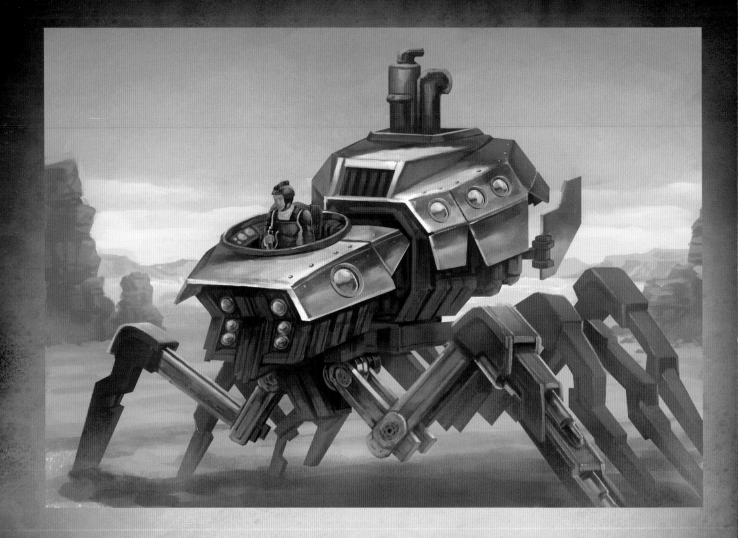

ABOVE: *Eight Legged Tin.*
RIGHT: *Terravithian.*

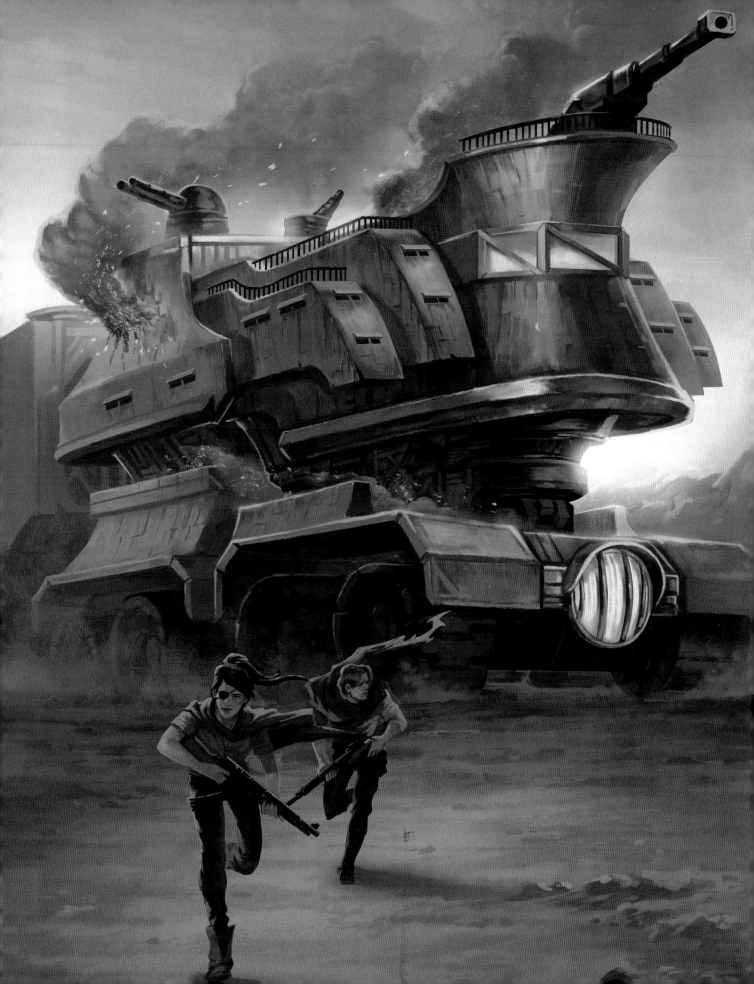

SnowSkadi

One of the most elusive of concept artists, SnowSkadi hails from Russia. He is widely recognised for his fantastic fantasy landscapes and for his images of great neo-gothic constructions amidst crashing cataracts and vertiginous rocks, like scenes imagined in the hyper-active imagination of William Beckford. In other works, his environments are populated by mysterious women, redolent of Gustave Moreau's symbolist paintings. His relatively few steampunk works are rather different: seemingly unmanned dirigibles homing into a peaceful landscape, bringing a sense of unease, or the contrast of a floating town on a rock, somehow powered by gears, flying over a peaceful scene of sailing boats. The unsettling perspective is equalled with a sense of foreboding – the town is on fire, and surely will crash at some point into the peaceful scene below. "I don't want to say too much about my sources of inspiration," says SnowSkadi "I just want the art to speak for itself."

RIGHT: *Airship.*

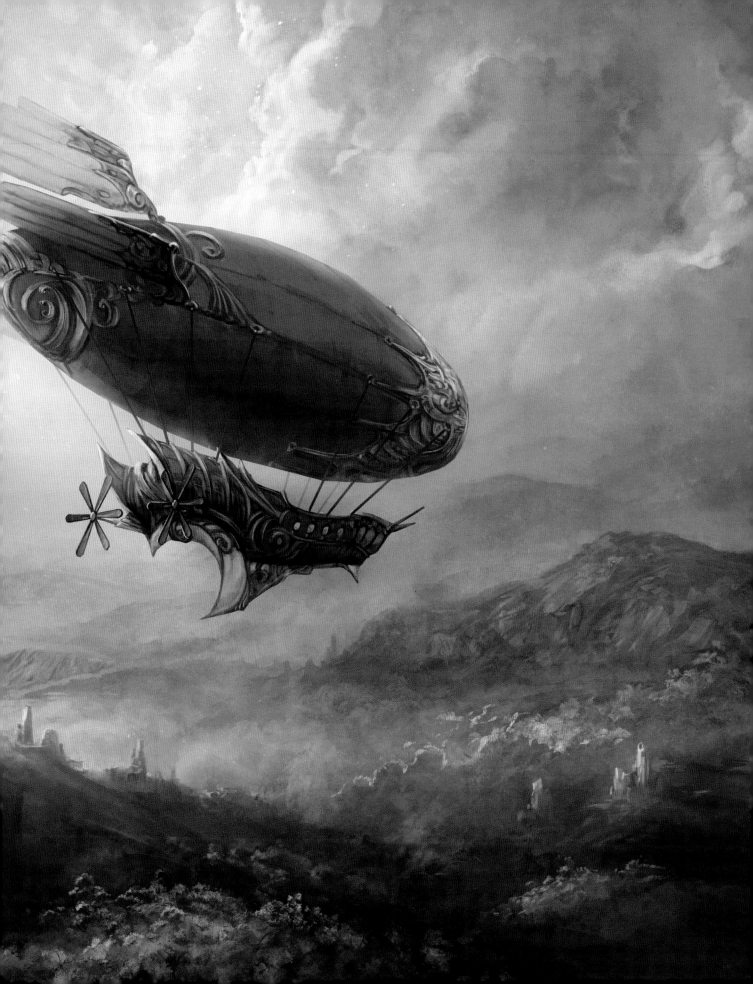

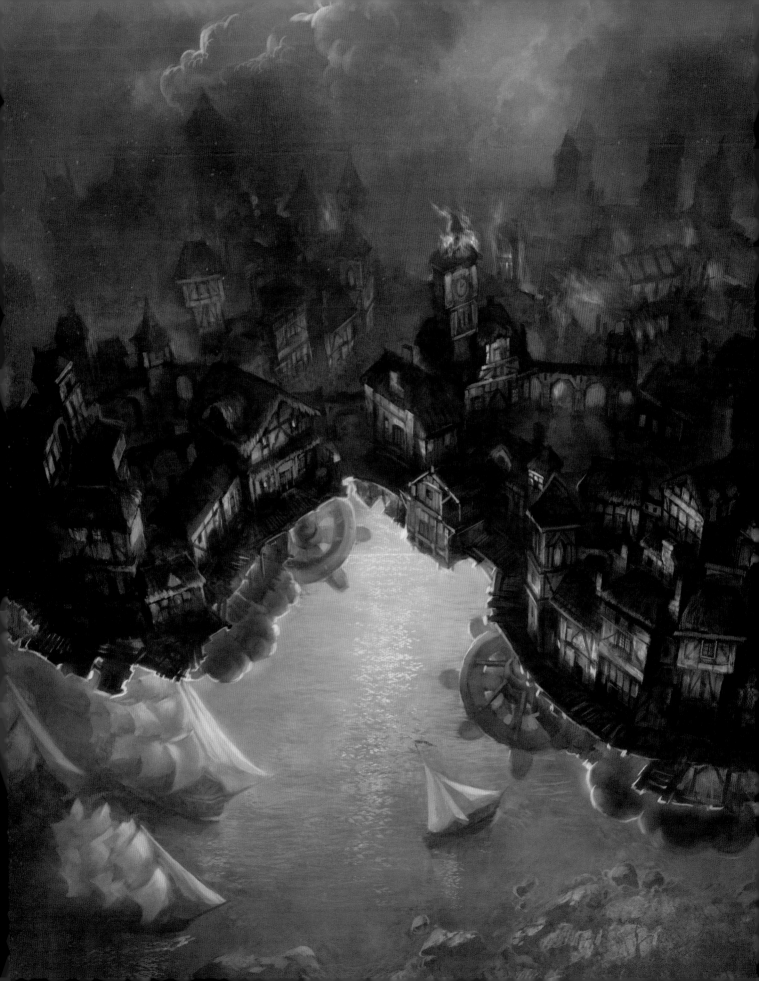

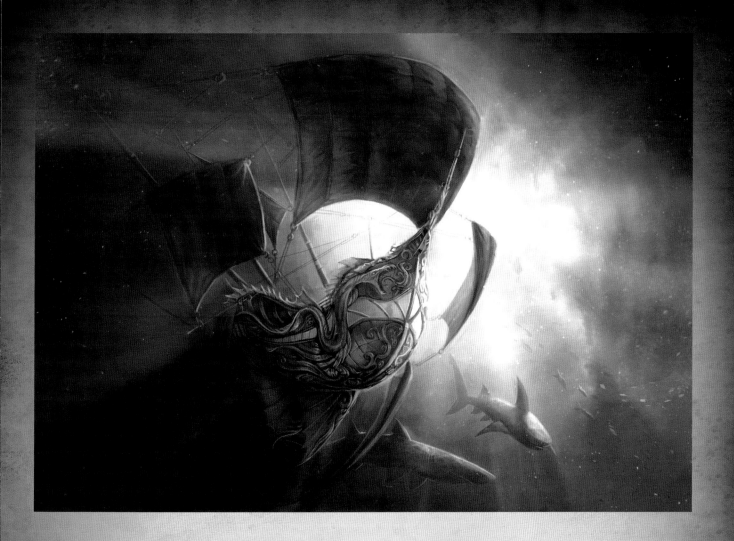

ABOVE: *Gulf Stream.*
LEFT: *Floating City.*

Voitv

Vadim Voitekhovitch (Voitv is his pseudonym) was born in the small town of Mozyr in Belarus and now lives in Halle, Saxony, Germany. Almost uniquely amongst contemporary steampunk artists, he only uses traditional materials in his work: watercolours, gouache or oils. "The aesthetics of the 19th century had a huge impact on me and in effect defined my style." He studied graphic design at art college in Bobruisk, but now works exclusively as a painter and to commission only. "My inspiration often comes from old photographs from the late 19th or early 20th century. My pictures capture a feeling of escapism and for me this is what steampunk is: a flight from the modern world and its characterless aesthetics. The pre-digital era is infinitely more inspiring." For Vadim, steampunk and its attitudes are more than an artistic genre. A regular participant at steampunk events, dressed in the manner of a Victorian or early Edwardian gentleman, he thinks that "in future, one can imagine it developing into a popular way of life."

RIGHT: *NW.*
Oil on canvas.

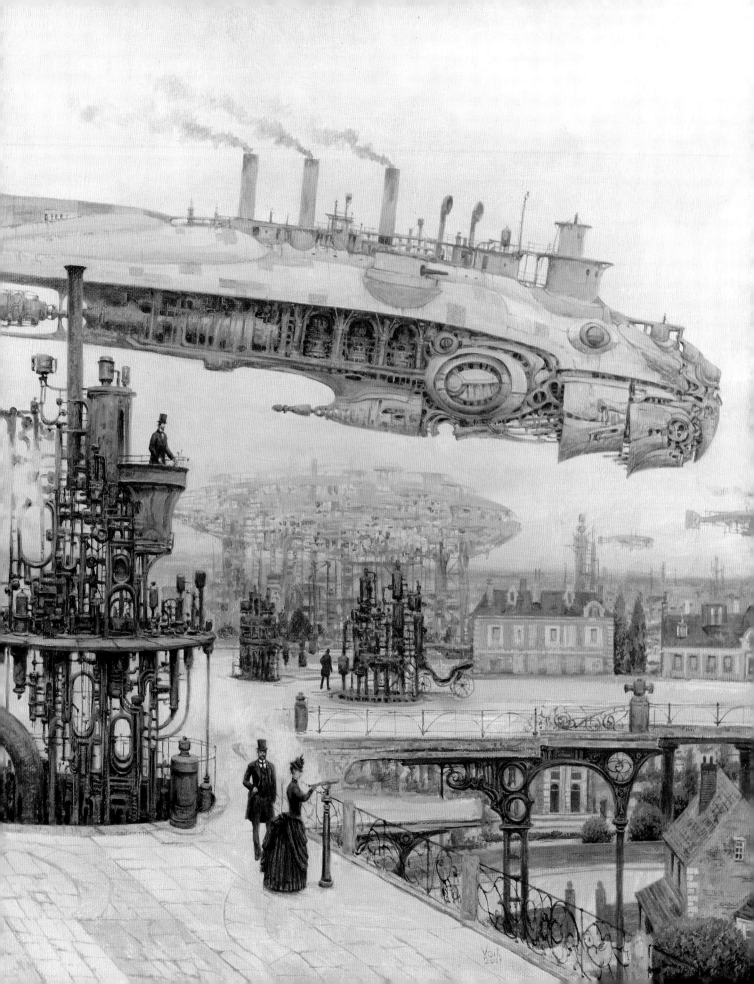

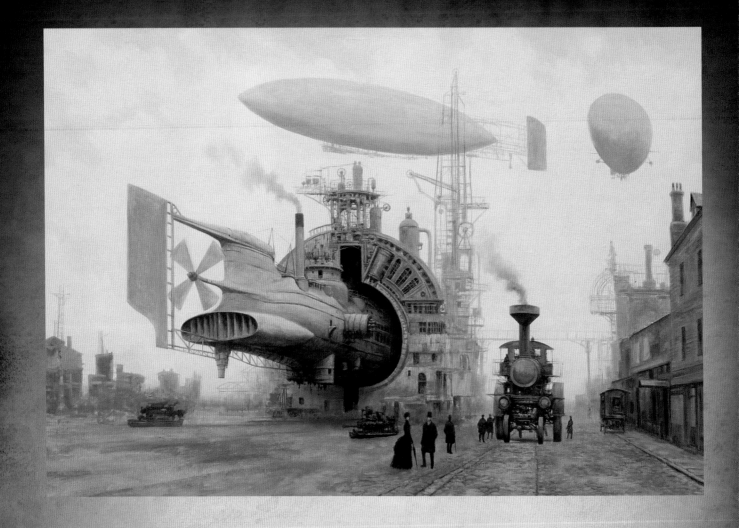

ABOVE: *Arrival.*
Oil on canvas.

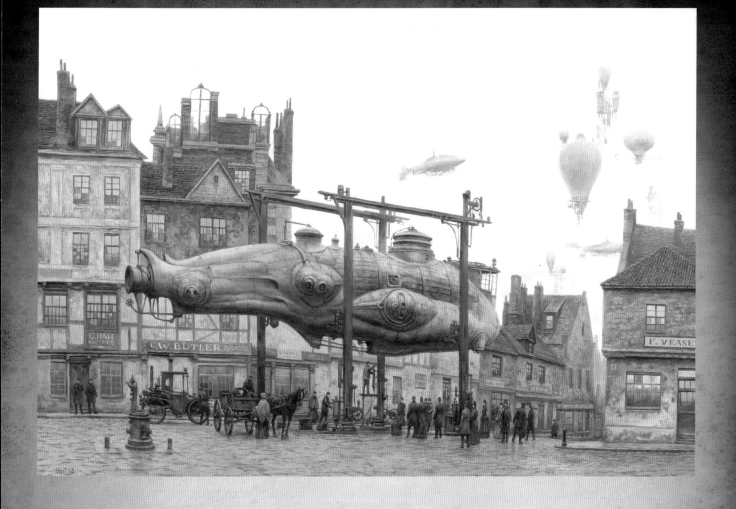

ABOVE: *Gift Grek*. Oil on canvas.
OVERLEAF: *Duty Vessel*. Oil on canvas.

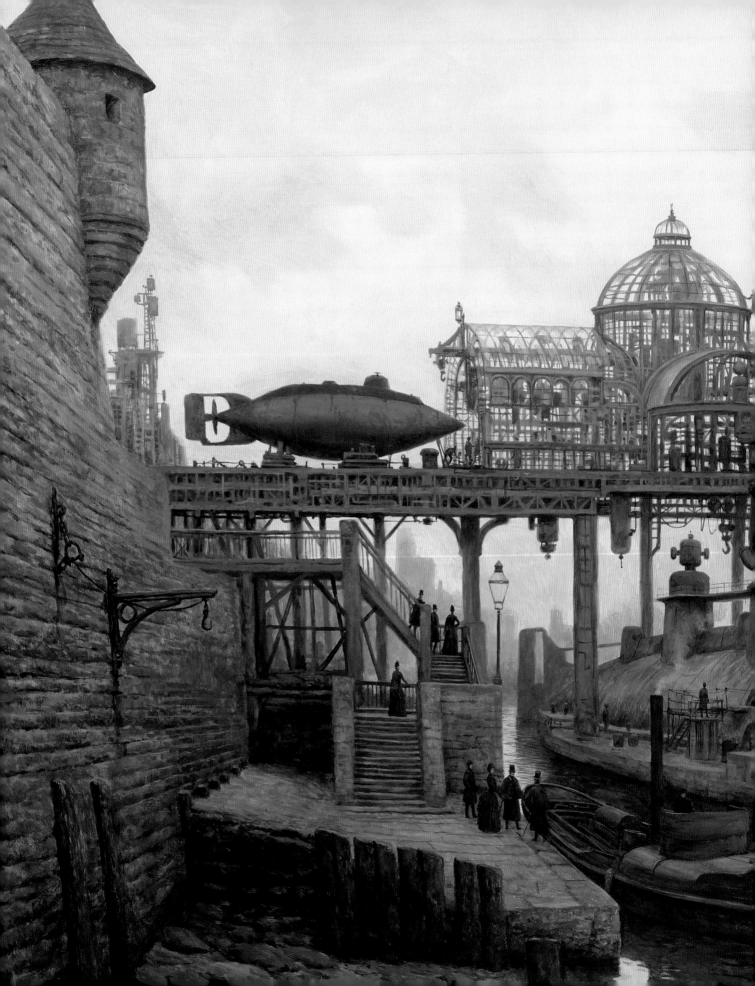

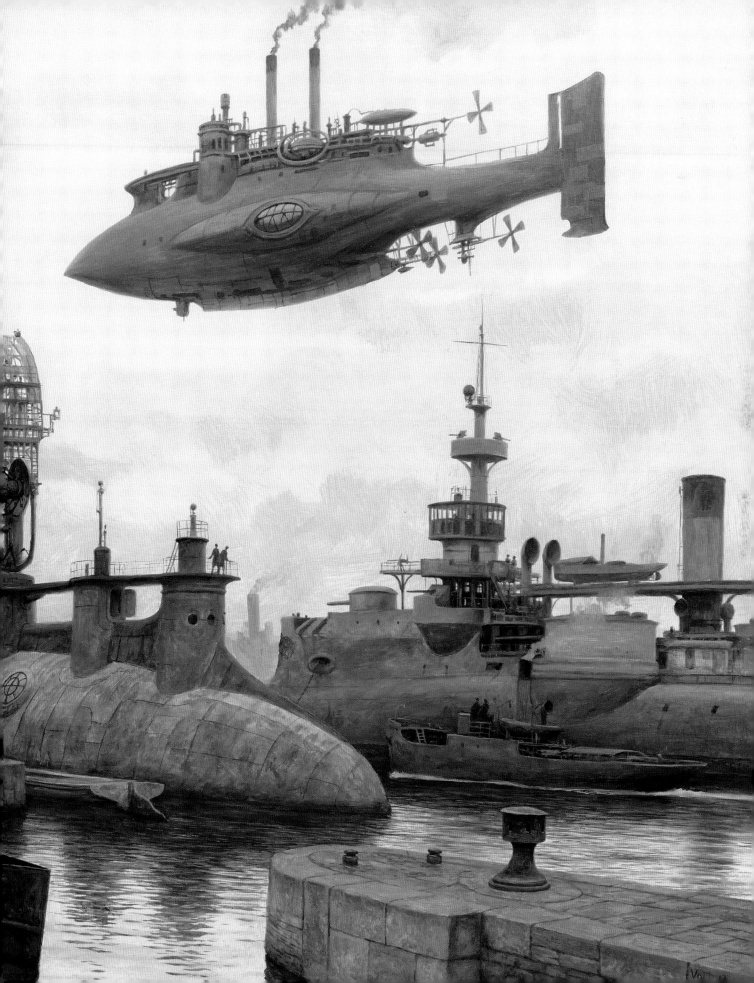

Zephyrchef

Zephyrchef, a.k.a. Jef Wall, originally from Kent, UK and now based in the north-east of England, developed an interest in sci-fi and horror illustration whilst at art school. Early inspiration came from the likes of Corben, Achilleos, Vallejo and Moebius. He got into steampunk whilst freelancing as a 3-D artist for various games developers, before joining CPP Games as a senior 3-D artist, where he is creating assets for the soon to be released VR game, *Valkyrie*. Today what he calls "steampunkery" is something he does for pleasure in any spare time he can find. "For me steampunk is fun, involving strange, eccentric and often insane characters who create weird and impossible machinery from whatever they find lying around. I don't know why the genre is now popular. It's just, well, cool. I can't help but smile when I stumble upon a new piece of steampunk art." When creating a piece, Jef starts with an idea, which he has to sketch immediately "often on toilet paper, so I don't forget it." He then starts modelling in 3-D Studio Max and then onto ZBrush for finer work, before finishing off in Photoshop. His influences, he says, are from too many artists to mention, "but I love science fiction and horror, both movies and other kinds of art....Frazetta, Caza, Druillet, Spielberg, Kubrick, Carpenter....loved their work for years."

RIGHT: The Listener.

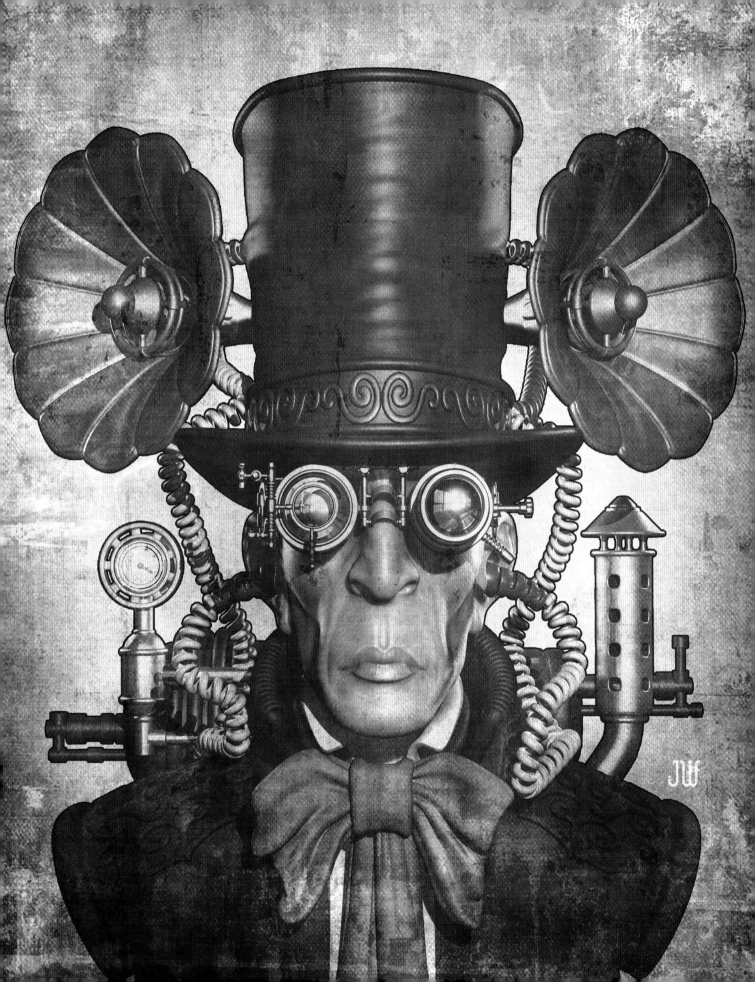

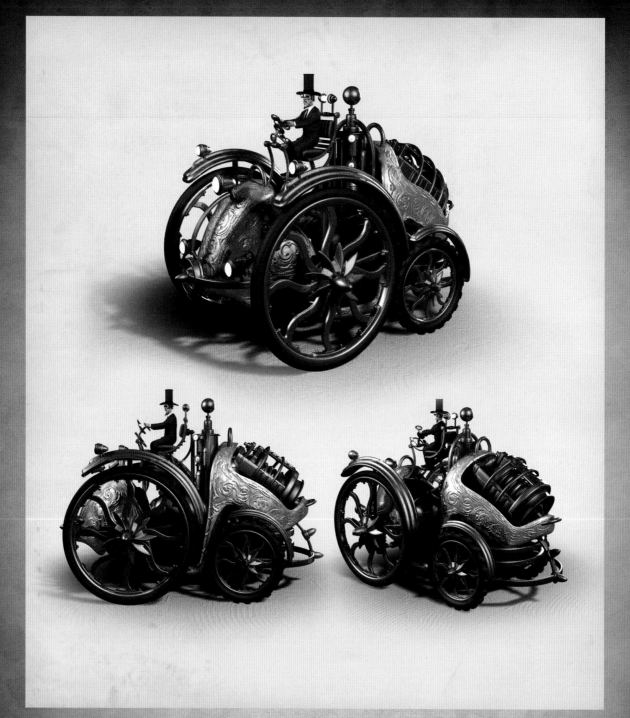

ABOVE: Concept-1, Automobile.
RIGHT: Concept -1, Balloon.

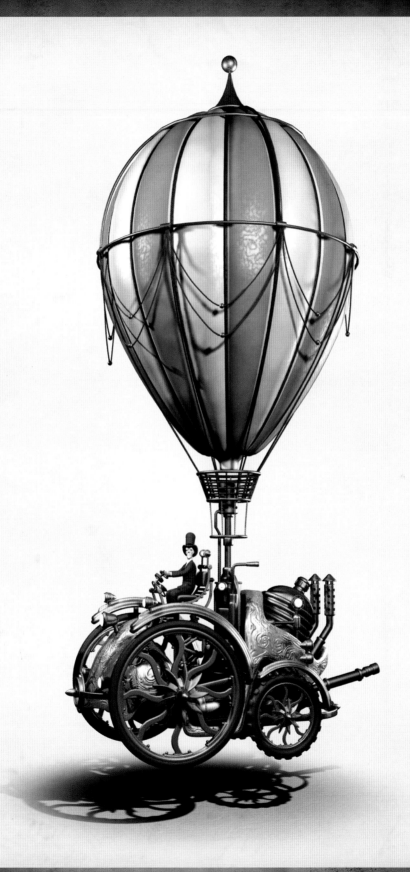

COSHWALL INDUSTRIES

Purveyors of quality eradication devices

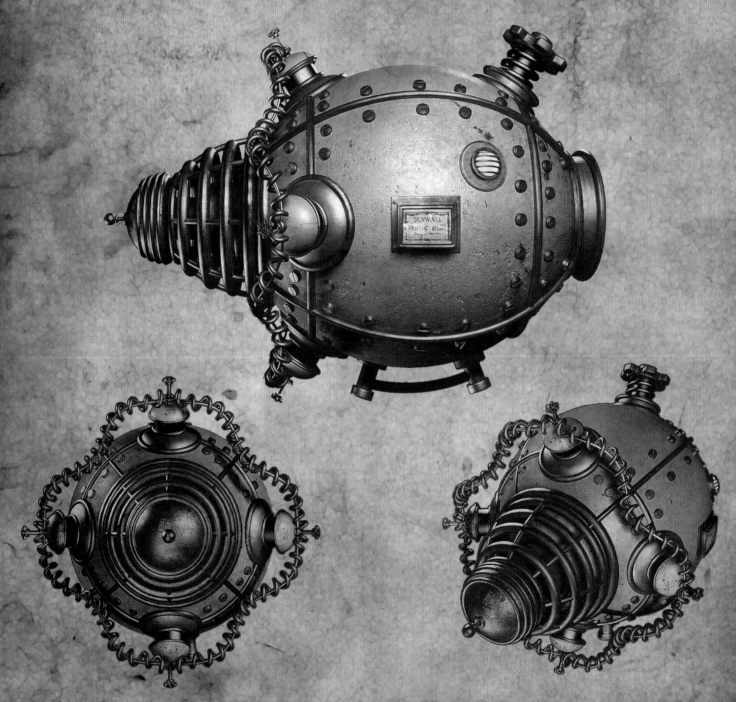

The Elektro-Plasmatronic Cellular Agitator

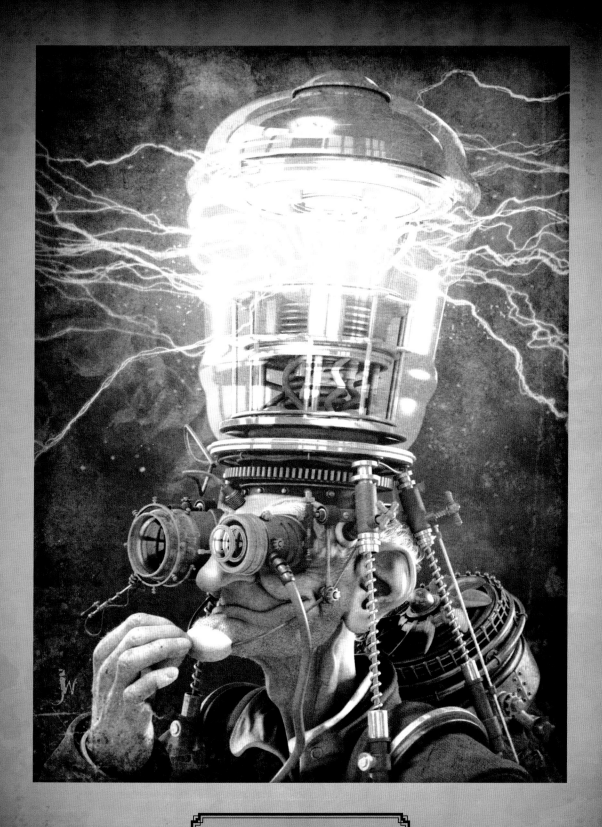

LEFT: *Plasmatronic Agitator.*
ABOVE: *Bulby.*

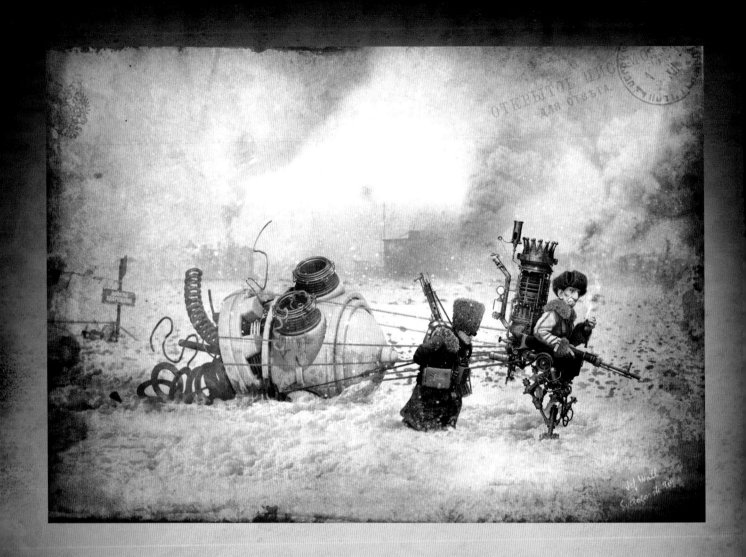

ABOVE: Robot Control.
RIGHT: Oberst.

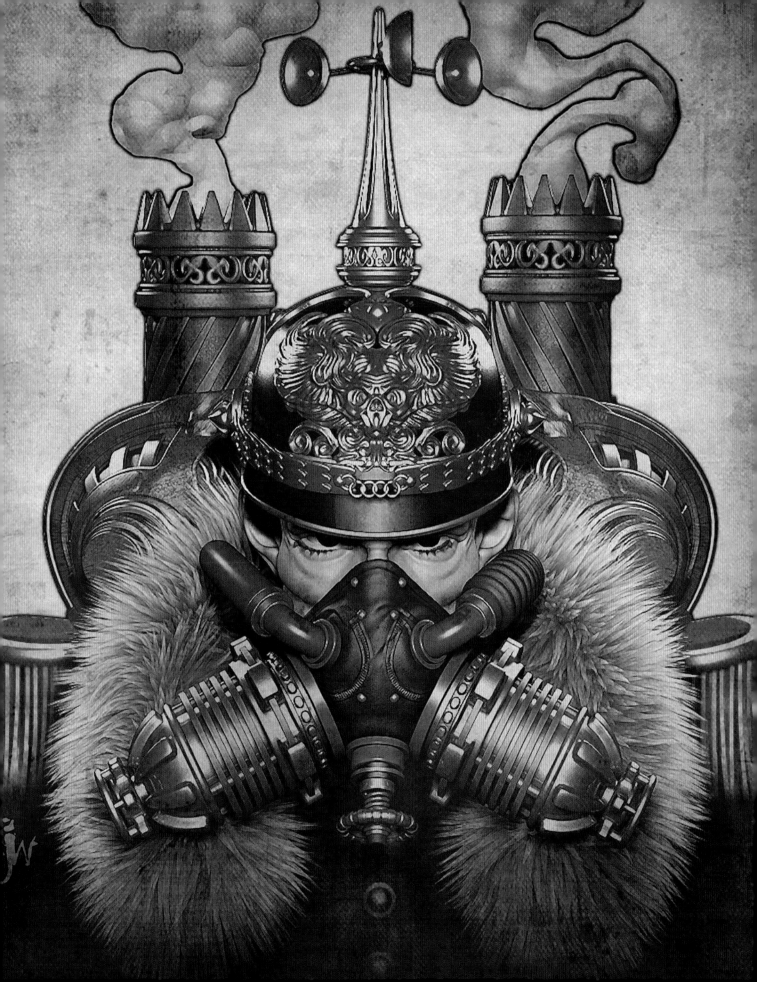

Individual Works

Many artists, grabbed by the steampunk bug, create extended series of works in the genre. Others have just done a few works, and yet they are so steampunk we are crying out for more. We feature some of these here. Ognian Bonev is a concept artist, originally from Bulgaria, now working in Austin, Texas. His range goes all the way from biomech, to highly technical, to medieval fantasy. American Christopher Vacher, a.k.a. Chvacher, creates astounding oils of imaginary, fantastic architecture and landscapes. His *Borealis* railway station is one of the most memorable images in the book. Originally from Serbia, but now based in San Francisco, Vladimir Petkovic, a.k.a. Cuber, has created an imaginary steampunk world, Cuberia, with its distinct muscular Serbian architecture, mixed with massive Franz Ferdinand-period military hardware and dirigibles. Mélanie Delon, renowned for her fantasy art nudes, has in her piece *Trapped*, created an almost pre-Raphaelite work, subtly packed with steampunk elements. One of the wittiest pieces in this book is 3-D modeller and animator, Guillaume Dubois's *Alice's Adventures in Steamland*. Mike Inscho has created a unique vision of a retro-futuristic Tower of Babel. Cory Jespersen's massive brass-and-gears mechanical scorpion, in *Steampunk Goliath*, is a violently powerful, but almost charming invention, facing a terrified small lad in the foreground. Germany's Victor Lammert has created a nocturnal work straight out of the heavily industrialised early 20th century Ruhr valley, with unlikely hot air balloons as well as dirigibles. In sharp contrast Little Green Frog's *Bioshock Warsaw* features many architectural periods, including 1930s and modernist skyscrapers. It's only the Victorian clothes and airships which anchor us in steampunk. SammaeL89's *Krakow* shows fantastic invention, with the Renaissance Cloth Hall in the centre of Krakow transformed into a machine of steam turbines and propellers, about to effect vertical take-off, with a levitating statue of an angel looking on. We can't think of an image which better illustrates the ability of steampunk to re-imagine a future that might have been.

The Outpost
by Ognian Bonev.

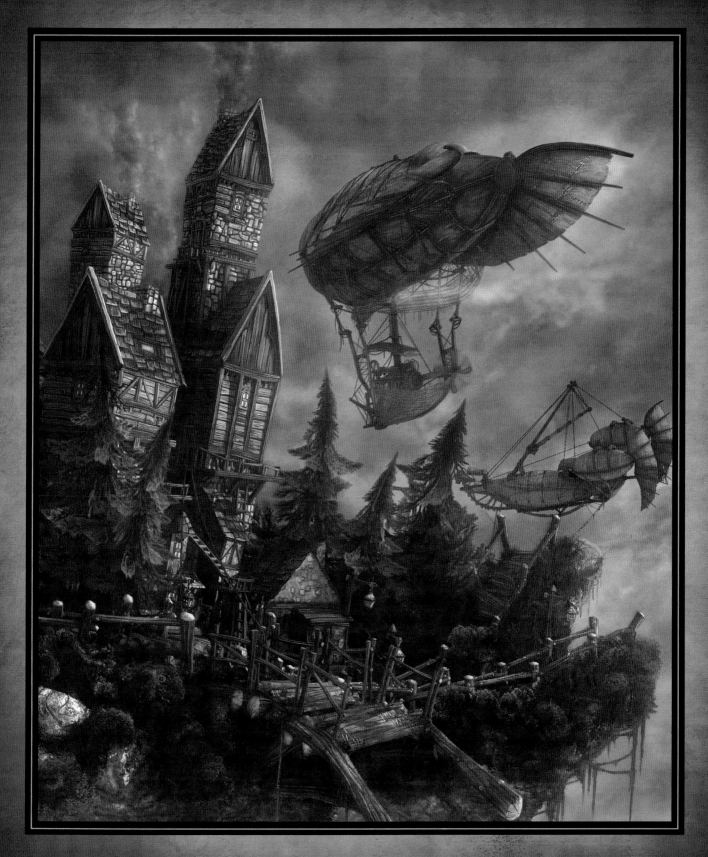

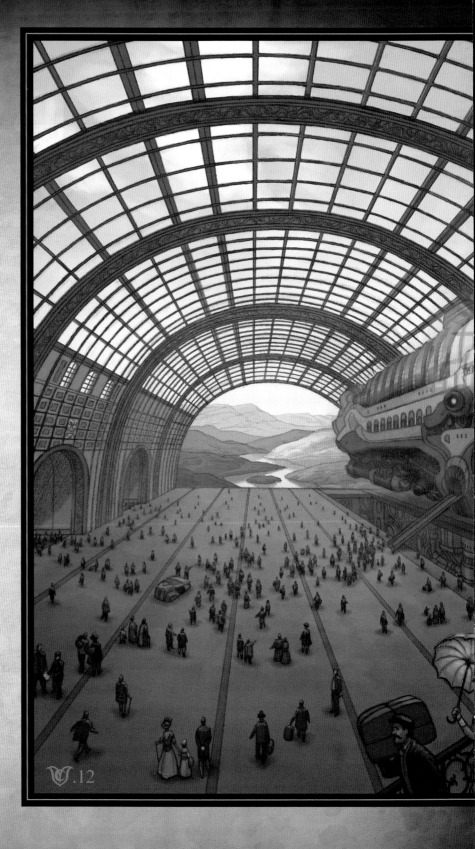

Borealis
by Chvacher (Christopher Vacher).

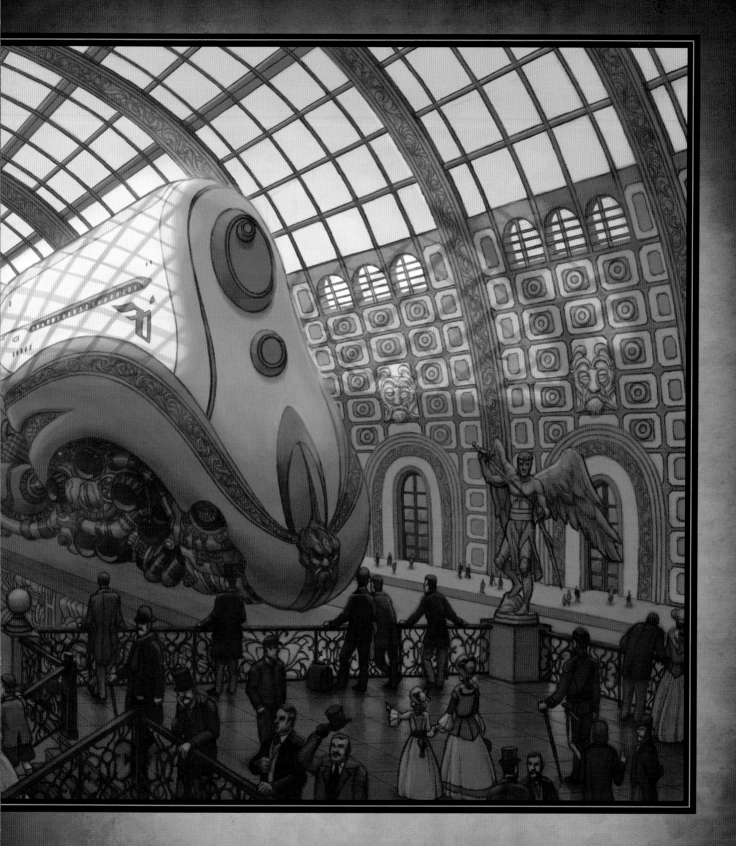

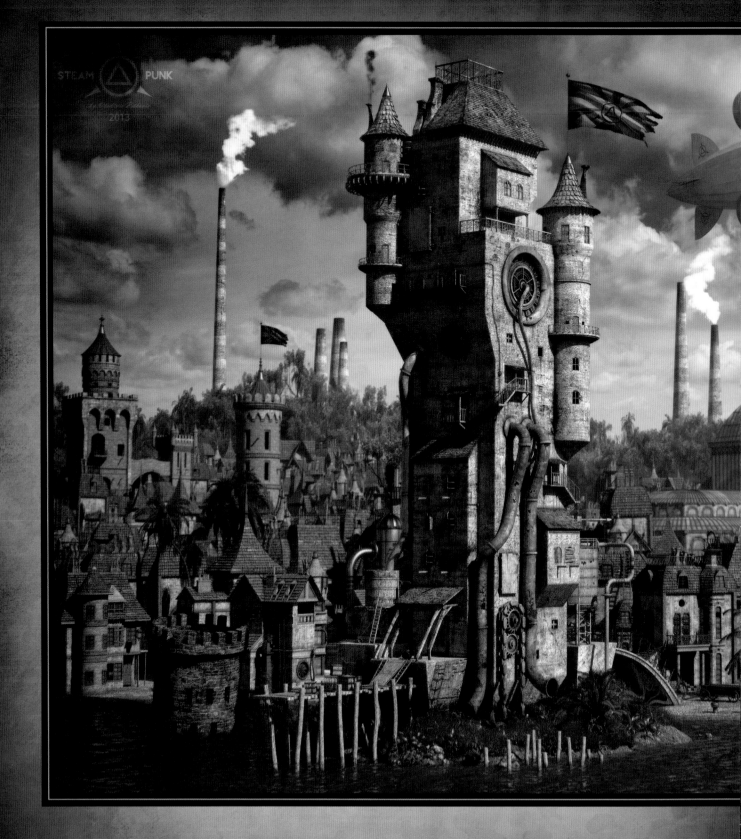

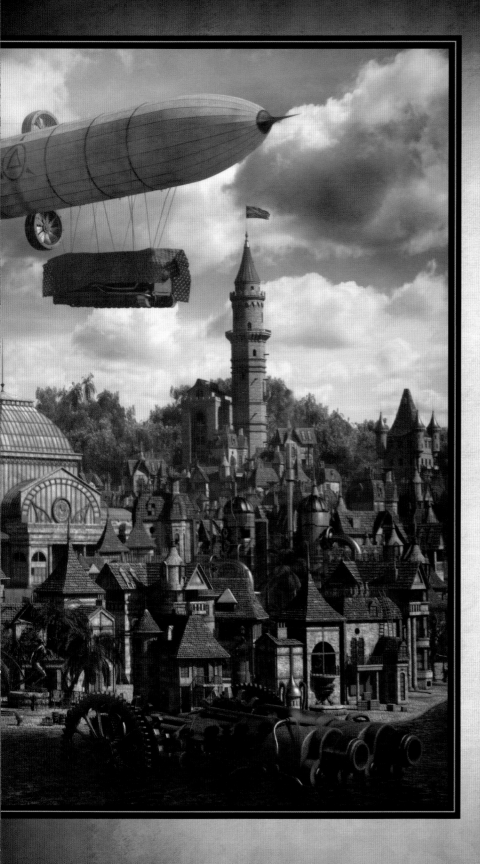

A View of Cuberia
by Cuber.

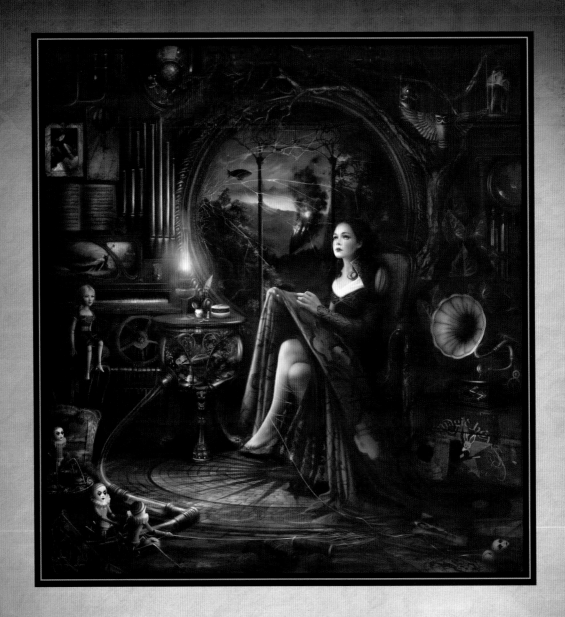

Trapped
by Mélanie Delon.

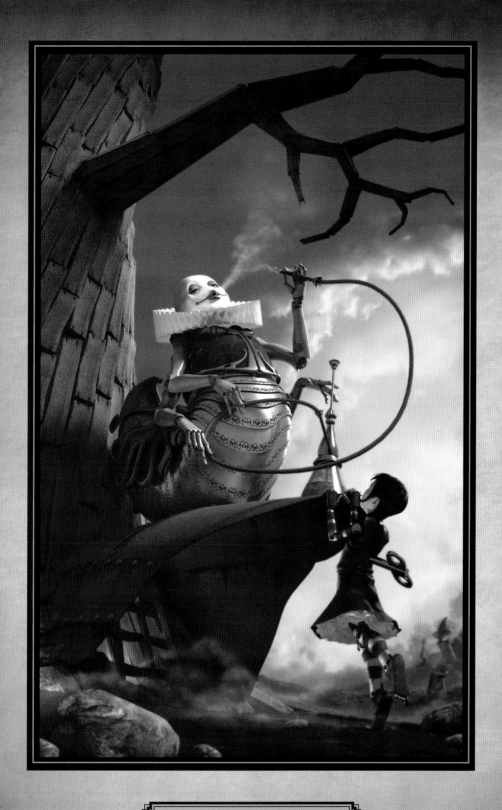

Alice's Adventures in Steamland
by Guillaume Dubois.

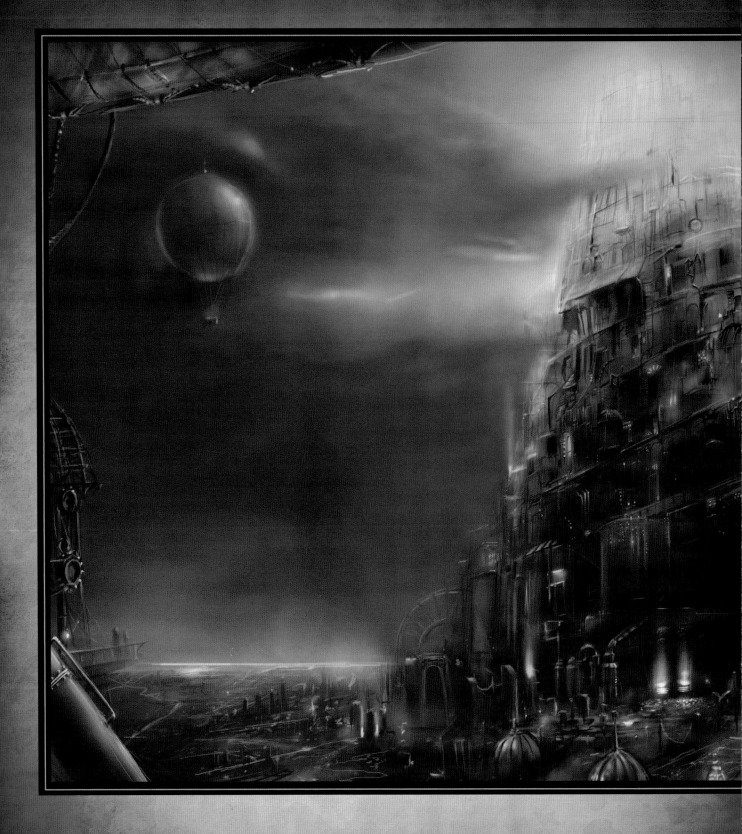

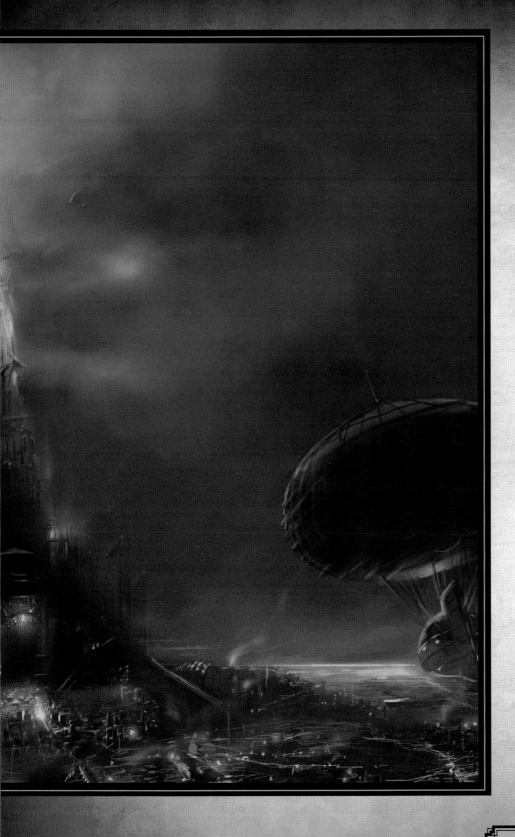

The Gate
by Mike Inscho.

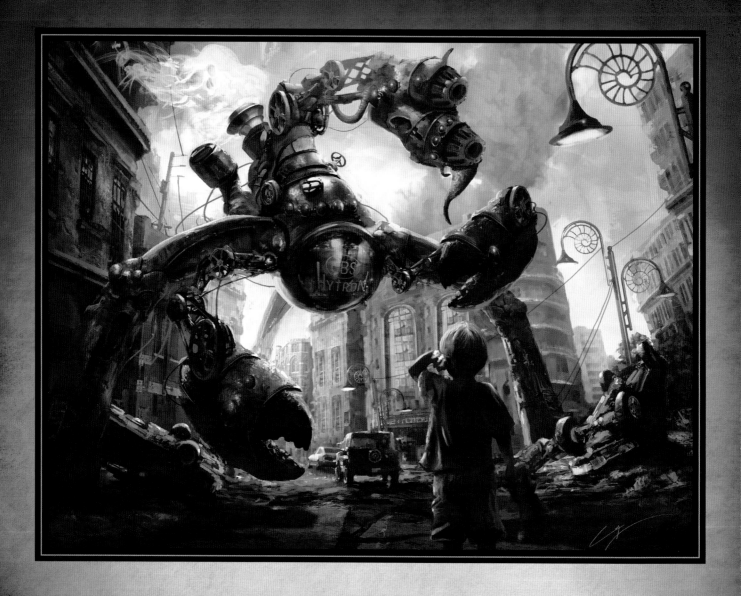

Steampunk Goliath
by Cory Jespersen.

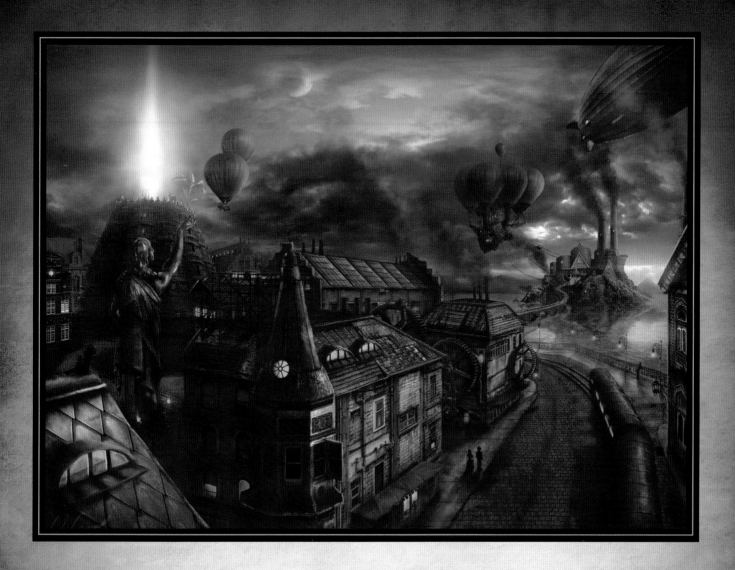

Workflow
by Victor Lammert (Victor-Lam-art).

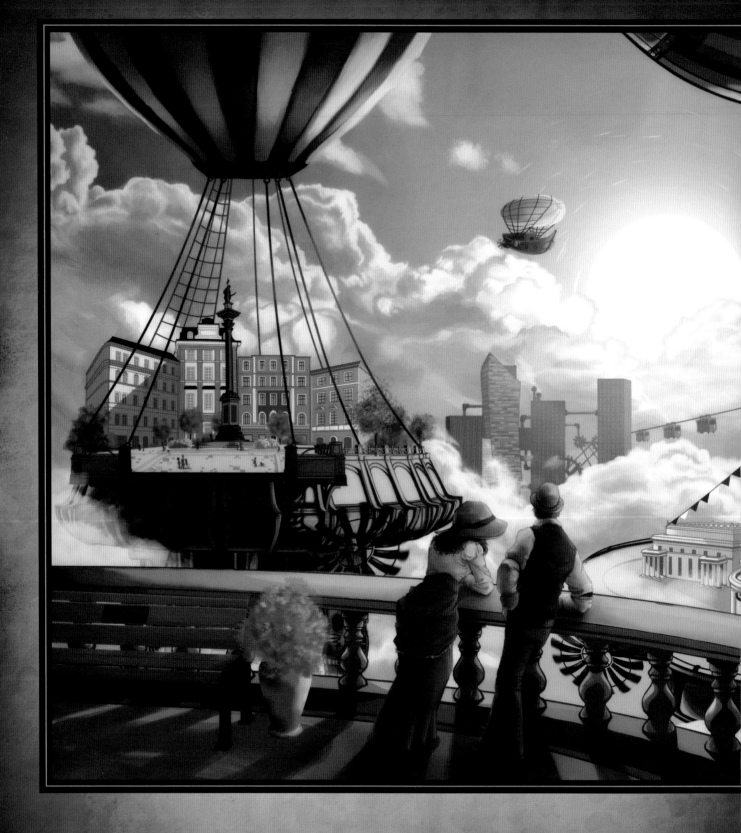

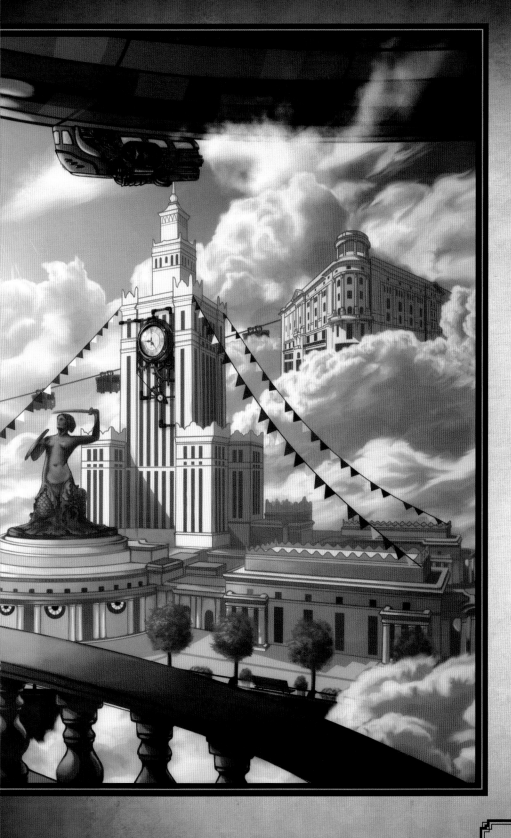

Bioshock Warsaw
by Little Green Frog.

Krakow
by SammaeL189.

Artists

VLADIMIR BONDAR
http://vladio.com.ua/en/

OGNIAN BONEV
http://www.northflame.com

LUIZ EDUARDO BORGES
http://ark4n.wordpress.com/

CHVACHER
http://vacher.com/

CUBER
http://www.vladimirstudio.com/

CINVIRA
http://cinvira.wix.com/cinvira

MICHAEL DASHOW
http://www.michaeldashow.com/

MÉLANIE DELON
http://www.melaniedelon.com/

CIHAN OGUZ DEMIRCI
http://codemirci.blogspot.co.uk/

GUILLAUME DUBOIS
http://www.duboisguillaume.be/

IOAN DUMITRESCU
http://www.ioandumitrescu.com/

DYSHARMONNIA
http://dysharmonnia.deviantart.com/

GWASANEE
http://gwasanee.deviantart.com/

TONY HOLMSTEN
http://www.tonyholmsten.com/

INDUSTRIAL-FOREST
http://industrial-forest.deviantart.com/

MIKE INSCHO
http://mikeinscho.blogspot.co.uk/

JANBORUTA
https://www.facebook.com/hans-boruta

CORY JESPERSEN
http://www.behance.net/coryjespersen

ARSENIY KORABLEV
http://drawcrowd.com/arsdraw

VICTOR LAMMERT
http://victor-lam-art.deviantart.com/

LITTLE GREEN FROG
(Justyna "Inka" Karaszewska)
http://frogmakesart.tumblr.com/

JEREMY LOVE
http://jeremylove.com/

LUCHES
http://luches.daportfolio.com/

M3-f
http://artistmef.co/

MATCHACK
http://matczak.blogspot.co.uk/

LUIS MELO
http://www.luismelo.net

KEVIN MOWRER
http://mowrerart.blogspot.co.uk/

KAZUHIKO NAKAMURA
http://www.mechanicalmirage.com/

JAMES NG
http://www.jamesngart.com/

MICHAEL PENN
http://www.michaeljpenn.com/

LAURENT PIERLOT
http://laurent.pierlot.free.fr/

IGOR RASHKUEV
http://oxeren.cgsociety.org/

REDKIDONE
http://www.redkids.co.nz/redkidone/

REMTON
http://remton.daportfolio.com/

RUWWE
http://hideyoshi-ruwwe.net/

SENSEVESSEL
http://sensevessel.daportfolio.com/

SNOWSKADI
http://snowskadi.deviantart.com/

VOITV
https://www.facebook.com/vadim.voitekhovitch

ZEPHYRCHEF
http://zephyrchef.cgsociety.org/

Acknowledgements

The publisher would like to thank all the brilliant artists
who have taken part in this project, our remarkable and
mysterious cover artist and creative impressario Kevin
Mowrer for his fascinating introduction.

ADDITIONAL CREDITS
In Ioan Dumitrecu's section:
The Train Station−16 © 2D Artist Magazine
The Flying Palace © Golem Studio

A NOTE ABOUT OUR CAPTION STYLE.
Most of the artworks in this book are created with 2-D and
3-D programmes in digital environments. Where other media
are used in addition, we specify the media used in creation.
Where we don't specify, the reader should assume that the
work in question was created in a digital environment.

OVERLEAF: *The Strongest Survives* by Arseniy Korablev

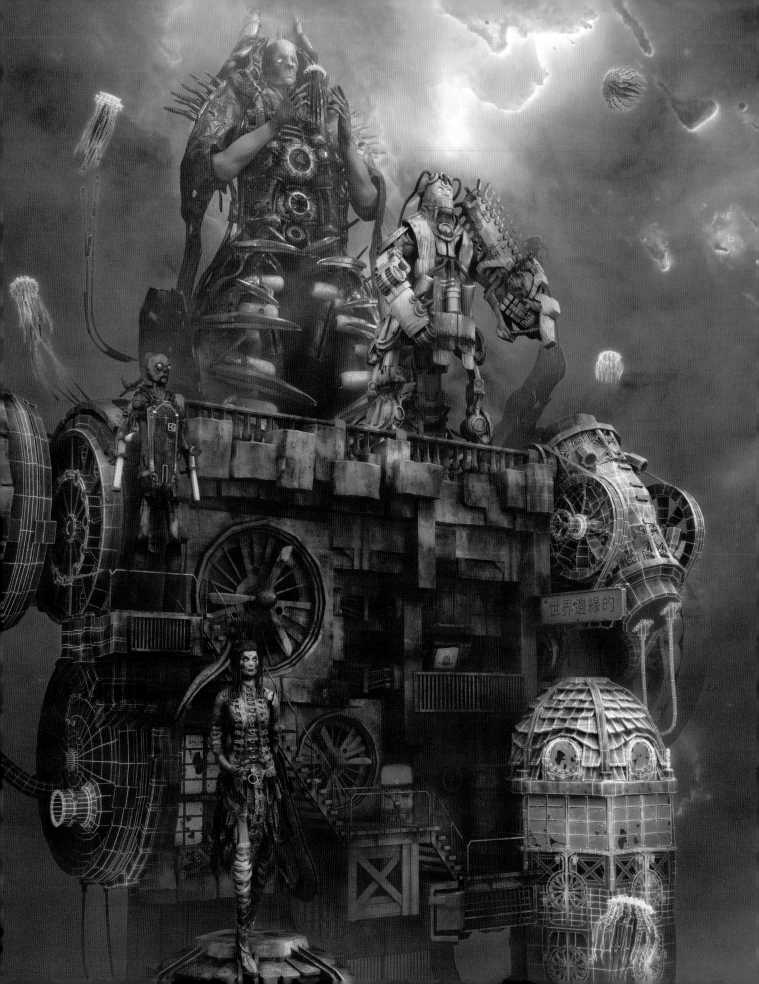

Fig. 7

Fig. 14

Fig. 29

Fig. 28

Fig. 8

Fig. 13

Fig. 33

Fig. 22

Fig. 30

Fig. 9

Fig. 23

Fig. 4